AN INTRODUCTION TO
ENGLISH PAINTING

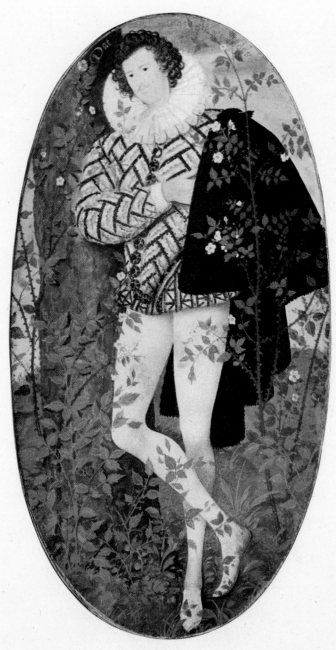

HILLIARD : *Youth Leaning Against a Tree.* C. 1588–1590
Miniature.——Salting Collection, Victoria and Albert Museum

AN INTRODUCTION
TO
ENGLISH
PAINTING

BY JOHN
ROTHENSTEIN

DIRECTOR OF THE TATE GALLERY

CASSELL
AND COMPANY LIMITED
LONDON · TORONTO · MELBOURNE
SYDNEY & WELLINGTON

MGE

First edition 1933
Second (revised) 1947
Third 1949
Fourth (revised) 1951

PRINTED AND BOUND IN ENGLAND BY
HAZELL WATSON AND VINEY LTD
AYLESBURY AND LONDON
451

FOR

EMILY HESSLEIN

WITH GRATITUDE AND AFFECTION

ACKNOWLEDGMENTS

FOR permission to reproduce pictures in their possession I have to thank His Majesty the King; G. W. Andrews, Esq.; Sir Edmund Bacon, Bt.; The City of Birmingham Museum and Art Gallery; the British Museum; the Marquess of Cholmondeley; Captain Cottrell-Dormer; the Croome Estate Trustees; Country Life; the Duke of Devonshire; Mr. Basil Fanshawe; the Marquess of Lansdowne; the Marchioness Dowager of Londonderry; the Musée du Louvre; the Manchester City Art Gallery; the National Gallery; the National Maritime Museum; the National Portrait Gallery; the Vicomtesse de Noailles; the Duke of Northumberland; the Earl of Onslow; the Tate Gallery; Professor G. W. Tristram; and the Victoria and Albert Museum.

Of the authorities consulted I must mention three to which I am particularly indebted, namely " Catalogue of an Exhibition of British Primitive Paintings," with an introduction by W. G. Constable; "English Mediæval Painting," by E. W. Tristram and Tancred Borenius, and " Lely and the Stuart Portrait Painters," by C. H. Collins Baker.

I should also like to place on record my gratitude for the valued assistance of Miss Mary Peter.

CONTENTS

COLOUR PLATES

viii

LIST OF ILLUSTRATIONS

ERRATA

For lines 1–19, p. 32 read:

Of these by far the most gifted was William Dobson, who expressed the romantic chivalry of the Cavaliers with acuter understanding than Van Dyck himself. Born in Holborn on March 4, 1611, the son of a man who seems to have been a *protégé* of Francis Bacon and a member of a good St. Albans family, there are grounds for supposing that he served his apprenticeship in the London studio of the German artist Francis Cleyn. It was almost inevitable that he should fall under the influence of Van Dyck, but the robust and almost assertive realism of his outlook and his susceptibility to the beauties of Venetian painting (the King is said to have called him the English Tintoretto), evident in both his colour and brushwork, give his work a character quite distinct from that of the great Fleming. Little is known of the early work or the career of Dobson. His earliest dated portrait, *An Unknown Officer* (formerly identified with Robert Devereux, 3rd Earl of Essex), of 1642, in the collection of Lord Sackville, shows how quickly his style matured. According to an old tradition, he was appointed Sergeant-Painter to the King. By far the most active part of Dobson's life were the years he spent at Oxford, when Charles I established his Court there during the Civil War. Indeed, his last dated portrait was painted only four years after the first, and outside these limits our knowledge of his work is slight and uncertain. At Oxford he painted a group of portraits marked by rare nobility, a direct but deep insight into character and resonant colour. Of these perhaps the finest are *John, 1st. Lord Byron*, of about 1644, belonging to Lt.-Colonel J. Leicester Warren, *An Unknown Man*, of about 1643, in the National Maritime Museum, *Sir Richard Fanshawe*, of about 1643–44, belonging to Captain Aubrey Fanshawe, R.N., and *James Compton, 3rd. Earl of Northampton*, of about 1644–45, belonging to the Marquess of

Northampton. Dobson died in extreme poverty in 1646 and was buried at St. Martin-in-the-Fields on October 28.

For lines 10–34, p. 34 read:

The year of his arrival in England is not precisely known but it was probably 1641 or 1642. Not long afterwards he abandoned his Dutch mannerisms and based his practice principally upon that of Van Dyck. Much remains to be learnt about Lely's early English portraits, but *Philip, 3rd. Earl of Leicester*, of about 1645, in the possession of the Earl of Darnley, is an excellent example of his sober, accomplished art. Two years later, recognized as the foremost painter in England, he was chosen to paint the King, a prisoner at Hampton Court, and other members of the Royal family.

AN INTRODUCTION TO ENGLISH PAINTING

MEDIÆVAL PAINTING

AT the time when the art of painting was first practised in England and for many centuries afterwards, both the spiritual and the closely related temporal ideas by which Europe was governed were unpropitious to the growth of national traditions. And so long as the spiritual supremacy of the Pope and the temporal primacy of the Emperor were generally accepted there arose no clearly distinguishable national schools of painting. Mediæval England was not even a politically independent unit, but merely one of an aggregation of states which owed allegiance to an English king. Until the beginning of the fourteenth century art was almost entirely in the hands of a super-national church; schools of art therefore tended to group themselves, independently of political divisions, around centres of religious life.

It is evident then that we cannot expect to find in early English painting the strongly individual character by which it was distinguished in the eighteenth and nineteenth centuries; but a spirit distinctively English did now and again assert itself.

Both wall and panel painting and illumination flourished in England from very early times, and the two forms reacted continuously on one another. There are cases where manuscript illumination appears to have been inspired by wall or panel painting, but generally it was the former which exercised the stronger influence.

Under the inspiration of the missionary church of Iona, which had as its principal centre the monastery of Lindisfarne on Holy Island, there flourished in the seventh and eighth centuries the first important English school of painting. In this fine but short-lived Northumbrian art, Byzantine and Irish-Celtic elements were fused with the native Saxon. The best surviving example is an illuminated manuscript, the magnificent *Lindisfarne Gospels*, in the British Museum, which was written between 687 and 721, and which excels even the celebrated Irish masterpiece of the same period, the *Book of Kells* at Trinity College, Dublin. Following the Synod of Whitby in 664, when, after hearing the arguments of both sides, King Oswy of Northumbria gave his judgment in favour of Rome as the inheritor of St. Peter's commission, the independent church of Iona began to lose its hold. Five years later the Pope appointed as Archbishop of Canterbury the indomitable Theodore of Tarsus, whom Dr. Trevelyan calls " perhaps the greatest prince of the church in all English history." Theodore, coming to England at the age of sixty-eight, established a new hierarchy, and after twenty years of toil brought all ecclesiastical England under the authority of Canterbury. Towards the end of the seventh century, therefore, the centre of power and of civilization began to move from the north into the south. Canterbury became an important school of Latin and Greek, and a centre where the arts flourished. Of the illuminated manuscripts produced there a fine example is the early twelfth-century *Psalter of St. Augustine's Abbey, Canterbury*, at the British Museum.

More important than Canterbury in this latter respect was Winchester, which from the tenth until the close of the twelfth century held the primacy in English illumination. It is, furthermore, in the work of the Winchester school that we find the nearest approach to a national art; there was nothing on the Continent quite comparable to it. The Winchester artists were greatly influenced by the Carolingian renaissance, by such manuscripts as the *Utrecht Psalter*, in the University Library, Utrecht, a product of the school of Rheims belonging to the

mid-ninth century, which was brought to England in the tenth.
Of early Winchester manuscripts the masterpiece is the *Bene-
dictional of St. Aethelwold,* in the collection of the Duke of Devon-
shire, which was written between 975 and 984 for St. Aethel-
wold, who was Bishop of Winchester from 963 until 980, by his
chaplain Godeman; but of almost equal beauty are the *Benedic-
tional of Archbishop Robert* (980–1000) and the *Missal of Robert
of Jumièges* (1008–1025), both in the Municipal Library at Rouen.
In the *Benedictional of St. Aethelwold* the survival of Byzantine in-
fluence, especially in the drapery conventions and the archi-
tectural details, is apparent; but the nervous vitality of the line
and the sense of drama and of movement already herald the
advent of the Gothic. Similar in character, except in so far as
the Byzantine influence has dwindled, are the eleventh-century
Grimbald Gospels and the *Liber Vitae* of the Abbey of Newminster,
both in the British Museum. Such manuscripts as these provide
some indication of the probable character of contemporary wall
painting.

From literary sources we gather that such painting was common.
In 574 Wilfred, the great Archbishop of York, caused the walls,
capitals of the columns and the sacrarium arch of his church
to be decorated with histories, images and figures carved in
relief in stone, and with great variety of pictures and colours;
the Venerable Bede tells us that in 678 Benedict Biscop brought
back from Rome paintings of the Virgin and Child, of scenes
from the Gospels and the Apocalypse, to adorn his Church of
St. Peter; and that in 685 he further decorated his church.
On the door of Peterborough Cathedral was once a painting
showing Abbot Hedda expostulating with a Danish king. There
is reason to believe that there were paintings at Glastonbury;
but all these have perished; and except for a few examples of
painted ornamentation which may be somewhat earlier, we
have no materials for a history of English painting (apart, of course,
from illuminated manuscripts) which can be dated farther back
than the twelfth century. A number of magnificent twelfth-
century wall paintings, however, have been preserved, among

them those on the apse of St. Gabriel's Chapel, of about 1130, and the figure of *St. Paul and the Viper*, of about 1170, in St. Anselm's Chapel, Canterbury Cathedral. This last work was fortunately protected for seven centuries by a wall. In character it is related to contemporary Winchester illumination, displaying the same combination of flowing line, sense of drama and Byzantine grandeur of design. This figure of St. Paul is one of the finest surviving examples of twelfth-century painting in Europe. There is, however, a clearly perceptible difference between such paintings as this, in which Norman influence is apparent, and the work of the school of Winchester, in which even after the Conquest, Saxon characteristics predominate. For whereas Norman painting, like the Romanesque from which it sprang, is static and monumental, Saxon is dynamic and airy, and nearer to the Gothic it foreshadowed. The two arts differ as much in form as in spirit: the Norman line is firm and decisive the Saxon nervous and sinuous; Norman colour is splendid and downright, and Saxon sober in comparison yet subtle and elusive. Contemporaneous with the *St. Paul*, but less grand in conception and less skilful in execution, are the paintings of *Christ in Glory* in the chancel of St. Mary's, Kempley, Gloucestershire, *The Doom* or *Judgment* over the chancel arch at Patcham, Sussex, *The Purgatorial Ladder* at Chaldon, Surrey, also the paintings at Hardham, and at Clayton, Sussex, at Copford, Essex, and those above the Galilee Porch in Durham Cathedral.

Splendid as several of these wall paintings are, it is in the realm of illumination that twelfth-century English artists surpassed themselves. Of the great Vulgate Bibles executed at this time six have fortunately survived. Among these the *Winchester Bible* holds the place of honour. This superb piece of illumination belongs to the middle of the twelfth century, and is probably the Bible mentioned in the life of St. Hugh of Lincoln as having been borrowed from Winchester by the monks of the Priory of Witham, Somerset, when the Saint was made Prior by Henry II in 1173. It was recognized by a visiting monk from Winchester, whither it was restored. It is now in the possession

of the Dean and Chapter of Winchester Cathedral. Almost as fine is another in the Morgan Library. During the twelfth century an important centre of the arts came into being in East Anglia, and at Bury St. Edmunds during the second quarter was produced a manuscript of special merit, *The Miracles of St. Edmund, King and Martyr,* in the Pierpont Morgan Library, New York.

During the thirteenth century wall painting was more widely practised. In the earlier half, under the guidance of John de Cella, the great building abbot, St. Albans became one of the foremost centres of the arts in Western Europe. Here, for the first time in the history of English painting, we have, in Master Walter of Colchester, a distinct personality. Besides a painter he was a sculptor, wood-carver and metal-worker. He became a monk at St. Albans about 1200, was appointed sacrist in 1213 and died in 1248. In St. Albans Abbey, on one of the piers on the north side of the nave, there still remains a painting believed to have been done by him about 1220. Its style shows traces of Byzantinism; yet this severe, monumental *Crucifixion* has a marked personal quality. Master Walter is also known to have made a retable in metal and wood for the high altar, the carved and painted rood-loft with its crucifix and figures of the Virgin and St. John, and the famous shrine of St. Thomas Becket in Canterbury Cathedral. With him worked his brother and pupil, Master Simon (*d.* before 1250), and Simon's son Master Richard (active 1240–1280).

But the dominant figure in the artistic life of St. Albans was the brilliantly versatile Matthew Paris (*c.* 1200–1259), by turns churchman, historian, painter, sculptor and goldsmith. There survives no painting which can with certainty be ascribed to him, but the original manuscripts of his writings, the *Chronica Majora,* at Corpus Christi College, Cambridge, the *Historia Minor* and the *Collections,* both at the British Museum, are ornamented with a remarkable series of outline drawings, believed to be by his hand. These drawings are far removed from the Romanesque as well by the sinuous flowing quality of the line as by

the sense of human emotion they reveal. In them the Gothic spirit is unmistakably manifest. One at least is a masterpiece, a *Virgin and Child*; and if it is indeed by Matthew Paris, he takes his place in the foremost rank of English draughtsmen.

To this period belongs one of the supreme examples of English painting, a *Virgin and Child*, framed by a quatrefoil, on the walls of the Bishop's Chapel at Chichester. Believed to have been painted about 1260, it is not known by whom; it has been variously ascribed to the schools of St. Albans, Winchester and Westminster. "That he [the painter] was a local master," says Mr. Constable, " is inconceivable, for here is a great tradition finding expression through the hands of a genius." The evidence would seem to favour St. Albans, for the affinity between it and the drawing in the *Historia Minor* of the same subject attributable to Matthew Paris is conspicuous.

The transcendent qualities of the *Chichester Roundel* have been widely recognized. "It is," say Dr. Tristram and Dr. Borenius, "the purest gem of English painting now in existence, so exquisite is it in the tender lyrical feeling which governs the whole conception and is communicated no less by the character of line and movement than by the expression of the heads and the incomparable delicacy of the scheme of colour." This work illustrates the decline in England of the influence of Romanesque art, the emergence of a new preoccupation with the workings of the human mind, a new perception of the poetry of movement and an enhanced sense of the significance of the visible world.

Several thirteenth-century paintings of the Winchester school also survive. Of these the earliest, the *Descent from the Cross* (in an excellent state of preservation), and the *Entombment* (which is badly injured), the *Entry of Christ into Jerusalem*, the *Descent into Hades* and the *Noli me Tangere*, are in the Chapel of the Holy Sepulchre, in the north transept of the Cathedral, and were executed about 1225. This group of paintings is forceful and monumental in design and intensely dramatic in conception. Of a contrasting character are the tender and delicate paintings

on the vaulting of the Chapel of the Guardian Angels, which date from the middle of the century.

During the second half of the thirteenth century London became the principal centre of English painting. Unlike those of Canterbury, Winchester and St. Albans, the school of London was the product not of monastic but of royal inspiration. Henry III (1216–1272) was of all the kings of England the greatest patron of the arts. In this capacity both his enthusiasm and his energy were prodigious. His passion was for the Gothic. When he visited Paris in 1254 he spent much of his time in churches. " He would have liked," says a contemporary poem, " to have carried off the Sainte Chapelle in a cart." He caused paintings and other works to be carried out in the palaces of Westminster, Clarendon and Woodstock, and in the castles of Winchester, Nottingham, Guildford and Dublin. The greater part of his energies were, however, lavished upon the rebuilding and decoration of the unique monument of the art of mediæval England, Westminster Abbey. Chief among the painters employed by Henry III on the Abbey was one who is called, in a document of the year 1256, " The king's beloved Master William, the painter monk of Westminster, late of Winchester." His wages are known to have been two shillings a day, twice the current rate. No works which can with certainty be attributed to him survive.

At the Palace of Westminster, under the King's direction, a series of magnificent paintings was carried out on the walls of the Queen's Chamber, the Antioch Chamber and in the Great Chamber of the King, sometimes called the Painted Chamber. This last was more than eighty feet long, twenty-six feet wide and thirty-one feet high, and was decorated throughout with paintings arranged in six horizontal bands with inscriptions in black on a white background. There was also an immense painting of the coronation of St. Edward the Confessor. The greater part of this work was carried out under the supervision of Master William, but Master Walter of Durham, a layman, also appears to have had charge of it for a time. All these paint-

ings perished in 1834 when the Houses of Parliament were destroyed by fire. Two copies of decorations in the Great Chamber of the King exist, the one by C. A. Stothard, belonging to the Society of Antiquaries, the other by Edmund Crocker, now at the Ashmolean Museum, Oxford. More convincing than these, however, are Dr. E. W. Tristram's reconstructions which hang in the House of Commons. The most characteristic surviving examples of the Westminster school of this period are the impressive figure of *St. Faith*, of about 1300, on the eastern wall of the chapel dedicated to her in the Abbey, and the lovely *Retable* of between 1260 and 1270, and also in the Abbey, one of the earliest paintings on wood known in England. The tall *St. Faith* exemplifies the severe attenuated character of early Gothic form, and the intense and exalted belief which inspired it. The smaller, more highly finished paintings on the *Retable* reflect a gentler, a more lyrical mood. These works differ in one important respect from early Gothic paintings such as the *Chichester Roundel*, in that their outlines are supplemented by modelling.

During the twelfth and thirteenth centuries, although English artists learnt much from their Continental contemporaries, their own influence was far from negligible. English manuscripts especially were held in high esteem abroad. Nowhere in Europe was the influence of English art stronger than in Scandinavia. Norway was christianized by Englishmen in the tenth century, Sweden by Englishmen and Germans in the eleventh. In both countries English Saints were venerated, Englishmen were appointed bishops and a large number of English works of art were imported, especially stained glass, embroidery and illuminated manuscripts. Haakon Haakonsson, King of Norway (1218–1264), an important figure in the artistic history of his country, was on terms of close friendship with Henry III, a circumstance which proved favourable to the growth of English influence. Haakon's palace at Bergen was modelled upon Henry's at Westminster; Haakon's seal was cut by Henry's seal-cutter, William of Croxton. In 1248–1249 Matthew Paris was sent on

8

a mission to Norway to supervise abbeys and convents of the Benedictine Order. With this visit is connected a remarkable painting of *St. Peter*, which once formed part of the altarpiece at Faaberg, but is now at the Oslo Museum. And this is believed not only to have been brought to Norway by Matthew Paris, but also to have been painted by him. The attribution is based on the close resemblance in design of the Faaberg panel to a drawing bound up with his *Collections*, in the British Museum, which is known to have belonged to Matthew Paris. This drawing, which represents *St. John's Vision of Christ*, is the work of William, an English friar, one of St. Francis's earliest disciples, who died at Assisi in 1232, and is buried there in the Church of St. Francis.

In other parts of Europe also, in France, Flanders and the Rhineland—in the sphere of illumination especially—English influence was strong. But towards the end of the thirteenth century French art for a time became dominant, and in the work inspired by Henry III at Westminster French influence is clearly evident.

During the latter part of the thirteenth century Westminster was not the only centre of activity. Wall painting, as well as manuscript illumination, was widespread; indeed it is probable that between 1250 and 1350 almost every church in England was repainted two or three times. Among the surviving examples of local as apart from royally inspired painting belonging to this prolific period, especially characteristic are the energetic, if crude, *Wheel of Fortune* in the choir of Rochester Cathedral, and a group of paintings in the nave of West Chiltington Church, Sussex. Both these were executed about the middle of the century. The manuscripts of that day, exquisite and ingenious as they are, lack both the grandeur and also the marked national character of the earlier Winchester and St. Albans work. The Bibles are small, and the subjects represented in the elaborate decorations on the borders of the psalters are mostly secular. Fine examples of this kind of illumination are the *Tenison Psalter*, at the British Museum, begun in 1284, *Queen Mary's Psalter*, at the

British Museum, the *Gorleston Psalter*, in Mr. C. W. Dyson Perrins's collection, executed between 1322 and 1324, the *Ormesby Psalter*, at the Bodleian Library, Oxford, between 1320 and 1330, and the slightly later *Arundel Psalter*, at the British Museum. The last three are products of the vigorous school of East Anglia, the first two possibly of Greyfriars, Westminster.

In the domain of mural and panel painting, Westminster remained until the end of the fourteenth century a notable centre of activity. Here, in addition to the ambitious decorations in the Painted Chamber, an elaborate series of paintings was carried out between 1350 and about 1363 in St. Stephen's Chapel. These, like the earlier work, were rediscovered in 1800, only to be destroyed by fire thirty-four years later. Some Westminster painting of this period, however, has been preserved. In the Abbey, on the front of the sedilia, are two portraits of kings, on the back is an *Annunciation* and *St. Edward* giving his ring to the pilgrim. There is also a painting on the tomb of Edward Crouchback, Earl of Lancaster. Prominent among the Westminster artists of the late thirteenth and early fourteenth centuries was Master Walter of Durham, who supervised the restoration of the Painted Chamber (which had been damaged soon after its completion) between 1267 and 1294, and who painted the Coronation Chair in 1301. With him worked his son Thomas, Richard Essex and John of Sonninghull.

By the middle of the fourteenth century the versatile monastic artist, of whom Matthew Paris was the supreme example, had been largely replaced by the layman who specialized in a single art or craft, by men of the type of Master Hugh of St. Albans, Master William of Walsingham, Master John Cotton and the two brothers Barnaby, all of whom were employed at Westminster.

Between the paintings in St. Stephen's Chapel and certain contemporary German work, notably that of the important school of Cologne, there is a marked affinity. Relations between Germany and England were close. Edward III (1327–1377) concluded an alliance with Lewis IV of Bavaria, and the two

kings met at Coblenz in 1338; his wife, Philippa of Hainault, had German connexions also. It has been assumed in England that, in so far as the arts were concerned, it was Germany that influenced this country. There, however, the contrary view is held. Count Vitzthum and Dr. Paul Clemen contend that Cologne was first influenced by England, and they support their contention by pointing out the similarity between certain fourteenth-century paintings in Cologne Cathedral and English manuscript illuminations, showing that certain features of style common to both schools are distinct from the indigenous Rhineland tradition.

If the great religious centres, Canterbury, Winchester and St. Albans, and the royal school of Westminster gave birth to most of the supreme examples of English mediæval painting, we have to look elsewhere for the typical expression of the pictorial genius of the age. We have to look, that is to say, to the village churches; for in these flourished exuberantly a wholly popular and spontaneous art. A series of paintings which may be taken as typical of those which existed in hundreds of thirteenth- and fourteenth-century parish churches throughout the country are those which survive at All Saints', Croughton, Northamptonshire, in a fortunate state of preservation.

These paintings were executed about 1300, and now cover the north and south walls of the nave to within a few feet of the floor, although the original scheme of decoration probably embraced the whole interior. They are divided into two series, the *Life and Death of the Virgin*, and the *Infancy and Passion of Christ*, comprising thirty-six scenes in all. They are on a plaster ground covered with a thin wash of ochre and lime which gives it an ivory tint. The sinuous Gothic line is reinforced with transparent colour delicately graduated.

The scenes illustrating the life of the Virgin are tender and intimate, while the others, dealing with the Passion, are abstract and severe. Compared with the work of a Giotto, the Croughton paintings are slight indeed. Dr. Tristram estimates that a painter and his assistant took no more than two

or three months to decorate an entire village church. They reveal nothing of Giotto's profound reflectiveness nor of his conscious pursuit of beauty, but on the other hand they are perfectly expressive of the ecstatic Gothic spirit by which the art of Giotto too was touched. There are also noteworthy examples of painting of a similar kind in the churches at Chalgrove, Oxfordshire, and Hailes, Gloucestershire. The unexpected presence of imperial eagles in the decoration of the latter is due to the founder of the Abbey of Hailes, Richard, Earl of Cornwall, having been called in 1257 by a group of German Electors to the throne of the Holy Roman Empire. His claim, however, was unsuccessful. To the first half of the fourteenth century belong also several notable panel paintings. Of these one of especial beauty survives, representing scenes from *The Life of the Virgin*, now at the Cluny Museum, Paris.

Although painting flourished throughout the century at Westminster, and its close witnessed a revival there, the Black Death, which first broke out in 1348, and continuous foreign warfare, gravely impaired the economic foundation upon which the arts were established. In the first year of the Plague there perished perhaps one-third, possibly one-half of the English nation, and there were two further devastating outbreaks in the thirteen-sixties. The consequent poverty and disturbance of the equilibrium between Capital and Labour brought about a fierce revolutionary movement, which found original and violent artistic expression. While the Court artists at Westminster pursued the gracious tenor of their way, defiant peasants were filling country churches with paintings the like of which had not been seen before. It would seem possible that these paintings were inspired by William Langland's *Vision of Piers Plowman*, written about 1352. This poem is a passionate lament for the unjust fate of the poor man and an affirmation of belief in a doctrine of salvation by labour. It takes the form of a vision which came to Langland while he slept " weori of wandering " on the Malvern Hills, in which he saw Christ in the guise of Piers Plowman, a humble man, sharing the labour, the hardships and the sorrows

of the poor, and showing thereby that man achieves salvation through his work. The poem crystallized the nobler among the aspirations which actuated the social revolutionaries of the time. John Ball quoted it in the letter he addressed to the Commons of Essex for which he was hanged. And the presence of the finest example of analogous revolutionary painting at Ampney St. Mary, Gloucestershire, so near to the place where Langland says he saw his vision, is not likely to be mere coincidence. There are, however, examples to be found in various parts of the country, and they are especially numerous in Cornwall, the best preserved being at Breage in that county. About twenty of these strange paintings are known; they are all in country churches and in every case the subject is the same, namely, Christ as a labourer, displaying His wounds, with a halo composed of tools of labour. "For what is the halo of Christ as Piers Plowman," ask Dr. Tristram and Dr. Borenius, in reference to the continuity of symbolism in revolutionary art, "but an anticipation of official emblems employed by the Soviet Republic of Russia?" Other authorities, however, have contended that these implements represent the Instruments of the Passion.

The Piers Plowman paintings are especially remarkable in that they appear to be the product of a wholly spontaneous appearance in England of the realistic impulse which on the Continent was beginning to renew the vitality of the late Gothic.

Beyond work of this character little painting worthy of note was carried out in provincial England in the second half of the fourteenth century. But with its closing years came an increase of activity at Westminster, where the arts came to an exquisite and lyrical flowering. Since all Europe was dominated by the Gothic spirit, and national and local traits were more than ever in abeyance, it is difficult to determine the origin of much of the art to which this age gave birth. England's ties with Germany have already been mentioned. Richard II's marriages, the first to Anne, sister of Wenceslaus of Bohemia (1382), and the second to Isabella, daughter of Charles VI of

France (1396), were both conducive to the spread of foreign influence in England, as were also his friendly relations with the Court of Burgundy. The influence of Italy too was considerable, so English art lost for a time its incipient national character and became wholly cosmopolitan. If it sacrificed a certain robustness in the process, and something of the energy that had formerly belonged to it, it gained in dignity and elegance.

Two characteristic examples of the panel paintings of this period are the celebrated *Wilton Diptych*, now at the National Gallery, and the portrait of *Richard II*, in Westminster Abbey. The nationality of the painters of both is unknown. Dr. Tristram and Dr. Borenius call the Diptych " one of the most remarkable embodiments of the late Gothic spirit in painting," saying that it seems to anticipate the work of Fra Angelico and Sassetta. It would indeed be difficult to praise too highly its delicacy and grace. On the left panel Richard II, attended by two of his predecessors, St. Edward the Confessor and St. Edmund, and St. John the Baptist, is kneeling to the Virgin and Child surrounded by angels shown on the right panel. On the back, on the one side are the Royal Arms of England impaled with those of St. Edward the Confessor, and on the other a white hart is seated upon grass. It was painted not earlier than 1381 and not later than 1394. By some authorities it is said to be the work of an unknown Bohemian artist, and the names of the French artists Jacquemart de Hesdin and André Beauneveu have also been suggested, while there are those who believe it to be the work of an Englishman. Controversy of the same kind rages around the portrait of *Richard II*, but here the case for English authorship is stronger. Dr. Tristram and Dr. Borenius assign it definitely to England, saying that it belongs to the same school as the St. Stephen's Chapel paintings. From the portrait are absent the poignant tenderness of feeling, the lyrical colour and the incomparable elegance of the *Diptych*, but it too is a masterpiece, revealing a developed sense both of character and design. It holds a unique place among English portraits of the age and is,

moreover, one of the earliest known. Its date is unascertained, but there is some reason to believe that it was painted in commemoration of the King's state visit to Westminster Abbey on October 13, 1390, the anniversary of the Translation of St. Edward the Confessor, when he and the queen sat crowned during the celebration of Mass. To the end of the fourteenth century belongs another notable panel painting, a retable decorated with scenes from the *Passion of Christ*, in Norwich Cathedral. Believed to have been presented to the cathedral by subscription as a thanksgiving for the suppression of the Peasants' Revolt in 1381, it was removed by Puritan iconoclasts in 1643 and used as a table, but it was replaced in 1847. In this retable we find the same tenderness of feeling, and the delicacy of colour and line that distinguishes the *Wilton Diptych*. On its discovery it was believed to be Sienese, but its English origin is now generally accepted. Very similar in character and workmanship and belonging to the same school and time are the panel paintings, also in Norwich, in the Church of St. Michael-at-Plea, representing the *Betrayal* and the *Crucifixion*. The lovely qualities of these and of the *Wilton Diptych* and the *Norwich Retable* are shared by a series of late Gothic drawings done by English artists between 1375 and 1400 in a sketch-book, in the Pepys Library, Magdalene College, Cambridge. In this Italian influence is also manifest. "It strikes a note," say Dr. Tristram and Dr. Borenius, "akin to that which is characteristic of Pisanello and his followers." To this period also belongs another remarkable work, a *Crucifixion*, in the National Gallery. The English origin of this has been disputed; its affinities with contemporary German and Netherland work are evident, yet Dr. Friedländer contends that it belongs to no known German school; on the other hand, it closely resembles in composition the central panel of the *Norwich Retable*.

Related to these panel paintings are a number of notable illuminated manuscripts. One, of especial beauty, is the *Sherbourne Missal*, in the collection of the Duke of Northumberland. It was executed for the Abbey of St. Mary at Sherbourne,

between 1396 and 1407. The illumination is the work of a group of four artists, of whom the chief was John Siferwas, a Dominican, ordained in 1380, who also executed the *Lovel Lectionary*, a fragment of which is at the British Museum. Another is the *Book of Hours*, now in the collection of Mr. Dyson Perrins, which once belonged to Elizabeth of York, Queen of Henry VI, whose signature it bears.

During the fifteenth century English painting suffered a grave decline. The country had by no means recovered from the ruin wrought by the outbreaks of the Plague, in addition to perpetual foreign war; and it had now to undergo five decades of bitter dynastic struggle. The Wars of the Roses completed what the Black Death had begun. Insecure in the tenure of their thrones, and impoverished by their efforts to gain or to retain them, the Yorkist and Lancastrian kings were without either the material resources or the security needful for the extensive patronage of the arts. The wealth and the leisure of the aristocracy were likewise diminished; nor dd the newly enriched mercantile classes do much to encourage the arts, except in particular regions, notably East Anglia. The Church, although she too suffered, remained the artists' foremost patron. Throughout the country churches continued to be decorated with paintings, but what was done, for the most part, is in no way comparable with the work of the three preceding centuries. The process persisted, because, although inspiration flagged and material resources diminished, a great and original tradition of painting yet survived, but England, which had given birth to painting comparable with any in Europe save that of Italy, now lagged behind, and the realistic movement that was transforming the art of the Continent had little effect upon our own. The realistic impulse is, indeed, perceptible in much English painting from the end of the fourteenth century, but it was evidently feeble. English artists no longer possessed, perhaps, the vitality to assimilate the new three-dimensional vision of the visible world, nor the technical resource needful to its realization.

During the thirteenth, and, to a lesser extent, the fourteenth centuries the paintings on the walls of churches generally formed part of complete schemes of decoration, but by the fifteenth they consisted for the most part of disconnected subjects. Legend, folk-lore and popular moralities figured prominently. One morality, The Three Living and The Three Dead Kings, enjoyed an especial vogue. Of this subject no fewer than twenty-six examples survive. Notable among them are those in Raunds Church, Northamptonshire, and Charlwood Church, Surrey. Another favourite subject was the Doom, or Last Judgment, painted either above the chancel arch or else on wooden planks above the rood screen.

From fifteenth- and also early sixteenth-century painting the symbolism that distinguished that of the preceding ages largely disappeared and was replaced by a more literal, anecdotal treatment. The workmanship is far below that of the earlier productions, yet the manner evolved by the artists of the age was admirably adapted to its purpose: vivid and energetic narrative. It is believed that the figures were for the most part not invented but copied instead from manuscripts or from Flemish and German engravings. Some of the best examples of the paintings of this age are to be found in Norfolk, which county, by virtue of its wool trade, enjoyed considerable prosperity. The most celebrated are those in Ranworth Church, where there is a screen of rare beauty, and in Cawston Church. Important painting, however, was not confined to the eastern counties. The fine *Coronation of the Virgin* in Exeter Cathedral and the decorations in the Guild Chapel at Stratford-on-Avon testify to the existence of a vigorous west of England school.

Such demand as there was for work of more sophisticated order was now met by Continental artists, Flemings for the most part. While no Flemish painter of the first rank appears to have worked in England at this time, several admirable pictures were executed abroad for English patrons. Of these the best known are the portrait of *Edward Grimston*, by Petrus Christus, dated 1446, in the collection of Lord Verulam at Gorhambury,

the altarpiece by Hugo van der Goes, at Holyrood, a triptych by Memling, at Chatsworth. This last was commissioned in 1468 by Sir John Kidwelly, who is portrayed in it together with his wife and daughter, when they and a number of other Yorkist nobles visited Bruges on the occasion of the wedding of Charles the Bold, Duke of Burgundy, to Margaret of York.

Although the northern strain is scarcely perceptible in his work, it may be mentioned in passing that there flourished in the middle of the fifteenth century in Spain an English artist of great accomplishment. Jorge Ingles (George the Englishman) painted a series of panels, about 1455, for the hospital of Buitrago, including full-length kneeling portraits of the donor, Don Inigo Lopez de Mendoza, first Marques of Santillana, and of his wife Doña Catalina Suarez de Figueroa. These are now in the chapel of the present Marques, in Madrid.

The most ambitious series of English fifteenth-century paintings are those lately re-discovered in Eton College Chapel. Executed between 1479 and 1488, they were whitewashed less than a century after completion, uncovered in 1847 and pronounced by the Provost unfit to be seen in a building dedicated to the use of the Church of England. The upper series was then almost wholly destroyed and the lower series hidden by a new set of choir stalls. The Prince Consort remonstrated vigorously with the Eton authorities, but in vain. The paintings all represent miracles wrought by the Virgin Mary. On the south wall is a continuous story, which Chaucer also tells, of an empress who was falsely accused and persecuted, and finally vindicated by the Virgin; on the remaining part of the same wall, and on the north wall, are isolated subjects. In one of these, for example, a pious lady who fails to attend Mass on Candlemas Day sees in a dream the Virgin and the Saints at Mass, and when she wakes she finds in her hand one of the lighted candles that had been distributed at the service of which she had dreamed; in another, a man places a ring on the finger of an image of the Virgin, and not being able to remove it, becomes a monk. If the subjects tend towards triviality and melodrama,

the treatment of them is grand and severe. The realistic impulse derived from Continental painting here finds vigorous expression, and the heads are strongly characterized. The whole series is painted in black and white on a ground of warm grey, while here and there the effect is heightened by touches of vermilion, ochre and green. There is an obvious resemblance between the Eton decoration and contemporary Flemish painting, especially that of certain followers of Roger van der Weyden and Dirk Bouts, yet apart from the fact that there is evidence that the artist, William Baker, was an Englishman, there are two reasons at least for doubting foreign authorship: the strikingly national character of the types depicted, and the fact that, during the relevant period, there was no Flemish, German or French artist capable of producing wall painting of similar quality. The style of these paintings suggests that Baker learnt his art in Flanders, but he succeeded nevertheless in preserving the simple, almost naïve graciousness and dignity typical of the best English mediæval art. No other paintings by him are known; but there are wall paintings in the Lady Chapel in Winchester Cathedral and in the Chantry Chapel of Abbot Islip in Westminster Abbey which have affinities with those at Eton.

In the fifteenth century political and economic conditions, as we have seen, had so far destroyed the economic foundations upon which the arts rested as to bring painting almost to a standstill. But the paintings in Eton Chapel show that when circumstances were propitious Englishmen were still capable of producing work not inferior to that of their north-European contemporaries. If patronage of the finer sort had lamentably declined, there remained painters capable of inspiration, with ample technical resources at their command; and there persisted, albeit somewhat infirmly, a great tradition of painting which had flourished for close upon eight hundred years, of which there yet remained abundant evidence on every hand. So long as this survived, an economic revival would surely have been followed by a revival of the arts. Indeed, considering the variety and the profusion of artistic genius displayed by the Englishmen of

the Tudor age, it is difficult to believe that painting too would not have flowered had not the native tradition been ruthlessly uprooted. The break with Rome in 1534 led finally to an alliance between the Government and the forces of Puritan iconoclasm; this in turn resulted in an attack upon ecclesiastical art which developed, in the end, into an attack upon all art. An attempt was made to implant in the Englishman's nature a hatred of art and to destroy existing examples. The attempt met with only too much success: works of art were destroyed wholesale throughout the land, and centuries passed before hatred of the arts dwindled into mere mistrust. The policy of destruction, initiated in the reign of Henry VIII, was carried into effect with far greater thoroughness by the Puritans during the following century. A vivid account of Puritan iconoclasm is given in the journal of William Dowsing, the Parliamentary Visitor appointed in 1643 and 1644 to demolish "superstitious pictures and ornaments of churches": "Peterhouse, Cambridge: We pulled down two mighty great Angells with Wings, & divers other Angells & the 4 Evangelists & Peter with his Keies, over the Chapel Dore, & about a hundred Chirubims & Angells & divers Superstitious letters in gold." "Little St. Mary's, Cambridge: We brake down 60 Superstitious Pictures, Some Popes & Crucyfixes & God the father sitting in a chayer & holding a Glasse in his hand." "Clare, Suffolk: We brake down 1000 pictures superstitious: I brake down 200: 3 of God the Father and 3 of Christ and the Holy Lamb, and 3 of the Holy Ghost like a Dove with Wings; and the 12 Apostles carved in Wood on the top of the Roof we gave orders to take down; and the Sun and Moon in the East Windows, by the King's Arms, to be taken down."

Another interesting record of the work of destruction is the drawing done by Thomas Johnson in 1657, owned by Mr. W. D. Caroe, depicting Puritan iconoclasts at work in the choir of Canterbury Cathedral. One of the seven men with high-crowned Puritan hats on their heads is probably the notorious Richard Culmer, nicknamed "Blue Dick of Thanet," who was appointed

in 1643 to "detect and demolish the superstitious inscriptions and idolatrous monuments in Canterbury Cathedral." He it was who destroyed with his own hands a window in the chapel of St. Thomas Becket. A large number of works of art escaped destruction only to be exported.

Mr. Constable quotes the following significant passage from a letter dated September 10, 1550, written by Sir John Mason, English ambassador to France, to the Privy Council:

"Three or four ships have lately arrived from England laden with images which have been sold at Paris, Rouen and other places, and being eagerly purchased, give to the ignorant people occasion to talk according to their notions; which needed not had their Lordships' command for defacing them been observed."

"It may well be," remarks Mr. Constable, "that paintings in Continental collections now called Flemish, German, Dutch or Catalan . . . came from England in similar fashion."

There is still much to be learnt regarding the technical methods of the English mediæval painters. True fresco, which is the method of painting on plaster while it is still wet, was rarely, if ever, used in England, or, indeed, anywhere in Northern Europe. The method most often employed by the English wall painters was to work on plaster that had already set, after damping its surface. The composition, which was sometimes original, sometimes an enlargement from a sketch-book, a book of types or a manuscript illumination, was first sketched in in pale red ochre outline, and the colour afterwards added.

The colours generally used were the ordinary earth colours, copper green, blue and vermilion. A wide range of tints was produced by the mixture of these with charcoal, lamp-black or lime. During the twelfth and thirteenth centuries the colour had a flat distemper quality; by the fourteenth the texture had become very elaborate, but in the fifteenth, as realistism tended to displace symbolism, the hieratic elaboration disappeared.

In the execution of more highly finished work, on wooden panels, dressed stone or marble, linseed oil was extensively used as a medium, and size also, in the paint as well as on the ground. Oil was also employed from time to time in wall painting, as at Eton.

CHAPTER II

TUDOR PORTRAIT PAINTING

THE life of English painting, which had grown feeble just before
the Reformation, was all but extinguished in the period that
followed. And the history of painting in England for two
hundred years becomes in the main the history of a long series of
foreign artists, mostly from the Netherlands, who, with few
exceptions, were concerned exclusively with portraiture. Even
if we make the fullest allowance for the destruction wrought by
plague, foreign and civil war, and the Reformation, bringing in
its wake iconoclasm, and, still more important, a modification
of the national outlook, there still remains something mysterious
about this all but complete interruption of the impulse to paint,
to draw, to engrave. For of English sixteenth-century paintings
other than a few portraits a mere handful survive, of drawings
scarcely more, of engravings perhaps a few hundred. An
explanation that has from time to time been advanced by various
writers, that the nation which gave birth to the great schools
of Lindisfarne, Canterbury, Winchester, Westminster and St.
Albans, to Matthew Paris, Hogarth, Gainsborough, Blake,
Constable and Turner is innately lacking in the impulse or the
capacity to paint, may be dismissed at once. But it is probable
that just as a race or a species of bird or beast, when its numbers
are reduced beyond a certain point, ceases to reproduce, so also
there comes a moment beyond which an art cannot survive
destruction and proscription and the collapse of its economic
foundations.

During these two hundred years ample opportunity was given
by contact with Continental masters for the foundation of new
schools. But the soil had become barren; neither Holbein's
sojourn at the Court of Henry VIII, nor Anthonis Mor's, Federigo
Zuccaro's and Rubens's at those of Mary, Elizabeth and Charles I
respectively, produced anything beyond a few uninspired imita-

tions. Had not vital elements been lacking, the existence of munificent and enlightened connoisseurship, and the consequent presence of many masterpieces in England might have led to the foundation of a national school of painting. Charles I assembled some of the finest works of the age, and a princely collection was made by the Duke of Buckingham; but both King and favourite were outshone by Thomas Howard, Earl of Arundel and Surrey, called by Horace Walpole "the father of virtue in England." These collections served, however, to foster connoisseurship rather than the creative impulse.

No single circumstance is more productive of art than the demand for it; yet not even the insistent demand for portraits of kings, noblemen and merchants of Tudor and Stuart times stimulated English artists to any notable extent. It is curious that the hundreds of English artists alive at the time of the Reformation, deprived of religious subjects, should not have turned, like the Dutch and Flemings, to portraiture; the more so as there was not only a demand, but also ample precedent. Portraits in manuscripts had existed in the fourteenth century, such, for example, as those on the frontispiece of the *Lovel Lectionary*, by John Siferwas, of about 1400, already referred to; while uniform series of mural portraits, usually of royal persons, had been made considerably earlier. When Edward II visited the Abbey of Gloucester he is recorded to have remarked on such a series in the abbot's parlour. The Englishman's innate interest in character, moreover, and the enhanced sense of his individual importance that he had derived from the Reformation gave an especial significance to portraiture. Under the early Tudors both manuscript and mural portraiture were practised, but without inspiration. A good example of the former is to be found on the back of the *Warwick Roll*, a family chronicle of the Earls of Warwick, now at the College of Arms. It is a large and lively self-portrait of the author of the Roll, John Rous, in pen and wash. Examples of the latter type are commoner; the practice of decorating the walls of a room with a series of portraits was continued until the end of the fifteenth century.

The best surviving example is the Windsor series mentioned in the inventory made for Henry VIII in 1542, which includes portraits of *Henry V, Henry VI, Edward III, Richard III* and *Queen Elizabeth of York*. At Windsor there is a second but inferior series, while parts of two others belong to the Society of Antiquaries. There also survive a large number of isolated examples. None of them appears to have been painted from life, and they are unlikely to have been done from imagination, although no evidence as to their source has hitherto come to light. The probability is, as Messrs. Collins Baker and Constable suggest, that they perpetuated established iconographic types. These portraits are all clumsy in workmanship, and the characters are imperfectly realized. The age did, however, produce some individual portraits of superior quality, such as those of *Henry VII* at the National Portrait Gallery and in the collection of Lord Brownlow; but it is likely that these are by Flemings. They both have an air of distinction, and both admirably represent the King's cold, devious wisdom. An interesting example, also, is the portrait of the King's mother, *Lady Margaret Beaufort, Countess of Derby*, at the National Portrait Gallery.

The painting of the following reign is dominated by the great figure of Hans Holbein the younger (1497–1543). He first visited England as a little-known artist in 1526, remaining for two years, under the patronage of St. Thomas More, of whom he made several portraits. He returned in 1531, but only during the last six years of his life was he given regular employment at Court. But it was in these years that he produced not only his own best work, but one of the finest series of portraits ever made. While it is likely that Holbein had assistants, he neither had pupils nor did he found a school by his example. Miniatures apart, the best of a handful of portraits done under his influence is that of *A Man in a Black Cap*, at the Tate Gallery. It was painted in 1545 by John Bettes, the only English painter of note at work during this period, who shows considerable competence and feeling for character. Another good portrait in which the influence of Holbein is apparent is one of *Henry VIII* by an un-

known artist, at St. Bartholomew's Hospital. There survive a number of portraits by Gerlach Flicke, a German who died in London in 1558, perhaps the best of which is believed to be *William, Lord Grey de Wilton,* in the National Gallery of Scotland. While these display marked accomplishment, the artist, as Messrs. Collins Baker and Constable remark, had no artistic personality of his own.

Towards the end of the reign of Henry VIII the influence of Holbein, never firmly established, began to be superseded by that of inferior Flemish painters, and by the end of the reign of Edward VI the process was all but complete.

One Flemish painter of distinction, however, visited England in Tudor times. Anthonis Mor, who probably accompanied Philip II of Spain when he came here on the occasion of his marriage to Mary I in 1554, painted a splendid portrait of the Queen, which now hangs in the Prado. In this the lady's character is vividly realized; but it was Mor's realism rather than his sense of character that impressed itself on his numerous imitators in England.

A typical example of the Flemish artist who worked in Marian and Elizabethan England was Hans Eworth, who settled here some time before 1545. The work of minor artists is moulded by the society they serve, and, on account of Elizabeth's inordinate preoccupation with clothes, her Court painters became primarily painters of fashion. Eworth, who in his early English portraits shows both imagination and insight into character, eventually became a manufacturer of elaborate costume pieces. Other Flemish painters, famous in their day, were Marc Gheeraerts the elder, who came from Bruges to England in 1568, where he died before 1599, and several members of the de Critz family, also from the Netherlands. Federigo Zuccaro, the Roman painter, visited England in 1574.

Towards the end of the reign of Elizabeth an English painter of some ability, George Gower, was at work, and there is a self-portrait by him in the collection of Mr. G. C. Fitzwilliam. There survive a large number of portraits by various hands of

the Queen herself; several of those at the National Portrait Gallery give convincing renderings of various aspects of her complex, enigmatic personality.

No English portraits of the age are equal either in accomplishment or grasp of character to those of the miniaturist Nicholas Hilliard (1537–1619). His art was closely linked with that of the English mediæval illuminators, but Holbein was his master. "Holbein's manner of limning," he declared, "I have imitated holding it to be the best." Among the most perfect of his works are the miniatures *Youth Leaning against a Tree*, and the *Self Portrait*, painted at the age of thirty, both at the Victoria and Albert Museum. He had at his command a line at once severe and gracious and a penetrating yet sympathetic insight into character. From Hilliard derived the gifted miniaturists Isaac Oliver (1564–1617) and his son Peter Oliver (1594–1646).

Although a number of Elizabethan portraits survive and the names of many contemporary painters are known, to make definite attributions is a difficult undertaking. This is due to a variety of causes, the most important being the practice of successful painters of employing assistants. Another confusing factor is the tendency on the part of members of the artistic families to intermarry with one another; Marc Gheeraerts the elder and his son and namesake, for example, both married sisters of John de Critz. Similarities of style were also encouraged by legislation, and painters were for a time forbidden to portray the Queen pending the painting of a portrait such as might be taken as a model to be copied.

STUART PORTRAITURE

THE Reformation had in a great measure insulated England from the spiritual influence of the Continent, and the triumphs achieved under Elizabeth in the spheres of war, diplomacy and above all in literature completed the evolution of a self-conscious and largely self-sufficient national temper. By the latter half of the Queen's reign this had become a force strong enough to exercise a decisive influence on the painting of foreign artists who worked in England. Not even the greatest of them were able thenceforward to resist it; neither Van Dyck, nor Lely, nor Kneller. Particularly striking is the difference between Van Dyck's portraits of Englishmen, whom he endows with a particular sensibility, thoughtfulness and reticence, and those of foreigners. And the national temper, it is hardly necessary to add, found a still more emphatic expression in the work of the native artists, Johnson, Dobson, Walker, Riley, How, Greenhill and their lesser-known fellows. And as the seventeenth century wore on this temper became more and more pronounced in the portraits painted in England, despite the personal ascendancy of foreigners.

The death of Elizabeth in 1603 caused no sudden break in the artistic tradition of the country, for the first artist to express an unmistakably English spirit in portraiture was already at work in the Queen's reign. This was Marc Gheeraerts the younger (1561–1635)—anglicized to Garret and Garrard—who came to England from Bruges with his father at the age of six. In his portraits we first get a hint of the lyric graciousness, the sensibility, the naturalness and spontaneity which were shortly to distinguish English portraiture. No English painter has ever portrayed the human face and form with the rich and subtle grandeur of Titian, nor revealed the depths of the soul so deeply as Rembrandt, nor grasped the lineaments of the face with the

miraculous certainty of Holbein, nor rendered character with the dynamic force of David, yet its special qualities have given to English portrait painting a unique place in the annals of art.

In his authoritative account of the subject, "Lely and the Stuart Portrait Painters," Mr. Collins Baker divides the painters of the period into four groups: the Jacobean or Archaic, the Carolean or Romantic, the Interregnum or Puritanic, and lastly, the Restoration or Flamboyant. Marc Gheeraerts the younger was the most outstanding figure in the first of these. Besides its wistful poetry, his painting is notable for its rare delicacy of workmanship. Gheeraert's power of rendering detail relates him, like Hilliard, to the English illuminators. Of the large number of paintings attributed to him the only fully authenticated examples are: *The Head and Shoulders of a Dead Man*, dated 1607, in the Kröller-Müller collection; a much-repainted portrait of *William Camden*, in the Bodleian Library, Oxford; and the portraits of *Elizabeth Cherry*, *Lady Russell* and *Sir William Russell*, dated 1625, in the collection of the Duke of Bedford.

Other artists belonging to this period were Sir Nathaniel Bacon (*c.* 1585–1627), probably an amateur, and Paul van Somer (1576–1621), a Netherlander. Bacon's best-known works are his self-portraits, the most remarkable being that in the collection of Lord Verulam. Von Somer's work is dull and heavy.

Mr. Collins Baker's second, Carolean or Romantic, group is dominated by the dazzling figure of Sir Anthony Van Dyck; but before he settled in England in 1632 there were several painters at work here who appreciably influenced the character of his English painting. For whereas Holbein, and Rubens, who worked in London for the greater part of the year 1629, were both possessors of visions so strongly individual that environment had but little effect upon their work, Van Dyck's was a receptive nature, acutely sensitive to atmosphere and local traditions. When Van Dyck came to England both were sufficiently strong to affect profoundly the character of his painting. Since the Elizabethan age the national outlook had changed. Then, the im-

pact of the culture of the Renaissance upon a race virile, adventurous, self-reliant and half-barbarous, had produced a sudden flowering, in a mood of exuberance and exaltation. But with the coming of the Stuarts this had largely receded and in its place came a grave and poetic romanticism, which found its supreme expression in the devotion and loyalty of the ideal Cavalier, of a Rupert or a Falkland. But it was also implicit in the portraits of the period, especially in the work of such men as Cornelius Johnson (c. 1593–1664) and Daniel Mytens (c. 1590–1642). Johnson was the son of one Cornelius Jansz, of Antwerp, but he was born in London and probably studied under the younger Gheeraerts. His portraits reveal a personality serious, reticent and poetic. Silvery in colour, in handling they are tight and polished, an example of the persistence of the miniaturist outlook and technique revived by Hilliard. Characteristic of his best work are his portraits of *Ralph Verney*, of 1634, in the collection of Sir H. Verney; *Lady Waterpark*, of 1638, in a private collection; and *Henry Ireton*, of about 1640, in the collection of the Duke of Portland, at Welbeck. In 1643 he went to Holland, when he lost the poetic quality which distinguishes his English portraits, and his work became commonplace.

Mytens, a Dutchman and possibly a pupil of Rubens, appointed Court Painter in 1621, but who probably came to England some years earlier, remaining until 1634, also reflects in certain of his portraits the romantic spirit of the Stuart age. His *James, second Marquess of Hamilton*, of 1622, at Hampton Court, anticipates Van Dyck both in spirit and style. Mytens remained in England at the King's request for some years after the advent of Van Dyck, but finally, being unable to compete with his great successor, he returned to Holland.

Sir Anthony Van Dyck was born at Antwerp in 1599 and studied under Rubens and in Italy. He first came to England in 1620–1621, when he painted a full-length portrait of James I. After several further visits he became Court Painter to Charles I and settled here more or less permanently in 1632, and a few

years later he married Mary, daughter of Sir Patrick Ruthven. He died in London in 1641 and was buried in St. Paul's.

In his portraits Van Dyck gave the supreme interpretation of the chivalrous romanticism, the gravely poetic spirit with which Englishmen of the age of Charles I were imbued. He took much from England in the process, but he transformed English painting in return. Every change brings loss as well as gain, and indeed, with the advent of Van Dyck, a certain naïve charm, an unconscious grace went out of English portraiture, but there came in place of these a new audacity and loftiness of vision, a new sensibility to style, a new understanding of the problems of design and colour.

As Horace Walpole observes, Van Dyck's works are so frequent in England that most Englishmen think of him as their own countryman; yet save for the poetic spirit he absorbed in England, he remained a Fleming and a true pupil of Rubens. We are therefore concerned not with his work but with its effect upon the development of the English school. Van Dyck found painting in England archaic and left it mature; he had, moreover, English pupils of whom one at least was a considerable artist, yet, like Holbein, he failed to establish an English school of painting strong enough to flourish without the aid of foreigners. The decade immediately preceding the outbreak of the Great Rebellion was a period full of promise for English painting; but the overthrow of the monarchy about which the artistic revival centred, the poverty brought about by civil war, and, most of all, the recrudescence of Puritanism in a still more militant form, once more delayed the establishment of a native school. Patrons were no more, the great collections were largely dissipated, and beauty was suspect as the enemy of the good. Small wonder, therefore, that when tranquillity was restored the foreign painter was able still to oust his English rivals. But if Van Dyck's English followers were prevented by circumstances over which they had no control from consolidating and handing on what he had taught, their own achievement was far from negligible.

Of these men by far the most gifted was William Dobson, who expressed the romantic chivalry of the Cavaliers more poignantly, if less ably, than Van Dyck himself. Born in Holborn in 1610 of a good St. Albans family, he entered Van Dyck's studio about 1635. He painted a number of portraits of members of the Royalist party, and also of the King himself, who is said to have called him the English Tintoretto. After a life of reckless extravagance he was committed to prison for debt, and emerged only to die, at the age of thirty-six. His style was quickly formed, for his earliest dated portrait, *Robert Devereux, third Earl of Essex*, of 1642, in the collection of Lord Sackville, is perhaps his most characteristic work. But his two most remarkable portraits are *Sir Richard Fanshawe* in the collection of Mr. Basil Fanshawe, and *Sir Charles Cottrell*, in that of Captain Cottrell-Dormer. The superb appearance of the sitter, the originality of the composition and the richness of the colour make the Fanshawe the most striking seventeenth-century portrait by an artist of English birth. The latter is an interpretation, as poetic as it is profound, of a head of rare nobility. With Dobson's may be mentioned the work of a lesser painter whom Mr. Collins Baker has provisionally named F. How. To this artist, who was active between 1645 and 1665, only three paintings are attributed: *Colonel Lovelace*, of about 1645, at the Dulwich Gallery; *An Unknown Divine*, of about 1648, in the collection of the Earl of Leicester, at Holkham; and *Jane Lane*, of about 1660, in the collection of Mr. H. H. V. Lane. These portraits are less accomplished than Dobson's, yet they have the same poetic, wistful quality.

Mr. Collins Baker's third, or Puritanic, group was most active during the Commonwealth. Puritanism tends at all times to be inimical to the arts; it is therefore hardly a matter for surprise that the militant Puritanism which dominated the decade contributed little of importance to the development of painting. Such of the Cavalier painters as were not irrevocably committed to the Royalist cause merely changed the superficial aspect of their painting in order to conform to the new taste. Their

vision and their technique remained the vision and the technique which Van Dyck had taught them.

But there was at least one among the painters of the Commonwealth who added to the sum of English art, though by an achievement psychological rather than æsthetic. Robert Walker (c. 1600–before 1660) did for the Puritans what Dobson had done for the Cavaliers, for his small series of portraits are a moving interpretation of the Puritan character. In his *Oliver Cromwell with his Squire* and his *John Hampden*, both in the National Portrait Gallery, the look of profound spiritual self-assurance tempered by a grave reserve, of self-reliance, of austerity which characterize the Puritan are admirably rendered. Admirably, that is to say, in so far as they can be rendered in terms of physiognomy alone; for Walker's figures in a measure belie his heads. Whereas his heads are truly and wholly Puritanic, his figures remain Van Dyckian. Technically, Walker's painting is sound but featureless.

A lesser artist than Walker, but one whose portraits of various Parliamentary leaders were marked by a certain originality, was Edward Bower, who was active between 1635 and 1670. Among his sitters were John Pym, Ferdinando, second Lord Fairfax, Thomas, Lord Fairfax, and Sir William Fairfax.

A curious painter, who seems to have enjoyed a greater reputation among his contemporaries than his few surviving works would appear to justify, was Isaac Fuller. Born towards the end of the first decade of the seventeenth century, possibly, as Mr. Lionel Cust surmises, of Jewish parentage, he is said to have studied in Paris under the engraver, François Perrier. Returning to England, he occupied himself with both portrait and wall painting. He died in Bloomsbury Square on July 17, 1672. The influence of Van Dyck touched him less than most of his contemporaries. Judging indeed from his self-portraits, all of about 1670, at the Bodleian Library, Queen's College, Oxford, and the National Portrait Gallery, and his *Matthew Lock* of about 1660 in the Examination Schools at Oxford, he was an artist of original temper with a robust and audacious technique.

33

He decorated a number of taverns, earning his entertainment by this means, no doubt, for he seems to have been of an improvident nature; he was also given to religious subjects, executing altarpieces for Wadham and Magdalen during his residence at Oxford.

Mr. Collins Baker's fourth, or Flamboyant, group was dominated by another foreign-born painter, Sir Peter Lely. Born in 1618, probably in Holland, possibly in Westphalia, and certainly of Dutch parents, Lely studied under F. P. de Grebber in Haarlem. In April 1641, William, Prince of Orange, came to England for his marriage to Mary, daughter of Charles I, and Lely came in his train. It has been suggested that it was Van Dyck's temporary absence from England that prompted Lely to try his fortune here. However that may be, his portraits of Prince William and his bride were generally admired and quickly established him in the royal favour. It was, in consequence, not long before he enjoyed an extensive practice.

On coming to England he quickly abandoned his Dutch manner for that of Van Dyck, to whom, and to Dobson and Fuller several of his early portraits have been attributed. Such portraits as his *Thomas Fanshawe* of about 1645, in the collection of Mr. Basil Fanshawe, and his *Sir Charles Lucas* of a year or two later, in the collection of Mr. George Macmillan, show how closely Lely followed the Van Dyckian tradition.

When the monarchy was overthrown and romanticism was supplanted by dour severity, Lely adapted himself without difficulty to the change. Indeed, a certain sombre, material quality in Lely's temperament caused him to respond more readily to Commonwealth subjects than to the elusive romantic figures of the Caroline era. Typical of his Puritanic portraits are his *Lady Bedel*, of about 1648–1650, at Bratton Fleming, his gloomy *John Holles, second Earl of Clare*, in the collection of the Duke of Portland, and his sinister full-length *General Monck* in that of the Duke of Devonshire.

But it was not until the Restoration that Lely's talents revealed themselves to the full. The repressions of Puritan rule led

inevitably to a violent reaction; and if the brooding sobriety of the Commonwealth suited Lely, the exuberant and somewhat gross materialism that characterized the succeeding age inspired his finest achievements, though a certain ponderousness in his temperament left him irresponsive to the spirit of comedy which also prevailed.

His activity during the Restoration is epitomized in his two great series of portraits: the *Flagmen* at the National Maritime Museum, Greenwich, and the *Windsor Beauties* at Hampton Court. The *Beauties* constitute Lely's most famous work, yet they fall below the *Flagmen* in quality as they excel them in fame. In the best of these Lely has combined austere and emphatic design and expressive glowing colour in a perfectly harmonious whole. But it is in the sphere of characterization that the disparity between the two series is most striking. The cold and sombre *Admiral Sir Jeremy Smith* is surely one of the finest portraits of the age. And there are others in the series that reveal a sense of character scarcely less inspired. As interpretations of character they have one shortcoming—they are lacking, as Mr. Collins Baker has observed, in the specific quality of Englishness. Indeed, throughout this period of foreign dominance in painting, native-born English artists not unnaturally showed a keener perception of the qualities peculiar to their fellow-countrymen than their generally more highly gifted and better-trained foreign rivals. In undertaking the *Windsor Beauties* Lely was not free to pursue the perfection of his art; instead he was compelled not only to flatter, but in deference to the taste of the Court to emphasize the sensual aspect of his sitters, which he interpreted with Dutch meticulousness and want of wit. Emphatic sensuality, while sometimes appropriate in figure painting, is deleterious to portraiture, for since the end of that art is the rendering of individual character, of that which is particular to the sitter, the exaggeration of a characteristic that is common to a great part of mankind is inevitably detrimental. Thus Lely's *Louise, Duchess of Portsmouth*, of about 1670, in the Craven collection, is, in effect, a study in sensuality rather than a portrait of a woman. In the

best of the *Windsor Beauties*, however, such as *Lady Byron*, *Lady Denham*, *Lady Whitmore*, *Comtesse de Grammont*, *Lady Falmouth* and *Princess Mary as Diana*, Lely was an admirable draughtsman and designer and a master of colour. Writing of the last three portraits Mr. Collins Baker pays him a fitting tribute: " It is not the brilliance of their colour, but its subtlety that holds one; his ash greys, pale honey silver-browns and *bleus cindrés*; his sonorous tawny copper, the pale ashy umbers in the hair, his simple opposition of chalk whites too with silvery half-tones to silvered Cambridge blue, all these setting off the subtle yet amazing luxurious quality of his flesh colour, place Lely apart, as far as English portraits are concerned, as a colourist of rare symphonic invention and instinct."

Lely died on December 6, 1680, and was buried in St. Paul's Church, Covent Garden. It is only to be expected that a painter endowed with such powers and who attained to a position of unchallenged eminence should have had a multitude of insignificant disciples, but among his contemporaries there were several painters of note, who, although affected by him, preserved their independence. John Hayls or Hales (*c.* 1600–1679), the author of the wretched portrait of *Samuel Pepys*, at the National Portrait Gallery, clearly shows the influence of Lely in his less known but excellent *Sir Greville Verney*, of about 1665, in the collection of the Duke of Bedford. A more considerable painter was Gerard Soest, was who born either in Holland or Westphalia about 1605 and came to England in about 1644, and died in 1681. As a technician he rarely approached Lely, but at his best he shows as firm a grasp of character and a superior comprehension of the English temper. Among his best portraits are *Aubrey de Vere*, *Earl of Oxford*, at the Dulwich Gallery, his *Self-portrait* at the National Gallery, Dublin; and Mr. Collins Baker highly praises his *Major Salwey*, dated 1663, in the collection of Mr. Roger Salwey. Another painter in the Lely tradition, but one whose work is more distinct than Soest's from that of his master, was Joseph Michael Wright, one of the few Scotsmen in the cosmopolitan medley of Stuart portrait

painters. Born about 1625 in Scotland, he visited England in 1641, worked in Florence and Rome and returned to England about 1652–1653 and died in 1700 and is buried in St. Paul's Church, Covent Garden. Occasionally he painted a portrait of real distinction, such as the *Lionel Fanshawe*, in the collection of Major C. H. Fanshawe, but there was a smallness and a hardness in both Wright's outlook and his technique that stultifies his considerable talent and renders somewhat repellent his interpretations of character. Even the *Lionel Fanshawe* is marred by a meagreness of feature; nor would the excuse that the sitter might be accurately represented avail, for the meanness was clearly inherent in the artist's manner of seeing. Wright's colour is prone to be dull and anæmic. The diarist John Evelyn praised him, but Pepys had no such high regard for him, as may be seen from the following entry in his Diary: " June 18th, 1662. Walked to Lilly's the painters, where I saw most rare things. Thence to Wright's the painters; but Lord! The difference that is between their 2 works." In one particular, however, Wright is Lely's superior: there is a crispness about his handling and an alertness about his sitter's expressions which contrast favourably with the lethargy of Lely's.

An artist with a strongly marked personality who founded himself upon Lely was Jacob Huysmans. He was born in Antwerp about 1633 and came to England, where he was generally known as Houseman, in his middle twenties, and died in 1696 and was buried in St. James's, Piccadilly. Although much inferior to Lely, he found favour at Court and made a considerable reputation. Charles II and his queen, Catharine of Braganza, James, Duke of York, and his Duchess, Anne Hyde, and the Duke of Monmouth sat to him. His *Isaak Walton* at the National Portrait Gallery, and *Frances Stuart, Duchess of Richmond in Man's Dress* at Windsor are works of exceptional ability. Pepys mentions him: " August 24th, 1664. To see some pictures at one Hisemans', a picture drawer, a Dutchman, which is said to exceed Lilly. And indeed there is both of the Queene's and Maids of Honour (particularly Mrs. Stewart's in a buff doublet

like a soldier) as good pictures I think as I ever saw. The Queene is drawn in one like a shepherdess, in the other like St. Katherine; most like and most admirably. I was mightily pleased with this sight indeed."

We have now to consider one who is perhaps the sensitive interpreter of character of all the Stuart portrait painters, John Riley. Born in Bishopsgate in 1646, he was possibly apprenticed to Fuller, and later worked with Soest. On Lely's death he shared Court patronage with Kneller, painting portraits of Charles II and his Queen, James II and his second wife, Mary of Modena, and the Duke of Monmouth. There are, in addition, a number of literary and ecclesiastical figures among his subjects. He died in January 1691, and was buried in St. Botolph's, Bishopsgate.

In spirit Riley was nearer to the romantic painters of the Carolean period, to men like Dobson, than to his own contemporaries. The Carolean portraits are of men who move in a society imbued with poetry and chivalry, a society, moreover, which we know to have been doomed to extinction. The Cavaliers possess in our eyes on this account something of the pathos that belongs to those who have not long to live. But if Riley's men have more in common with these than with the typical gentlemen of the Restoration, they are distinct from them. In place of the guileless nobility that distinguishes a *Sir Charles Cottrell* or a *Sir Richard Fanshawe* by Dobson we perceive in Riley's finest portraits sophistication and reflective wisdom. Riley's men have learnt much from the cataclysm that overwhelmed their fathers. In his series of portraits he has portrayed a less obvious aspect of the Restoration, and with the rarest insight. The *Duke of Lauderdale* in the Duke of Northumberland's collection, and the *William Chiffinch* at the Dulwich Gallery as revelations of character are rarely surpassed in the whole history of English painting.

Riley's was a morbidly shy and self-mistrustful nature. Russell, the painter, who entered his studio as assistant in the year 1680, relates that Riley could not bear his students to watch him at

work and when his paintings were criticized he would rush from the studio " to vent his passion and uneasiness." From the same source comes the anecdote Walpole tells of how Charles II sat to Riley " but almost discouraged the bashful painter from pursuing a profession so proper to him. Looking at the picture he cried, ' Is this like me? Then, odd's fish, I am an ugly fellow.' " This so much mortified Riley that he abhorred the picture—though he sold it for a large price. Had Riley's diffidence not caused him to mistrust his own manner of seeing he might have left a gallery of great portraits, but as it was there remain a mere handful. His extreme diffidence not only led him to fruitless imitation but to take into partnership an artist whose outlook was antithetic to his own, Johann Baptist Closterman (1660–1711), a German with a coarse and flashy talent. The two collaborated on a number of pictures, and on Riley's death his unfinished canvases were worked upon by Closterman. An interesting Riley-Closterman portrait is the *Sir Christopher Wren*, of about 1688, at the Royal Society.

After Riley the most important painter of English birth active in the latter part of the seventeenth century was John Green-hill. Born about 1644 in Salisbury of a well-established family, he began to paint in his native town, where the earliest-known example of his work is preserved in the Town Hall. Its subject is the Mayor, *John Abbott*, who is said to have refused to sit to Greenhill, who thereupon painted the portrait from notes taken through a keyhole. He came to London about 1662 and entered Lely's studio. Greenhill's personality never quite emerged from the shadow of Lely's. He died in 1676 when he was about thirty-two, and considering his youth and the debauchery which both impaired his talent and lost him his once-flourishing practice some time before his death, his achievement was a respectable one. Among his best portraits are *Sir James Oxenden* in the collection of Lady Capel Cure and *Captain Clements* at Greenwich.

A painter who, though she did not study in Lely's studio, was even more completely dominated by him than was Green-hill was Mary Beale. She was born at Barrow, near Bury St.

Edmunds, in 1633, and is believed to have studied under Robert Walker. A large proportion of her sitters were clergymen, but now and then she painted a layman of distinction. She died in London in 1699. Owing to the circumstances that her husband, Charles Beale, kept a number of diaries we know more about her than about any other minor artist of the time. The diaries contain, among other information pertaining to Mary Beale's work, full lists of the portraits she painted during the sixteen-seventies. The greater part of her work is dull and spiritless.

Such minor artists were by their nature incapable of adding anything of importance to the tradition established by Van Dyck and carried on by Lely. But about six years before the latter's death in 1680, there came to England a young German who was destined to be the link between Stuart portraiture, which despite the strong native influence earlier referred to, was foreign in origin and dominated by foreigners, and the national school that came into being early in the following century. Sir Godfrey Kneller, Bt., was born on August 8, 1646, at Lübeck, and studied art in Holland, apparently under Ferdinand Bol, where, according to tradition, he came in contact with Rembrandt. Thence he proceeded to Rome and Naples, and settled in England in 1674. Here he built up a vast practice; ten sovereigns, as Walpole observes, were among his sitters, besides Wren, Newton and Dryden. He married, at St. Bride's, London, Susannah Crane, daughter of the Reverend John Cawley, Archdeacon of Lincoln, and died in 1723, being buried in his garden at Twickenham.

Kneller's production was enormous: indeed, Mr. Collins Baker reckons him the most prolific portrait painter of this or any other country. The extraordinary speed at which he worked is illustrated by the well-known story of how, in his early days in England, when he and Lely both had a sitting from Charles II at the same time, he won the King's applause by finishing his portrait when Lely had only laid his in. He was not only a rapid and dexterous executant but perhaps more lacking in

conscience than any other artist of his rank. " Where he offered one picture to fame, he sacrificed twenty to lucre," complained Walpole, not without justice, but he no less justly blames his patrons: " he met customers of so little judgment, that they were fond of being painted by a man who would gladly have disowned his works the moment they were paid for." He was, in short, an artist of extraordinary talents, who was unable to withstand the temptations of fashionable patronage. But in spite of his want of conscience, his uncertain grasp of character, and his propensity for being bored by his sitters, Kneller produced a handful of portraits of rare quality. Perhaps his greatest achievement is his *William Wycherley*, the dramatist, of about 1705, in the collection of Lord Sackville. This portrait is painted with an emotional force evident in no other work of his hand. Less inspired than the haunting *Wycherley*, but nevertheless of exceptional merit, are *Thomas Burnet*, of 1693, at the Charterhouse, London, *William, first Duke of Portland*, of 1697, at Welbeck, and *Richard Boyle*, *Viscount Shannon*, of about 1717, in the National Portrait Gallery.

Kneller's considerable influence upon his successors in England was exerted in two ways: by his example, and by his teaching. His studio was the parent of the first real drawing school in London, in which the chief English artists of the eighteenth century were trained. But his influence is not easy to assess precisely, for, unlike that of Lely, Kneller's technical development was capricious and haphazard. While Lely proceeded in an orderly fashion from " tightness " towards freedom, Kneller varied from year to year, but it was the swift and light handling he used in his finest portraits that most impressed his immediate posterity.

The history of Stuart portrait painting may be said to come to an end with the death of Michael Dahl in 1743. Born about 1659, probably in Stockholm, Dahl first came to England in 1682, but remained only two years, visiting Paris, Rome, Naples and Venice until 1688, when he finally settled in London. As a technician he ranks far below either Lely or Kneller, although

his conscientious nature prevented him from falling so low as Kneller at his most slovenly. His outlook was commonplace, but he showed at times a subtle sense of colour. His best portrait is his *Admiral Sir Cloudesley Shovell,* of about 1702, at Greenwich. Wanting as he was in personality, Dahl was at all times a respectable painter, and in no wise to be classed with such men as Riley's partner, Closterman, or William Wissing (1656–1687) who debased the Van Dyck-Lely tradition, which he brought instead to a dignified if uninspiring end.

HOGARTH AND THE REBIRTH OF POPULAR PAINTING

BEFORE the end of the seventeenth century there were abundant signs that the virtual monopoly enjoyed by portraiture among the fine arts ever since the Reformation was not to endure for ever. An English school of landscape painting, which will be described in a later chapter, was coming unobtrusively into being. The erection of great houses in the Italian style gave scope for wall painting, which was also stimulated by the decorations on the ceiling at Whitehall carried out by Rubens during his nine-months' sojourn in London from June 1629 until March 1630.

The first Englishman to practise this form of painting with marked ability was Robert Streater, a versatile artist, and one of great repute in his own day. Evelyn thought highly of him; Pepys records how, on February 1, 1669, he visited Streater's studio and found there several virtuosos, including Sir Christopher Wren, admiring his paintings. Pepys, impressed though he is, confides to his diary that he does not consider Streater's decorations rank with Rubens's, "though the rest think better . . . I am mightily pleased," he goes on, "to have the fortune to see this man and his work, which is very famous; and he a very civil little man, and lame, and lives very handsomely."

Although his work inclines to be florid and derivative, Streater at his best was a far from negligible artist, as his decorations on the ceiling of the Sheldonian Theatre at Oxford show, and they do not deserve the ridicule which Robert Whitehall's couplet brought upon them:

> "Future ages must confess they owe
> to Streater more than Michael Angelo."

Besides the Sheldonian, Streater carried out decorations in the Chapel of All Souls College, Oxford, in St. Michael's, Cornhill,

and at Whitehall. Streater was born in Covent Garden in 1624 and died in 1680.

Work of a similar character was that of Antonio Verrio, an Italian, born at Lecce, near Otranto, in 1639, who died at Hampton Court in 1707. Verrio painted ceilings at Windsor for Charles II, who made him " Master Gardener " and gave him a house in the Mall. James II also employed him, but he rejected the patronage of William III. Besides his Windsor ceilings, of which little remains, he carried out decorations at Hampton Court.

A far more ambitious exponent of the art of wall painting than either of these was Sir James Thornhill. He was born in 1675 at Melcombe Regis in Dorset and studied painting under Thomas Highmore, a Dorset man and an uncle of Joseph Highmore. Queen Anne employed him as a mural painter at Windsor, Hampton Court, Greenwich and St. Paul's. In spite of the damage caused by repeated restoration Thornhill's eight scenes from the life of St. Paul in the interior of the Cathedral dome have an authentic grandeur and dignity, but their great distance from the ground renders them ineffective. The scheme was undertaken in the face of Wren's opposition. Thornhill's masterpiece is the Painted Hall at Greenwich, on which he was at work for the better part of twenty years. This has been condemned on account of its flamboyance and a certain absence of taste. These defects are undeniable, but what the late Mr. Lionel Cust said in defence of Verrio, namely that the faults of taste evident in his work were those of his age rather than his own, applies to Streater and Thornhill as well. Streater's wall paintings at Oxford, and Thornhill's at Greenwich, to a far greater degree are, within the obvious limits imposed by the conditions under which the artists worked, of exceptional merit. The Greenwich paintings are both grand and original in conception and superbly carried out. Thornhill has endowed them with an exuberant vitality which places them in the foremost rank among English wall paintings subsequent to the Reformation. Wall painting is, however, an art

in which Englishmen have rarely excelled since the Middle Ages.

Thornhill carried out a number of mural decorations at Chatsworth, Blenheim, Easton Neston and Wimpole, also at All Souls, Queen's and New College, Oxford. He also painted a number of competent portraits, including one of *Newton*.

The importance of Thornhill's place in the history of English art is due not only to his achievement as a painter, but also to the part he played as a pioneer of a national school of painting. The scheme for a Royal Academy of Painting which he submitted to the Government was not accepted, but he was one of the twelve original Directors of Kneller's School, and he later founded one of his own in James Street, Covent Garden, and after his death the furniture belonging to it was used in the St. Martin's Lane Academy, where his son-in-law Hogarth taught. Thornhill was the first English-born artist to be knighted and he represented his birthplace in Parliament from 1722 to 1734. He died on May 13, 1735, at Thornhill, the family house he had repurchased.

At the beginning of the eighteenth century portrait painting was no longer virtually the sole concern of English painters, but it was still predominant. After the death of Kneller in 1723 there was no portrait painter of comparable gifts to take his place, but there were a number of capable journeymen. Chief among these was Jonathan Richardson the elder, who was born in 1665 and died in 1745. He studied painting under Riley, whose niece he married, and was the master of Thomas Hudson, who was Reynolds's master. Nothing of the romance or the characterization of Riley's best work is to be found in that of his pupil. Richardson had the reputation of being able to obtain a good likeness—a talent for which Kneller was not conspicuous—and he was a sound, solid, self-confident painter, but one whose manner, as Reynolds remarks, is cold and hard. According to Dr. Johnson, Richardson was better known by his books than his pictures. He published four works of note:

"Essay on the Theory of Painting," in 1715, "An Essay on the Whole Art of Criticism, in relation to Painting," "An Argument on behalf of the Science of a Connoisseur," in 1719, and "An Account of the Statues and Bas-reliefs, Drawings and Pictures in Italy and France, etc., with Remarks, etc.," in 1722. In the first of these he displays a faith in the power of English artists to do great work which is said to have inspired both Hogarth and Reynolds. The fourth was the first English guide to the works of art in Italy, and no less an authority than the great German scholar Winckelmann, the founder of modern archæology, pronounced it to be "despite its deficiencies the best book to be had upon the subject."

A lesser artist, who with Richardson enjoyed a considerable measure of popular patronage after the death of Kneller, was the Irishman Charles Jervas, who was born about 1675 and died in Cleveland Court, London, in 1739. He lived for a year with Kneller, who had a poor opinion of his abilities, and who, hearing that he had bought a carriage and four, remarked: "If his horses do not draw better than he does he will never get to his journey's end." Pope, who was an amateur painter, studied under Jervas for a year and a half. According, however, to a letter which the poet wrote to John Gay in August 1713, his efforts were of small account. "Every day," he says, "the performances of others appear more beautiful and excellent—and my own more despicable. I have thrown away three Dr. Swifts, each of which was once my vanity, two Lady Bridgwaters, a Duchess of Montague, besides half a dozen earls and one Knight of the Garter. . . . However, I comfort myself with a Christian reflection, that I have not broken the commandment; for my pictures are not the likeness of anything in heaven above, or in earth below, or in the water under the earth." Richardson's pupil, Thomas Hudson, ran away with his master's daughter and succeeded him as the most fashionable portrait painter of the day. His work is very competent, but the especial excellence of his draperies is said to be due to the skill of his assistant, Joseph Van Haecken. Hudson was born in Devonshire, probably

at Bideford, in 1701, where, some thirty-nine years later, he met Reynolds, who entered his studio and quickly eclipsed him. He died at Twickenham on January 26, 1779, after having painted many of the most celebrated men of his day.

Another capable pupil of Richardson's was George Knapton, who was born in London in 1698, where he died in 1778. His most striking work is the fanciful series of portraits of members which he executed for the Dilettanti Society, of which he was an original member and official portrait painter. The series includes: *The Duke of Dorset as a Roman General, Viscount Galway as a Cardinal, Sir George Dashwood as St. Francis adoring the Venus de Medici, Mr. Howe drawing a Glass of Wine from a Terrestrial Globe,* and *The Earl of Bessborough as a Turk,* all of which are still in the possession of the Society.

Able at last to hold their own, English artists displayed much talent but no genius. Of genius indeed they had had little enough since the Reformation: a flash here and there—a portrait by Hilliard, Dobson or Riley—that was all. The emergence of a distinctive English art took place in inauspicious circumstances, for England had art patrons and connoisseurs before she had artists, and foreigners were well established before a national impulse to express itself in terms of paint came into being. And their art did not spring from the people but was imposed upon them. English art had no youth and so lacked the passion and the innocence that belong to youth. And English artists, having little to express, were content merely to repeat what Holbein, Van Dyck, Lely and Kneller, men belonging to older traditions, had already said. In short, they were like children who imitate without fully understanding the sophistication of their elders.

English artists, furthermore, had been engaged in the production of a single commodity, the aristocratic portrait. That a portrait painter may attain greatness is a truism, but in order to do so he must consider neither flattery nor even likeness as his ultimate objective. The English portrait painters mentioned hitherto rarely regarded their sitters as characters to be

interpreted with the utmost insight and imagination, but were mostly concerned to make stylish, flattering likenesses. Astonishingly and unheralded there appeared upon the scene dominated by the pupils and imitators of the bored and unscrupulous Sir Godfrey Kneller one who proceeded, with enormous gusto, to thrust upon English art the very qualities of which it stood in extreme need.

In his attitude towards the art he practised, Hogarth differed from his contemporaries. His principal aims were æsthetic, but because of the abundance of drama and wit and above all moral conviction to be found in his paintings, his contemporaries and many others since believed them to have been primarily didactic. The fundamentally æsthetic character of his aims did not, however, preclude his ethical ideas from playing an important part. The painters at work in England from Holbein to Dahl had two attributes in common: they one and all exalted, in the persons of kings, noblemen, statesmen, merchants and clergy, the established order of society, and none of them made any comment upon it. Hogarth, on the other hand, satirized society from the highest to the lowest, and by depicting and commenting upon the life about him he gave to English art the descriptive character which is the necessary foundation of a healthy tradition. In short, Hogarth was a belated primitive; but he was akin not to a belated naïve such as the douanier Rousseau, but to the fathers of schools, to the Giottos and the Van Eycks. He gave to the post-Reformation English school the youth which it had never possessed, and the energy and enthusiasm that are among youth's most precious possessions. The innocence of youth he could not give, for the world into which he was born was already old and cynical.

With Hogarth art became not a plutocratic luxury but spontaneous expression. And it is not too much to say that he created, and for the first time since the Reformation, a subject-matter understood both by artist and layman, a circumstance which powerfully favours a flourishing condition of the arts. As Englishmen had wept long ago to see the Passion

of Christ or the Sorrows of the Virgin portrayed on the walls of their parish churches, so now they shook their heads over Hogarth's unhappy *Harlot* and his *Rake*, shuddered at his *Death of the Earl* and laughed at his *Calais Gate*.

William Hogarth, the son of an impecunious schoolmaster and scholar, was born at Smithfield on November 10, 1697, and baptized in the church of St. Bartholomew the Great. Being early addicted to drawing and fearful of the poverty which his father's lot made him suppose to be that of all scholars, he apprenticed himself to a silverplate engraver named Ellis Gamble, at the Sign of the Golden Angel, Leicester Fields. At the age of twenty he learnt copper engraving, and was thereby enabled to express himself. At twenty-three he went to work under James Thornhill, with whose daughter Jane he eloped in 1729, and he began to paint in oils during the late seventeen-twenties.

In the autobiographical fragment published under the title "Anecdotes of William Hogarth," which constitutes our principal source of information regarding his life, he is at pains to make himself out an idle fellow, but in reality he showed prodigious industry. Indeed, save for his elopement, his arrest in France for sketching the Arms of England above the old gate of Calais, his remarkable essay, "The Analysis of Beauty," and a few bitter quarrels, the story of his life is a record of ceaseless toil with brush and graver. He died in his house in Leicester Fields on October 10, 1764, and was buried in Chiswick Churchyard.

In Hogarth, as in such men as Fielding, Dr. Johnson, Cobbett and Dickens, the spirit of England was to a special degree incarnate. Of the half-dozen major painters to which this country has given birth Hogarth was perhaps the most profoundly, the most aggressively English; yet even to-day he remains the least appreciated among them. He had been dispraised, first of all, on the ground that he was a moralist, a satirist, and an illustrator before he was a painter, that his art was nothing more than a pictorial counterpart of the theatre. Hogarth was in some measure himself responsible for this misunderstanding: "I wished," he

said, " to compose pictures on canvas similar to representations on the stage; and further hope that they will be tried by the same test and criticized by the same criterion." By this he meant that he desired to endow them with similar movement and character, and, being a born painter, to attempt to obtain these qualities by the deliberate sacrifice of essential pictorial elements was a procedure that would never have occurred to him. His ambition was then to add new qualities to the art of painting, and this he achieved. Judged by æsthetic standards alone, however, in spite of his exquisite sense of colour, he was not an artist of the first rank. For skill in composition, for example, he is not only inferior to Watteau—who played, in the history of French painting, a part somewhat analogous to Hogarth's in that of England—but even to lesser members of his school. Yet how virile, how pungent and how great in its range is the art of Hogarth compared with that of Watteau and his followers! But to assess the art of Hogarth solely in æsthetic terms is to be blind to an important part of his achievement; for his genius also lay in his perception of the dramatic possibilities of his age and his power of translating them into pictorial terms with impressive copiousness and energy.

Secondly, Hogarth has been dispraised on the ground that his pictures represent a more or less literal representation of what he saw about him, that he lacked imagination. Yet to anyone who looks at life as closely as pictures—a habit rarer than many suppose—it will be apparent that Hogarth was not aiming at literal transcription. We have in addition the artist's own testimony that although he " ever found studying from nature the shortest and safest way of attaining knowledge," he rarely worked directly from life. He believed on the contrary " that he who could by any means acquire and retain in his memory, perfect ideas of the subjects he meant to draw, would have as clear a knowledge of the figure, as a man who can write freely hath of the twenty-four letters of the alphabet, and their infinite combinations." Hogarth's own method and precept are clearly those of the imaginative artist.

The independence and originality of Hogarth's character and vision together with his pugnaciously English outlook brought him into hostile contact with the exponents of the cosmopolitan art which for the better part of two centuries had been dominant in England. For the professional portrait painters— the portrait manufacturers was what he called them—who worked on, profitably but unreflectively, in the exhausted tradition of Van Dyck, for the connoisseurs who puffed them, he felt hostility and contempt. These, when they felt the lash of his tongue or his pen, sought shelter, after the manner of their kind, behind the great figures whom they aped. And Hogarth, incensed, was thereby led on " to utter," as he confesses, " blasphemies against the divinity even of Raphael Urbino, Correggio and Michael Angelo." But at heart he hated only their fashionable disciples, and, despite his strictures on foreign art, he learnt much from the more robust among the Netherlanders, Ostade, Jan Steen and Teniers, as well as from Callot. His true attitude towards the great masters is aptly illustrated by a remark of his quoted by Hester Lynch Piozzi in her " Anecdotes of Samuel Johnson," published in 1786. Hogarth, she says, declared that the conversation of Dr. Johnson compared with that of other men was like Titian's painting compared with Hudson's. " But don't you tell people that I say so," he continued, " for the connoisseurs and I are at war, you know; and because I hate *them*, they think I hate *Titian*—and let them ! "

Hogarth began his career as a painter with conversation pieces, an excellent example of which, *The Cholmondeley Family*, of 1732, belongs to the Marquess of Cholmondeley. He then turned his attention to what, with justification, he calls " a still more novel mode, viz. painting and engraving modern moral subjects, a field not broken up in any country or in any age," otherwise to his more ambitious series of progressive moralities, *The Harlot's Progress*, of 1731, in a private collection, *The Rake's Progress*, of 1735, at Sir John Soane's Museum, *Marriage à la Mode*, of 1745, at the National Gallery, and *Four Times of the Day*, of 1738, belonging

to the National Trust and the Earl of Ancaster. Later came *The Gate of Calais*, of 1749, at the National Gallery, and in the following year *The March to Finchley*, at the Foundling Hospital, and *Four Pictures of an Election*, of 1755, at Sir John Soane's Museum. He executed in addition in the " historical " style several large religious paintings for St. Bartholomew's Hospital, in 1736, and for the Church of St. Mary Redcliffe, Bristol, in 1756. Of his portraits perhaps the most characteristic are those of *Simon, Lord Lovat*, of 1746, at the National Portrait Gallery, his *Self-Portrait*, of 1745, and *The Shrimp Girl*, both at the National Gallery. This last was declared by Whistler to be the best portrait ever painted by an Englishman.

Although he achieved little worldly success, and had many enemies among the arbiters of taste, Hogarth revealed to Englishmen their innate love of humanly significant subjects. Inspired by his narrative and conversation pieces a number of his contemporaries and successors became aware of the dramatic possibilities of contemporary life, and, while portraits continued to be painted in undiminished numbers, a new school of painters and draughtsmen of social life came into being. Joseph Highmore, who was born in London on June 13, 1698, although he painted many portraits, is best known for his narrative pieces. The most celebrated examples of these are his twelve illustrations to Samuel Richardson's " Pamela," which are divided equally between the Tate Gallery, the Melbourne Gallery and the Fitzwilliam Museum. He died at Canterbury in 1780, and was buried, according to the register, in the cathedral "in the body of the church and wrapped in sheep's wool."

An entertaining minor artist, whose caricatures are yet more reminiscent of the work of Hogarth, was Thomas Patch, an English artist born in 1700, who lived in Florence, where he died in 1782. He is notable, not only as a witty caricaturist of English visitors to Florence, but as one of the first artists to perceive the greatness of Masaccio's frescoes in the Church of the Carmine, of which he made careful drawings. These are the more valuable as the originals were shortly afterwards damaged by fire. Although without previous experience, Patch etched them on

copper and published them in twenty-six plates as the " Life of the Celebrated Painter, Masaccio," in 1770.

Francis Hayman, who was born in Exeter in 1708, also painted conversation pictures. There is a well-known example at the National Portrait Gallery, showing the artist in his studio painting Sir Robert Walpole. He was a friend of Hogarth, with whom he decorated some alcoves at Vauxhall with scenes of contemporary life and fashion. In addition he painted two pictures of cricket which belong to the M.C.C. He died in Dean Street, Soho, on February 2, 1776.

Another conversation painter of exceptional charm was Arthur Devis, who was born in Preston in 1711 and died at Brighton in 1787. More sophisticated work of the same order was done by another of Hogarth's friends, the adventurer, John Marcellus Laroon the younger, who was in turn diplomat, actor, solicitor and officer in the Foot Guards, who was born in London in 1679 and died at Oxford in 1772.

Of a younger generation, and perhaps the most original of all the artists inspired by Hogarth, was John Zoffany, who was born at Frankfurt of a Bohemian family in 1733. Settling in England at the age of twenty-five, he found favour with George III and was among the forty original members of the Royal Academy. His work sometimes lacks unity, but he painted with rare grace and fluency, and in sense of drama and power of characterization he sometimes approaches Hogarth himself. Zoffany spent seven years painting in India. This gifted and prolific artist died at Strand-on-the-Green on November 10, 1810. Zoffany was the last oil painter of importance whose outlook was directly influenced by Hogarth; but the robust, exuberant spirit to which Hogarth was the first to give expression has proved a lasting element in English art, and in the water-colours of Rowlandson, the prints of James Gillray (1757–1815), and the drawings of George Cruikshank (1792–1878) and of Charles Keene (1823–1891) it is especially evident.

SPORTING AND ANIMAL PAINTING

PARALLEL with that which derived from Hogarth, there grew up another popular art, namely, sporting and animal painting. This was popular in a limited sense, but compared with fashionable portraiture or mural decoration, of which the greater part of the painting of the seventeenth and eighteenth centuries consisted, it was popular indeed, and as early as the reign of Charles I it was the delight of innumerable countrymen. It is curious that England, a nation which has accorded to sport a pre-eminence undreamed of elsewhere, should have shown for her sporting art an indifference so complete. Fortunately such neglect has done little harm, for the chief patrons of this art, the country gentry, have proved steadfast, and for generations have not only preserved the examples they inherited, but commissioned others, and shown themselves thereby wiser than the professional connoisseurs. So it happened that when, not many years ago, sporting and animal painting was "discovered," the greatest examples, the Stubbses and the Marshalls, were for the most part not in the great collections but in the hands of those whose ancestors had commissioned them.

In its beginnings in England sporting and animal painting owed almost as much as portraiture to foreigners. John Wyck (1650–1702), one of the first to practise the art here, and the master of John Wootton, came from Holland; another, Pieter Tillemans (1684–1734), the master of Devis, from Flanders in 1708; the Sartorius family from Bavaria and the Alkens from Denmark.

The founder of the English school of sporting and animal painting, however, and the most brilliant of its early representatives, was the Englishman Francis Barlow. Born about 1626 in Lincolnshire, he studied with a portrait painter named Shepherd.

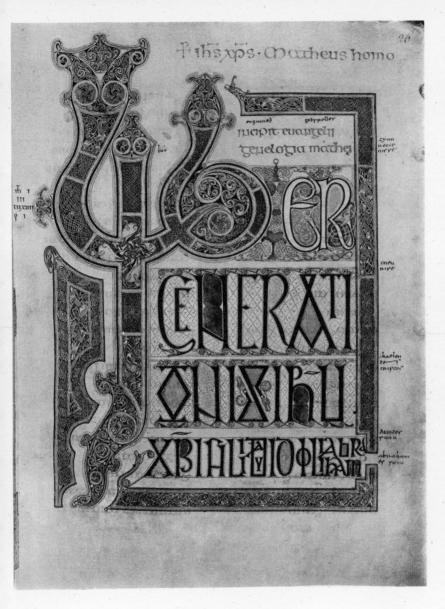

1. *The Genealogy from St. Matthew*
from the Lindisfarne Gospels
c. 687-721
Illuminated MSS.

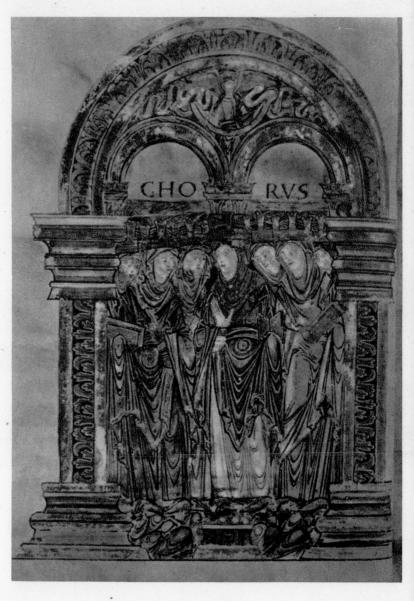

2. *Choir of Virgins*
A page from the Benedictional of St. Aethelwold
c. 975-980
Illuminated MSS.
Collection of the Duke of Devonshire

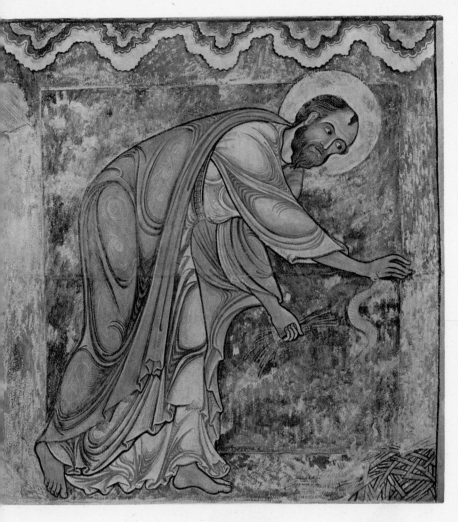

3. *St. Paul and the Viper*
St. Anselm's Chapel, Canterbury Cathedral
c. 1170
Wall painting
(From the copy by Professor E. W. Tristram)

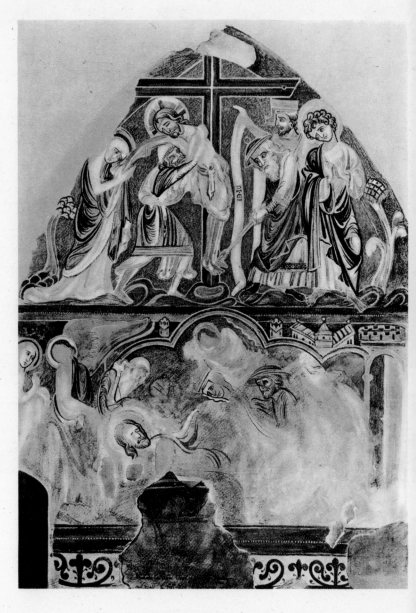

4. *The Descent from the Cross and the Entombment*
Chapel of the Holy Sepulchre, Winchester Cathedral
c. 1225
Wall painting
(From the copy by Professor E. W. Tristram)

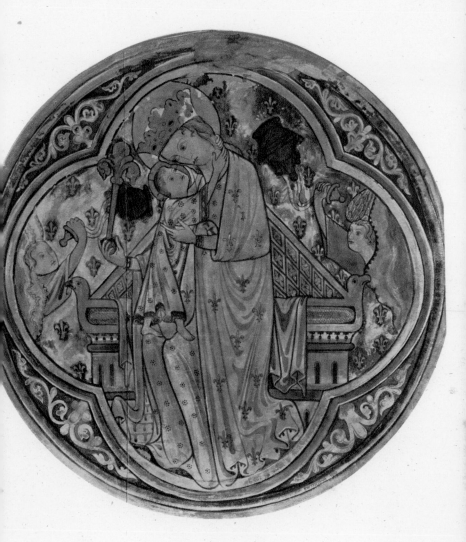

5. *The Chichester Roundel*
The Bishop's Palace, Chichester
c. 1250
Wall painting
(From the copy by Professor E. W. Tristram)

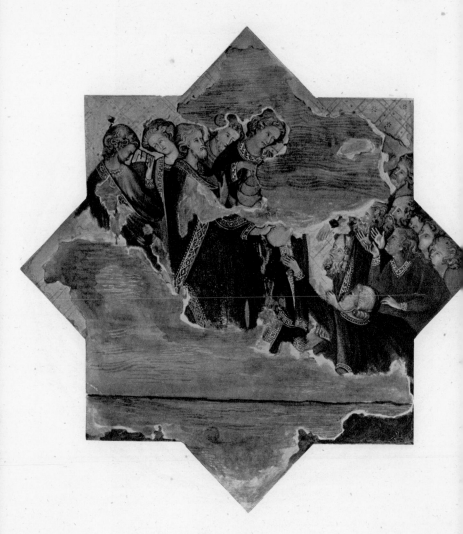

6. *The Miracle of the Loaves and Fishes*
Retable in Westminster Abbey
c. 1260-1270
Panel painting
(From the copy by Professor E. W. Tristram)

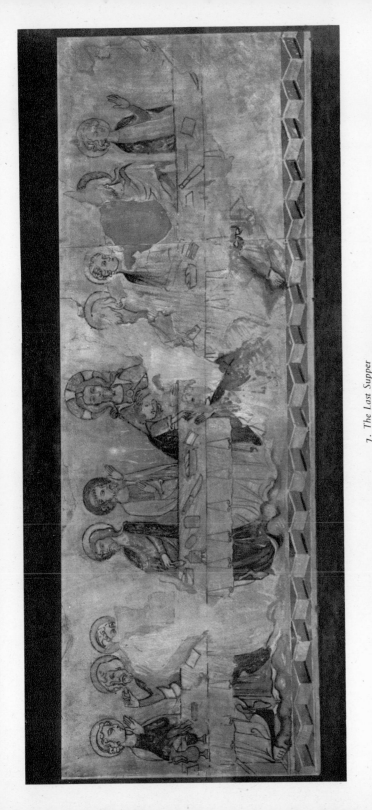

7. *The Last Supper*
All Saints, Croughton, Northamptonshire
c. 1300
Wall painting
(from the copy by Professor E. W. Tristram)

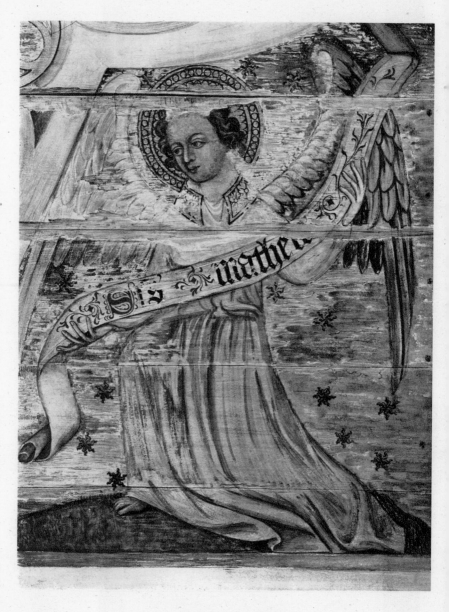

8. *The Symbol of St. Matthew*
Tester of the Black Prince's Tomb, Canterbury Cathedral
c. 1376
Panel painting
(From the copy by Professor E. W. Tristram)

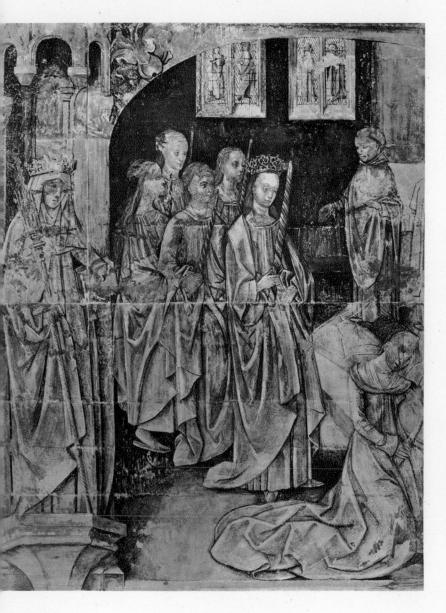

9. *Candlemas*
Eton College Chapel
c. 1479-1488
Wall painting
(From the copy by Professor E. W. Tristram)

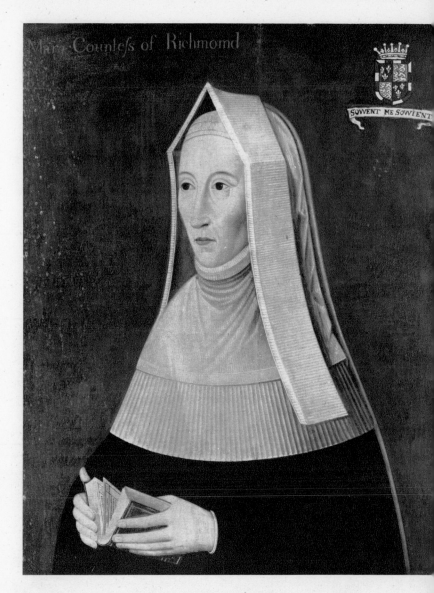

10. *Lady Margaret Beaufort*
late fifteenth century
Panel
National Portrait Gallery

11. BETTES:
Man in a Black Cap
1545 Panel
 Tate Gallery

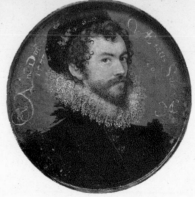

12. HILLIARD:
Self Portrait (at. 30)
1577 Miniature
Victoria and Albert Museum,
 Salting Collection

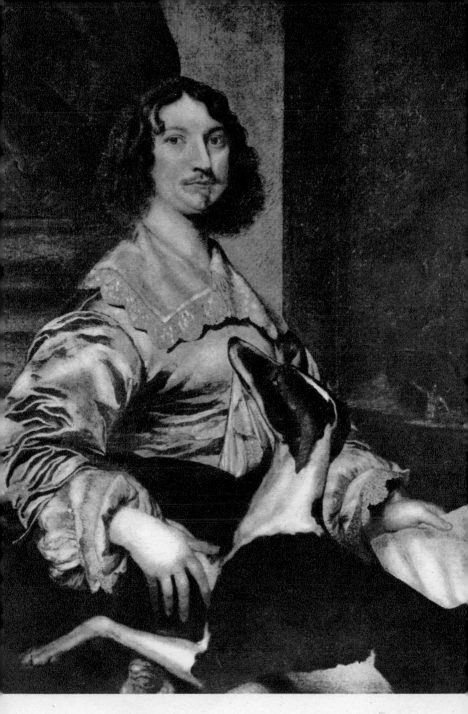

13. DOBSON: *Sir Richard Fanshawe* c. 1644
Canvas Collection of Basil Fanshawe, Esq.

14. DOBSON: *Sir Charles Cottrell* c. 1646

Canvas Collection of Captain Cottrell-Dormer

15. LELY: *Admiral Sir Jeremy Smith* 1665

Canvas National Maritime Museum, Greenwich

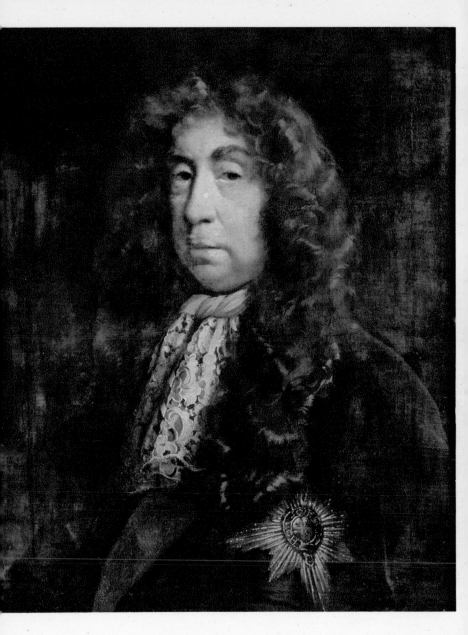

16. RILEY: *The Duke of Lauderdale*

Canvas Collection of the Duke of Northumberland

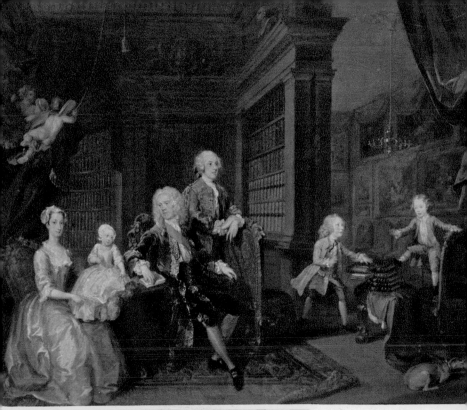

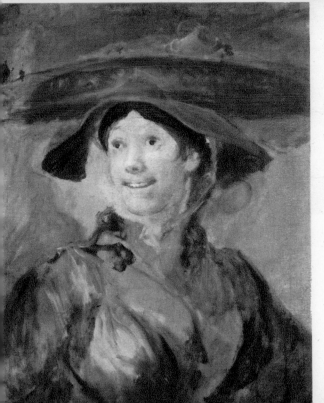

17. HOGARTH
The Cholmondeley Family
1732 Can
Collection of the Marquess (
Cholmondeley

18. HOGARTH:
The Shrimp Girl
Canvas
National Gallery

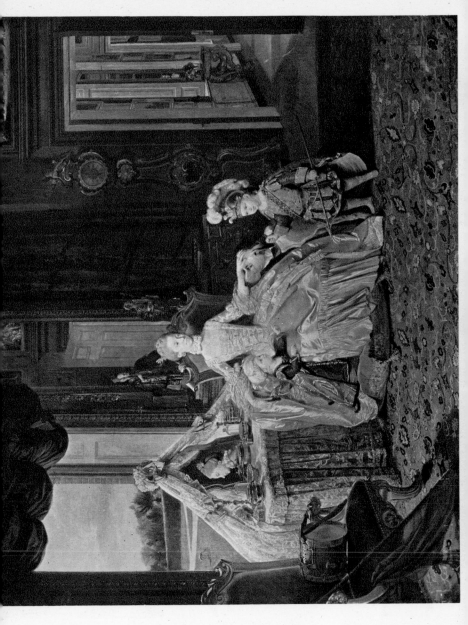

19. ZOFFANY: *Queen Charlotte and her two Eldest Children* 1766-1767
Canvas Windsor, by gracious permission of His Majesty the King

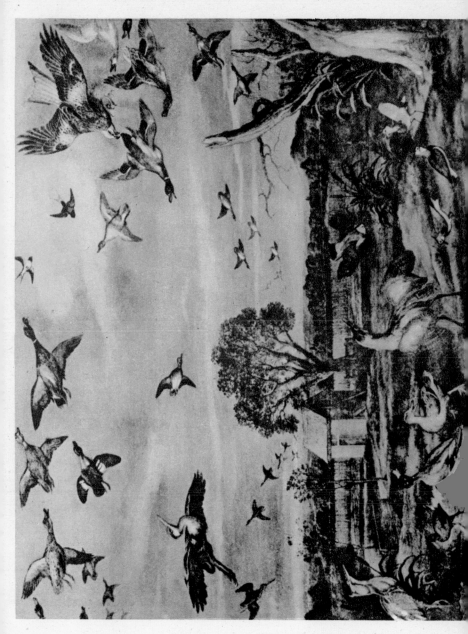

20. BARLOW: *The Decoy at Pyrford Startled by a Bird of Prey* c. 1668

Canvas Collection of the Earl of Onslow

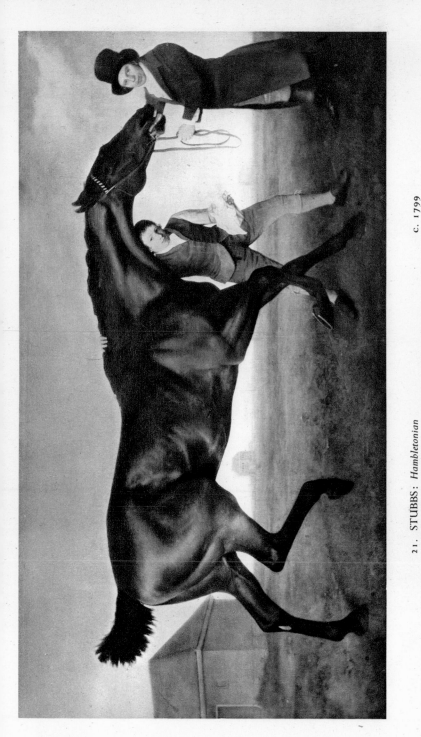

21. STUBBS: *Hambletonian* c. 1799

Canvas Collection of the Marchioness Dowager of Londonderry

22. GAINSBOROUGH: *Mr. and Mrs. Andrews* 1748

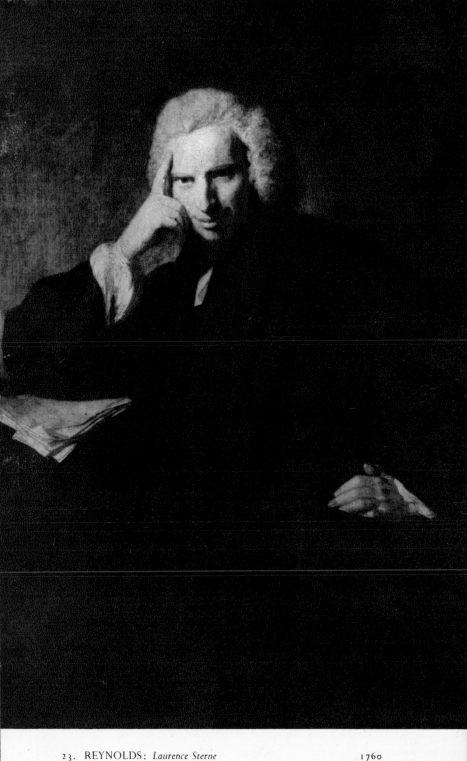

23. REYNOLDS: *Laurence Sterne* 1760
Canvas Collection of the Marquess of Lansdowne

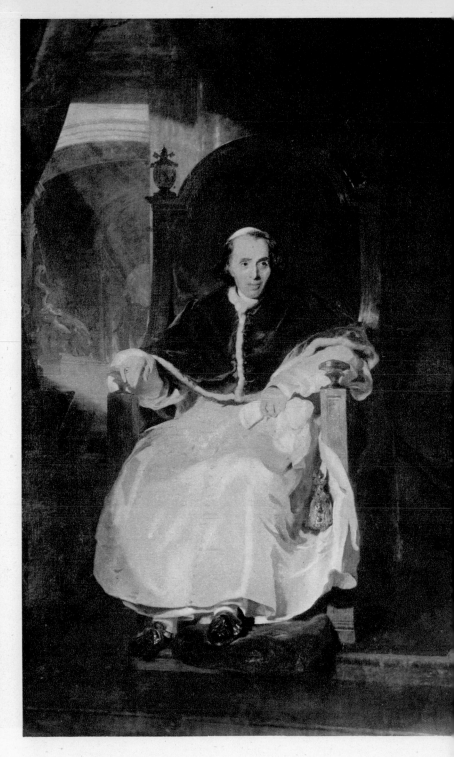

24. LAWRENCE: *Pius VII* 1819
Canvas Windsor, by gracious permission of His Majesty the King

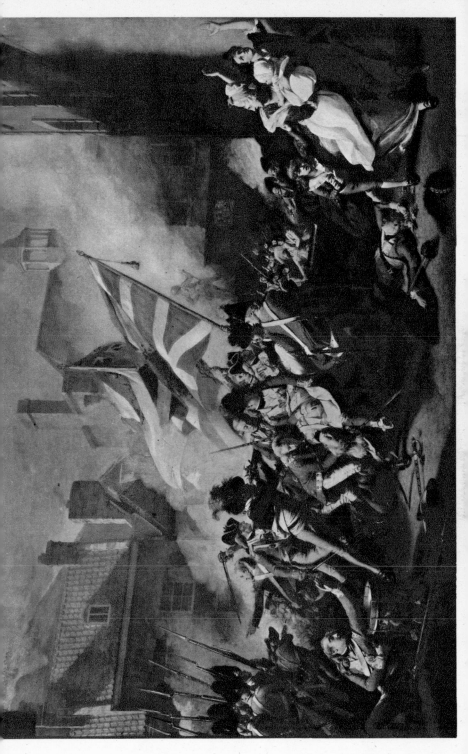

25. COPLEY: *The Death of Major Peirson* c. 1784

Canvas Tate Gallery

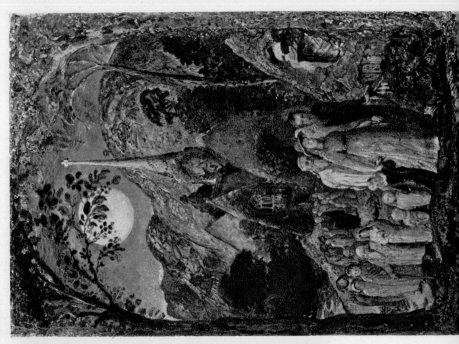

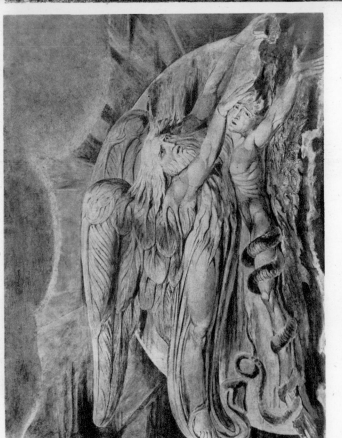

26. BLAKE: *Elohim Creating Adam* 1795
 Colour print Tate Gallery

27. PALMER: *Coming from Evening Church* 1830
 Oil and Tempera on Canvas Tate Gallery

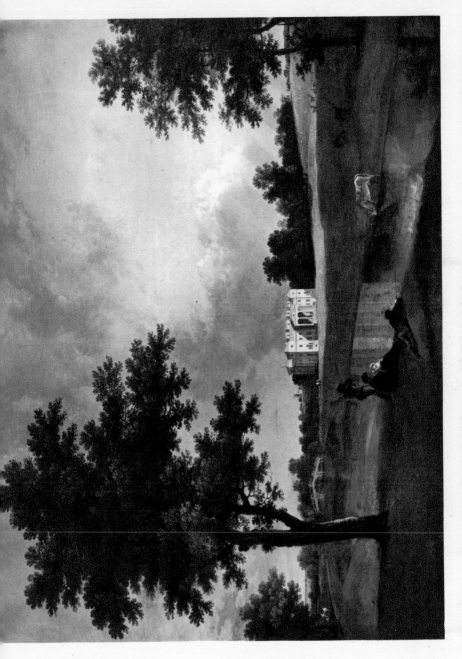

28. WILSON: *Croome Court, near Worcester* after 1763
Canvas The Croome Estate Trustees

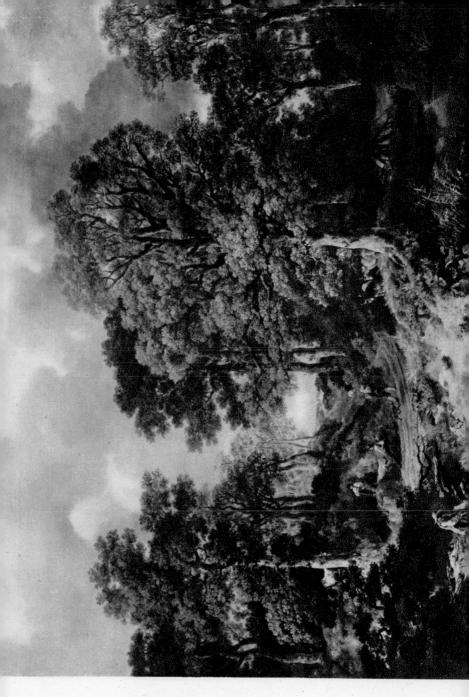

29. GAINSBOROUGH: *Cornard Wood*
Canvas

c. 1748

National Gallery

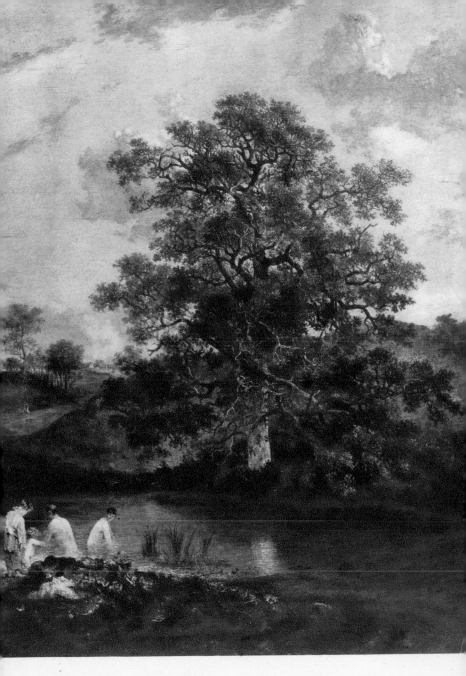

30. CROME: *The Poringland Oak* c. 1820
Canvas National Gallery

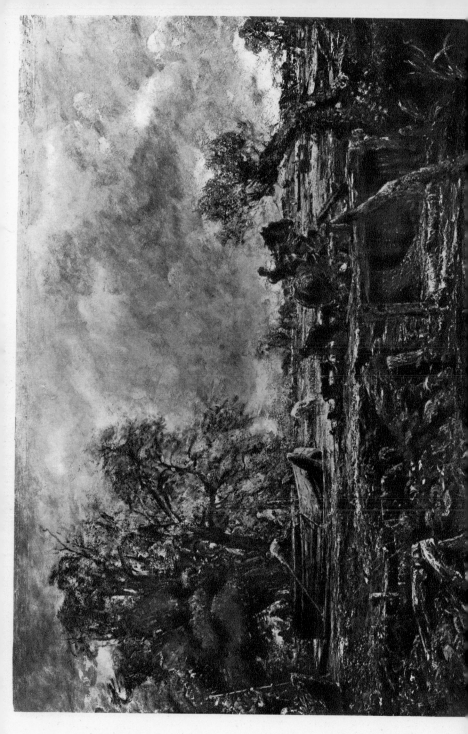

31. CONSTABLE: *the full-size sketch for The Leaping Horse* 1825
Canvas Victoria and Albert Museum

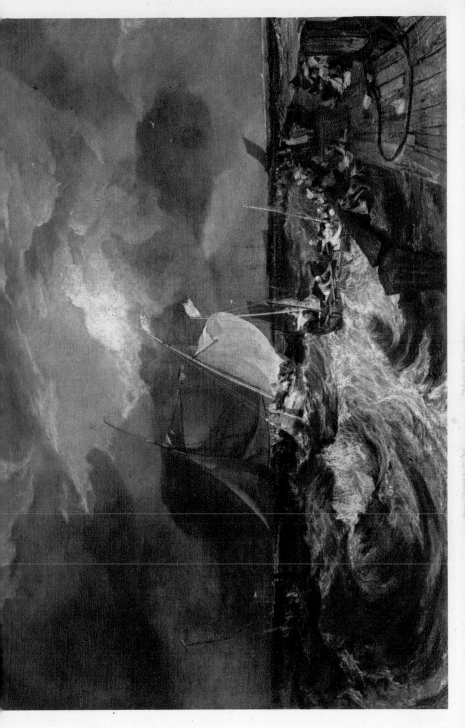

32. TURNER: *Calais Pier* C. 1802-1803
Canvas Tate Gallery

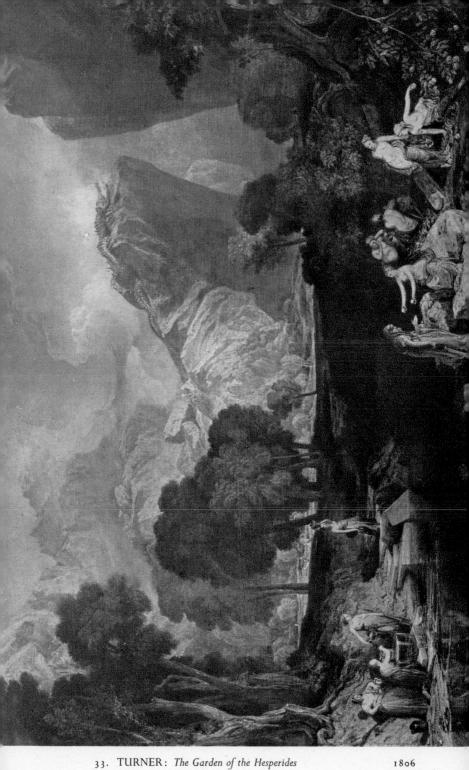

33. TURNER: *The Garden of the Hesperides* 1806
Canvas Tate Gallery

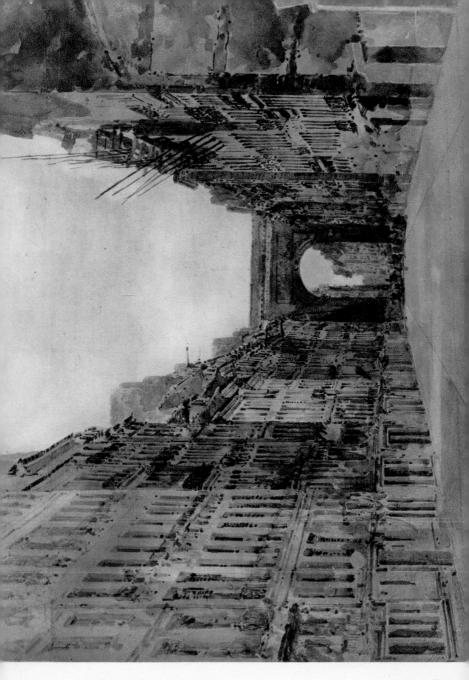

34. GIRTIN: *Porte St. Denis, Paris* c. 1801-1802
Watercolour Collection of Sir Edmund Bacon, Bt.

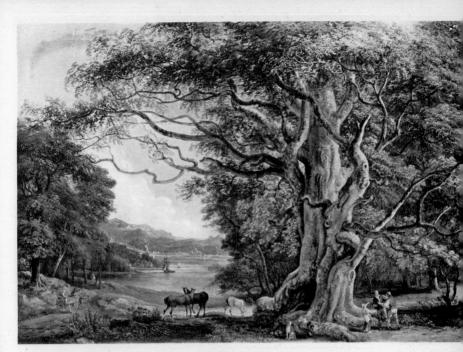

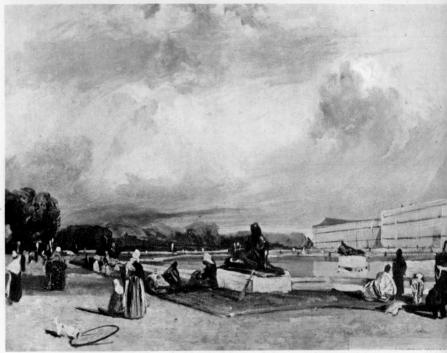

35. SANDBY: *Ancient Beech Tree* 1794
 Body-colour Victoria and Albert Museum

36. BONINGTON: *Versailles, View of the Park* 1826
 Canvas Musée du Louvre, Paris

37. COTMAN: *Greta Bridge*
Watercolour

1805
British Museum

38. STEVENS: *King Alfred and his Mother* c. 1848
Oil on Panel Tate Gallery

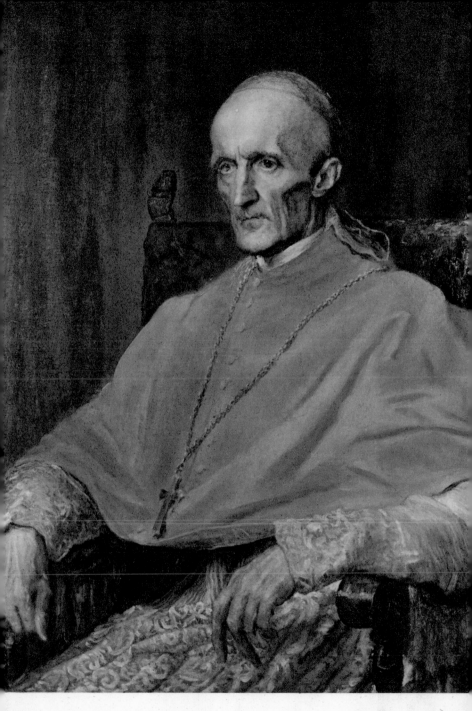

39. WATTS: *Cardinal Manning* 1882
Canvas National Portrait Gallery

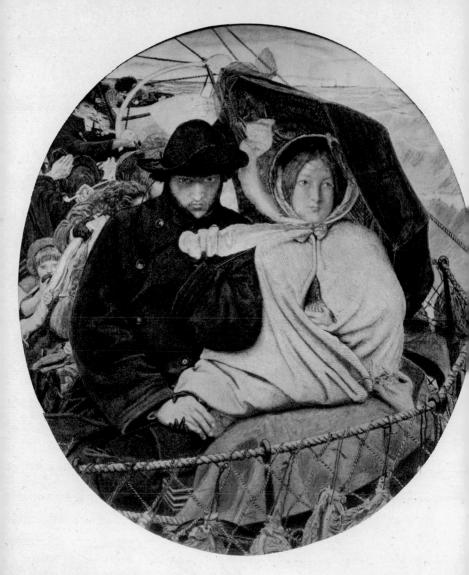

40. BROWN: *The Last of England* 1864-1866
Canvas Tate Gallery

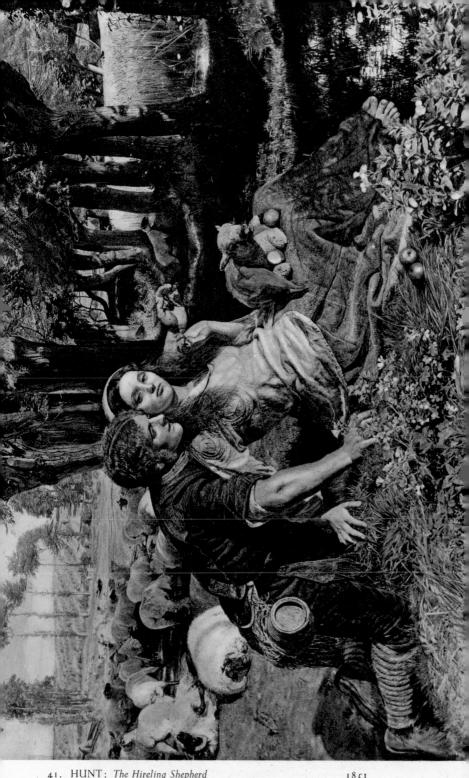

41. HUNT: *The Hireling Shepherd* 1851
Canvas Manchester City Art Gallery

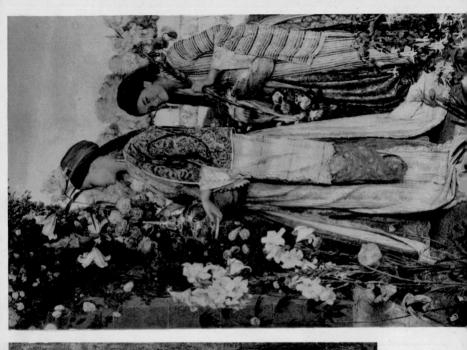

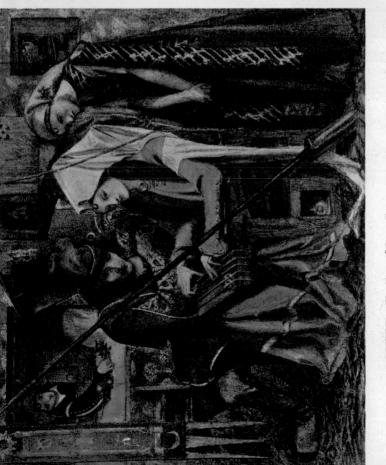

42. ROSSETTI: *The Tune of Seven Towers* 1857
 Watercolour Tate Gallery

43. LEWIS: *Lilium Auratum* 1871
 Canvas City of Birmingham Museum and Art Gallery

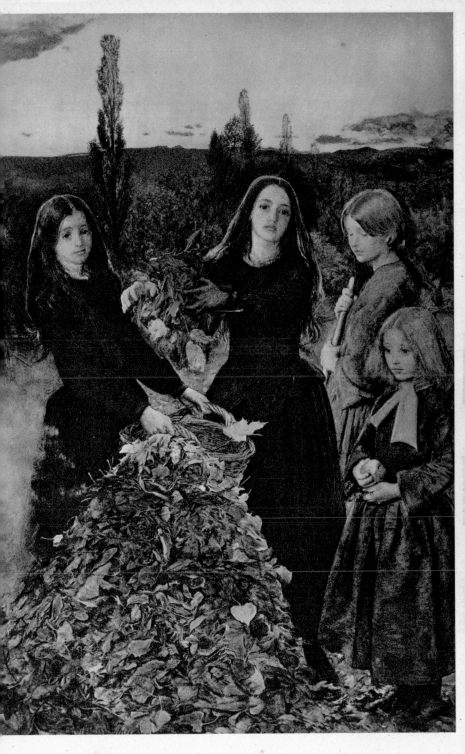

44. MILLAIS: *Autumn Leaves* 1856
Canvas Manchester City Art Gallery

45. WHISTLER: *Portrait of Miss Cicely Alexander: Harmony in Grey and Green* c. 1872-1
Canvas Tate Gall

46. BURNE-JONES: *The Wheel of Fortune* 1883
Canvas Collection of the Vicomtesse de Noailles

He painted and drew many sporting subjects and did a set of illustrations for Æsop's Fables. Among the finest of his surviving works are two large paintings in the collection of the Earl of Onslow, *The Decoy at Pyrford with Waterfowl at Sunset startled by a Bird of Prey* and *At Sunset, after a Day's Fishing*. The latter is signed and dated 1667. A combination of severe, almost majestic design with drama and intimacy makes these two the masterpieces of early English sporting art. A drawing of *Hare-hunting* by Barlow, etched in reverse by Hollar, at the Ashmolean, perhaps most clearly reveals the pronouncedly national quality of his art; for not only are the huntsmen and indeed the entire outlook quintessentially English, but the line itself shows an affinity with that of Hogarth and his followers. Barlow made a reputation on the Continent; how considerable it was may be gauged from the fact that in 1714, twelve years after his death, more than a hundred of his etchings were republished in Holland, a country rightly proud of her own seventeenth-century school of bird and animal painters.

The next important painter of similar subjects was John Wootton, who was born about 1678 and died in 1765. He studied under Wyck and painted a large number of favourites at Newmarket as well as ambitious classical landscapes in the manner of Claude and Gaspar Poussin. Wootton was the first horse-painter of his day and an artist whose talent only just fell short of his high ambition. He loved to work on a grand scale, and there is an imposing series of big horse-pictures by his hand framed structurally in the walls in the entrance hall at Althorp. There are two especially good examples of his work at Welbeck, *Bonny Black* and *The Bloody-Shouldered Arabian*. So obsessed was he by the classical art of the Continent, that he often placed his horses among Roman columns. A lesser artist was James Seymour (1702–1752), a belated primitive whose paintings of horses reveal a weighty and sombre talent.

We have now to consider one who stands head and shoulders above the other sporting artists of the English school, George Stubbs. He ranks among the greatest animal painters of the

E.P.—8

world, and as a portrayer of horses he has never been excelled and seldom rivalled. Yet it is only in the last few years that his work has ceased to be regarded as popular illustration, and allowed æsthetic merit. Even the perspicacious Redgraves, writing in the eighteen-sixties, apologized for it, saying, " it is doubtful, even in our own day, if the general public is not satisfied with subjects of far less merit as works of art." But most of those who owned his work have cherished it; indeed it is probable that until the recent boom in sporting art no paintings of equal importance have changed hands less often than Stubbs's. Now, however, his qualities as a painter—the grandeur of his composition, the subtlety of his tones, his comprehension of landscape and of character and above all his miraculous gift for rendering the character and movement of animals—have ample recognition. He was the first European artist to paint animals as they are: " he never showed," to quote his inadequate biographer Joseph Mayer, " an immortal soul in a poodle's eye," unlike many of his nineteenth-century successors.

George Stubbs was born in Liverpool on August 24, 1724, and began to study anatomy at an early age. When he was twenty-one years old, desiring to learn whether art were superior to nature, he journeyed to Rome, and deciding that it was not, left forthwith. In 1766 he published his great work, " The Anatomy of the Horse," which has remained to this day an authority on the subject. The drawings alone took eighteen months of incredible industry; then, undismayed at his inability to find a suitable engraver, he learnt the art himself, and the engraving of them occupied his spare time during six or seven years. Stubbs's strength of both mind and body was prodigious, and as he lived until July 10, 1806, he was able to produce a quantity of work. His most famous, as well as his most impressive painting is his superb life-size portrait of the great horse *Hambletonian*, in the collection of the Marquess of Londonderry. Among other paintings in which his genius is manifest are, *Whistlejacket*, at Wentworth Woodhouse; *The Third Duke of Portland*, of 1767, at Welbeck; *Freeman, Keeper to the Earl of*

Clarendon, in the possession of Messrs. Agnew; *Mr. Wildman and his Sons*, in the collection of Mr. Walter Raphael; *The Haymakers* and *The Reapers*, both at Upton House, and *Lord and Lady Melbourne with Sir Ralph and Lady Milbanke*, belonging to Lady Desborough. In his conversation pieces, in which category the last four may be placed, the affinity of his art with Hogarth's is evident.

George Morland (1763–1804), whose art will be discussed in a later chapter dealing with landscape, also painted a number of sporting subjects. Of these *Full Cry—and a Fall*, at the Victoria and Albert, may be taken as a good example. Thomas Rowlandson (1756–1827) also drew similar subjects in pen and wash, such as *The Village Hunt*, in the possession of a London dealer. Julius Cæsar Ibbetson (1759–1817), an artist who visited China and Java, did some respectable sporting paintings, likewise Samuel Howitt (1765–1822), Rowlandson's brother-in-law, a Quaker, whose work has a strongly personal, slightly archaic quality. But the most considerable figures in the world of sporting and animal art since Stubbs were Benjamin Marshall (1767–1835), and James Ward (1769–1859), Morland's brother-in-law. It would be difficult to find two contemporaries whose work offers so complete a contrast. At its most characteristic the painting of Marshall is of a startling severity: horses with every visible muscle, artery and tendon starkly emphasized, stand beneath slaty skies. His backgrounds are often bare houses or sheds, grimly rendered, as in the *Portrait of Wizard*, of 1810, in the collection of Captain R. B. Brassey. Like Stubbs before him, Marshall was fascinated by anatomy, and the contrast between, for example, his early *Squire's Favourites*, and *Portrait of Sailor standing on the Downs*, of 1819, in a private collection in America, or *Portrait of Mameluke*, of 1827, also in Captain Brassey's possession, shows how much the spell grew upon him. His horses' heads are, nevertheless, almost invariably too small. Ward's painting is turbulent; he looked, not as Marshall looked, to his own immediate predecessors, but to Rubens for inspiration. Instead of the severe calm which prevails in Marshall's paintings, the weather of Ward's is stormy. His colour

is rarely good, but the dynamic power he showed, especially in his rendering of wild animals, moved Delacroix to admiration. This and his sense of magnitude and drama make him the most typical figure in the romantic movement in English painting. Characteristic of him are *Harlech Castle*, of about 1808, at the Tate Gallery; *Landscape with Cattle*, 1820–1822, showing an Alderney bull, cow and calf, life size, *Regent's Park, Cattle-Piece*, of 1807, and *Gordale Scar, Yorkshire*, all at the Tate Gallery. In one respect Marshall and Ward are alike: neither has received the honour due to him. Marshall was not, until lately, considered worthy of mention in the " Dictionary of National Biography," when a note on him was included in one of the supplementary volumes. Ward compelled attention by the sheer volume of his work (he exhibited no fewer than four hundred paintings), but he also is neglected, partly, perhaps, because there is something in the unashamed grandeur of his vision, untempered either by reserve or a touch of intimacy, which is too much at variance with the national taste.

There is, unfortunately, no space in this brief survey to discuss the work of the Sartorius and Alken families, of J. E. Ferneley (1781–1860) and Charles Towne (*c.* 1760–1850)—gifted minor members of a notable but, until recently, a neglected school of painting.

GEORGIAN PORTRAITURE

SOON after Van Dyck established himself in London English painting showed academic tendencies; but an academic tradition can only flourish in societies where academies exist, and in England there were none. In Tudor and early Stuart times the young artist, upon entering the profession of painting, was formally apprenticed to a master. Since his years of apprentice-ship were spent in preparing canvases and panels, grinding colours and such-like occupations, rather than learning the fundamental principles of his art, the apprentice acquired little beyond the idiosyncrasies of his master. The man of genius can learn without, and even in spite of, the teaching of academies, but to others some knowledge of the principles which their predecessors have evolved is indispensable. During the eighteenth and nineteenth centuries, academies sought forcibly to impose their principles and showed themselves almost invariably hostile alike to genius and to necessary change, and fell, in consequence, into disrepute. But there can be little doubt that the lack of an academy of some kind in the Stuart and Commonwealth periods was detrimental. For just as the now discredited practice of duelling was originally a humane innovation, whereby personal combat was substituted for civil war, so was the academic a vast improvement on the apprentice system. And until English artists possessed an academy which enabled them to preserve the knowledge that their predecessors had acquired, they remained at the mercy of every foreign adventurer however superficial his skill.

The first English academy of drawing and painting was founded on October 18, the day of St. Luke, Patron Saint of artists, 1711. More than sixty members gathered together in an old house in Great Queen Street and elected a Governor, Sir Godfrey Kneller, and twelve directors, among whom were

Thornhill and Richardson. And among the electors were Dahl, Wootton, Tillemans and George Vertue. To the last-named, students of the fine arts in England owe more than to any other man, for Vertue devoted forty fruitful years to gathering materials for a history of the subject. To this end he secured the patronage of the Duke of Norfolk, the Earl of Oxford and a number of other noblemen and travelled indefatigably about the country visiting the great houses. He left an invaluable series of notebooks, containing records of all he had been able to see and learn of the art and artists in England in every period. This, now at the British Museum, was purchased from his widow by Horace Walpole, who compiled from it his " Anecdotes of Painting in England." Vertue, who, unlike the majority of his country-men, was a Catholic, was born in 1684, died on July 24, 1756, and was buried in the cloisters, Westminster Abbey.

Kneller's institution was followed by a number of others, all of a more or less ephemeral nature, and it was not until more than half a century after its foundation that a permanent academy was established. The first meeting of the Royal Academy took place on December 14, 1768, and Reynolds was elected its first President. Academic art in general, and the Academy in particular, were fortunate in having so eminently suitable a figure to preside over their destinies. Reynolds was a great artist, but the fact that in a society dominated by the nobility he was also a great gentleman and, in one in which scholarship was honoured, a great scholar, enabled him to enhance the prestige of the fine arts. In a different fashion he exercised as decisive an influence on English painting as Hogarth himself, for he brought it to a maturity and a splendour that caused the work of his predecessors to appear archaic and provincial by comparison. Sir Joshua Reynolds was born at Plympton, Devonshire, on July 15, 1723 (the year of Kneller's death), the son of a clergyman who was also master of the local grammar school. In October 1741 he came to London and spent two years as the pupil of Thomas Hudson, at the end of which time he returned to practise his art in Devonshire. From 1749 to 1752 he lived abroad, largely

in Rome, industriously studying the great masters, Rembrandt and Rubens, as well as Raphael, Titian and Michael Angelo. On his return to London he was recognized as the first portrait painter in England. From January 1769 to December 1790 he delivered his celebrated " Discourses on Art," and in the latter year resigned the Presidency of the Academy. He died in London on February 23, 1792, and was buried in St. Paul's Cathedral.

The decisive event in his life was his Italian journey. Reynolds's was predominantly a classical temperament and he saw in the work of the artists of the High Renaissance the supreme embodiment of the classical tradition. But he was also a northerner, who responded to the romantic colour of the Venetians and the romantic spirit of the great northern painters, Rembrandt and Rubens. So while he held up the classical Italians as examples to be followed by his students, his own work reflects in a marked degree the colour and atmosphere of northern romanticism. For this inconsistency he is often unjustly attacked. He believed that the classical artists of Italy had perfected a tradition to which no others could hold a candle, that they were, in short, masters of the great unchanging principles of painting. He himself admired the works of Rembrandt and Rubens rather as expressions of individual genius than as the products of a great tradition, but it seemed to him wiser for students to study first the work in which fundamental principles were most clearly manifest, and only later spontaneous expressions of individual genius.

More fundamental in Reynolds's scheme of things than the distinction between the art of Italy and that of the north was that between " historical " painting and that of all other kinds. Herein he showed himself at one with the classical masters, who maintained that art should concern itself only with ideal aspects of nature, and its subjects be drawn from history or mythology; that it should be free from personal, topical, accidental elements, free, in short, from what Poussin called " workaday grime." Reynolds has been deemed an over-proud man, yet when we reflect that to him portraiture—the branch of painting in which

he himself excelled—was a minor art, there is a touching humility in his eagerness that his students should devote themselves to what he believed to be the supreme art, the painting of " history," in which he knew himself to have failed. Accomplished as they are, his *Holy Family*, of about 1788, at the Tate Gallery, or his *Ugolino and his Sons*, of 1773, at Knole, are as little convincing as *The Pool of Bethesda* or *The Good Samaritan*, historical pictures which Hogarth painted with his tongue in his cheek. But we, who do not share his views as to the disparity between " historical " and other art, are able to praise him without reserve for what he was, a portrait painter of genius.

Reynolds was an eclectic, but unlike the majority of his kind, he never allowed his own vision to be compromised by the qualities he sought to emulate; in spite, therefore, of his borrowings, his own art maintained a strongly individual character. So if his portraits are in some respects inferior to the greatest, they have a well-rounded harmonious quality which justifies their being placed in the first rank. He was born without a strong sense of form and he never fully mastered the art of drawing, but for the combination of penetrating insight into character, power of invention and sense of colour Reynolds has rarely been excelled. Although, unlike Hogarth, he learnt his art from foreign masters, Reynolds's interpretations of his own countrymen, his *Dr. Johnson* portraits and his *Laurence Sterne,* of 1761, in the Marquess of Lansdowne's collection, for instance, or the *Edmund Burke,* of 1769, at the National Portrait Gallery, are as unmistakably English in feeling as Hogarth's *Dr. Hoadley, Bishop of Winchester,* at the Tate. The national collections are fortunate in possessing a large number of his works.

Reynolds exercised a twofold influence on English art: his practice determined the character of portrait painting up till the death of Lawrence in 1830, while his precept served to establish a school of painters of " history." But before considering these two schools deriving from him we must notice his great rival Gainsborough, who stood somewhat apart from the mainstream of tradition. In their own day these two masters were rivals

and they are rivals still. The common prejudice in Gains-
borough's favour is thus explained by Sir Charles Holmes: " Art
with Reynolds is made to seem so like a conscious intellectual
force, that we do less than justice to the æsthetic enthusiasm
which inspired it, whereas with Gainsborough this last is plainly to
the fore. We therefore accept the fact of his genius more easily,
because it corresponds with what is commonly regarded as genius,
a faculty which works wonders by processes unknown. . . ."

English art as a rule has flourished most where official super-
vision has been absent, and the Olympian arbiter of public taste—
the English counterpart of Poussin, David or Ingres—has been
so rare a phenomenon among us that we are prone to distrust
him when he does appear; and for this reason also the unofficial
Gainsborough is favoured above his Olympian rival. Gains-
borough neither challenged authority, like Hogarth, nor, like
Reynolds, sought to wield it, but was indifferent and remote.
As a draughtsman he was Reynolds's master; his silvery colour
has a subtle, illusive loveliness that the richer golden tones of
Reynolds rarely equal, nor did Reynolds, except in certain of his
children's portraits, often succeed in endowing his sitters with
the pure and unaffected grace, the intimate feeling that is Gains-
borough's special gift. But how far, on the other hand, in
energy, in invention, in grandeur of vision and in psychological
insight does Reynolds surpass him! The influence of Reynolds,
moreover, upon both contemporaries and successors was in-
comparably stronger.

Thomas Gainsborough was born at Sudbury in Suffolk in 1727,
and was baptized at the Independent Meeting House on May 14.
He was the son of a Dissenting wool-merchant and a member
of an ingenious family: his elder brother John attempted to fly
with the aid of an elaborate pair of copper wings of his own
construction, while his mother excelled in flower painting.
At thirteen, we are told, Thomas was " a confirmed painter."
His main interest then as always lay in landscape, but this aspect
of his art will be noticed in a later chapter. In his fifteenth
year he came to London and appears to have undergone some

instruction from Gravelot, the French engraver, and also from Hayman, as mentioned earlier, but, unlike most of his contemporaries, Gainsborough never studied abroad. In 1745 he returned to Sudbury. In 1760 he was persuaded by an enterprising patron to go to Bath, where for a number of years he made portraits of the great and fashionable men and women of the day. From 1784 he lived in Pall Mall, London, in the enjoyment of fame and wealth. He died on August 2, 1788, and was buried in Kew Churchyard.

With Reynolds his relations were strained. He had taken his election to the Academy (of which Reynolds was President) as a matter of course and evaded his responsibilities. The President called upon him and the call was not returned; Gainsborough asked him to sit to him and did not finish the portrait. Reynolds bought his *Girl with Pigs*, and declared him the first landscape painter in Europe, thereby bringing on himself Richard Wilson's celebrated retort that Gainsborough was, in his opinion, the greatest portrait painter of the day; yet Gainsborough held aloof. But when he was dying he wrote to Reynolds asking to see him: " Come under my roof," he said, " and see my things." Speaking of their meeting afterwards, the President said that if any little jealousies had subsisted between them they were forgotten in those moments of sincerity. " We are all going to heaven," the dying painter whispered to him, " and Van Dyck is of the company."

In the December following his death Reynolds paid a noble tribute to Gainsborough's art in his Fourteenth Discourse, which for weight and insight has never been surpassed. Reynolds, the most self-controlled of men, was overcome by emotion as he spoke of the qualities of his great rival. " On pronouncing the eulogium at the Royal Academy," says a contemporary, " his praises of Mr. Gainsborough were interrupted by his tears." Gainsborough was an unequal painter, but at his best he stands alone among the English for the exquisite refinement of his vision and the dexterity of his handling of the brush, which he acquired from his lifelong study of Van Dyck, his chosen master. Like

Reynolds he is well represented in the national collections. Especially lovely are *The Artist's Daughters*, of about 1759, at the National Gallery, the *Eliza and Thomas Linley*, of 1768, in the Morgan Library, the *Duchess of Cumberland*, of 1777, at Buckingham Palace, the *Duke of Bedford*, at the National Portrait Gallery, the *Mrs. Sheridan and Mrs. Tickell*, of about 1782, at the Dulwich Gallery, the *Mrs. Robinson*, of 1784, in the Wallace Collection and the early group of lyrical outdoor portraits of *Mr. and Mrs. Andrews*, belonging to Mr. Andrews, *Heneage Lloyd and his Sister* at the Fitzwilliam Museum, and *Mr. and Mrs. Brown* from the collection of the late Sir Philip Sassoon. Hogarth began the liberation of English portraiture from the formality imposed upon it by foreign masters; Gainsborough completed the process, and in doing so he brought to it a new spirit—fresh, informal and unselfconscious. But although this is in some measure evident in the portraits of all his successors, it was not to Gainsborough but to Reynolds that they turned for guidance. From Reynolds even Allan Ramsay, a portrait painter of rare distinction ten years his senior, deigned to learn.

Ramsay was born in Edinburgh in 1713, the eldest child of the author of "The Gentle Shepherd." At twenty he visited London, and after an extended Continental tour returned to the city of his birth, but in 1756 he settled in London. His fluent brushwork influenced Reynolds, but by the next decade Reynolds had become the master and Ramsay the student. He was very successful, becoming Court Painter in 1767, after which he was compelled to employ a large number of assistants; but in spite of this he maintained an exacting standard. Besides innumerable Court portraits, among which perhaps the finest is *Queen Charlotte*, of about 1762, at Buckingham Palace, Ramsay painted many persons of eminence, among whom were *Jean-Jacques Rousseau*, who visited England in 1766, *David Hume* and *Lord Chesterfield*. The first two are at the National Gallery of Scotland and the third at the National Portrait Gallery. He was also a writer of some distinction, as is evident from his volume of essays, "The Investigator," published in 1762, and his four anonymous political tracts. His charm and

intelligence were highly praised by Dr. Johnson. Dying at Dover in 1784, he was buried at St. Marylebone, London.

A more faithful but far less accomplished follower of Reynolds was Francis Cotes, one of the original Academicians, a pupil of Knapton's, who was born in London about 1725 and died at Richmond, Surrey, in 1770. Another disciple, Nathaniel Dance, adhered as closely to Reynolds's practice as his talents permitted him. A son of George Dance the architect, he was born in 1735, and studied with Hayman and in Italy, where he also nourished an unrequited passion for Angelica Kauffmann. Dance abandoned his profession, it was generally said, on account of his marriage with a rich wife, but this charge was ill-founded, for he ceased to exhibit in 1776, and his marriage did not take place until five years later, in 1781. It was at this time, however, that he retired from the Academy, of which he was an original member. In dismantling his studio he gave to Gilbert Stuart, the American painter, then a struggling student, a mass of painting material which included a palette formerly owned and used by Thomas Hudson. Dance added to his patronymic that of Holland, was created a baronet and became a Member of Parliament. Late in life he painted a number of landscapes of merit, and died in 1811. The portraits of Tilly Kettle (c. 1740–1786) were also based on those of Reynolds, but were wanting in both boldness and energy. Among the best are the *Rear-Admiral Kempenfelt*, at Greenwich, and the *Eliza and May Davidson*, at Dulwich. From about 1770 until 1777 he painted in India, sending back numerous pictures for exhibition at the Academy. In 1786 he started on a second visit, but died at Aleppo.

A far more famous yet greatly overrated painter was George Romney. Born at Dalton-in-Furness, Lancashire, on December 26, 1734, he was first apprenticed to a cabinet-maker and afterwards, in 1755, to a painter named Christopher Steele, at Kendal. To this man Romney is said to have owed his expertness in the grinding and mixing of colours. For whereas the colour of many artists of the time has become dull, notably that of the innovating Reynolds, Romney's retains an extraordinary fresh-

ness. At the age of twenty-two he married and almost simultaneously deserted a wife. After subsisting for several years as an itinerant portrait painter he settled in London in 1762. From 1773 to 1775 he travelled abroad. About a year after his return he produced what is generally considered to be his masterpiece, *The Children of Earl Gower, afterwards Marquess of Stafford*, in the collection of the Duke of Sutherland. In this Romney shows powers of composition uncommon with him. Meanwhile he had achieved success as a portrait painter and was soon the rival of Reynolds and Gainsborough for the patronage of the fashionable world, but he never became a member of the Academy.

In 1782 Romney found in Emma Hart, or Lyon, the model perfectly suited to his art. Of the many artists for whom she posed he has left the subtlest and most seductive records of her beauty. He painted of her no fewer than fourteen finished pictures, in addition to innumerable studies. He continued to paint her after her marriage to Sir William Hamilton, British Envoy to the Court of Naples and generous patron of archæology. Both Romney and his " divine lady," after moving in the most brilliant society in Europe, ended their days in ignominy. After the death of her husband and of Nelson, Emma Hamilton gave way to dissipation and fell into debt, and finally fled to Calais with Horatia, her daughter by Nelson, where she died in poverty in 1815. Circumstances hardly less melancholy attended Romney's declining years. Overborne by the classical dogma which was everywhere in the ascendant, and which was preached in our own country with so much eloquence and so much learning by Reynolds, the dogma of the inherent superiority of " history " painting over all others, Romney, like so many portrait and genre painters of his day, did violence to both his inclinations and his talents and attempted to excel as a " history " painter. To this end he studied assiduously on his Continental journeys, and built up adequate financial resources, but no sooner did all circumstances appear to favour his ambition, than his health gave way, and he was forced to return, a hopeless invalid, to

the wife whom he had deserted for thirty years, who received him, says his biographer, without a word of reproach. Shortly afterwards, in November, 1802, haunted by a melancholia which ever increased its hold on his imagination, he died. Romney's end was a personal tragedy, but it is clear from his essays in the "historical" style that posterity is little the poorer for his comparatively early death, for he was deficient in the power of handling large and complex designs, the scholarship, and above all, the grandeur of vision essential to the painter of "history." It is by his portraits that Romney's reputation stands or falls. The best of these have a certain breadth and rhythm and an indubitable charm. These qualities are all present in a marked degree in such a portrait as the *Mrs. Mark Currie*, of 1789, at the Tate. In the larger part of his productions, however, it is his shortcomings that are most in evidence: a monotony that challenges comparison even with Kneller's, a predilection for brickish colours, and worst of all an emptiness of both vision and technique, for he possessed little psychological insight and his forms are poorly modelled. Romney was an accomplished and imaginative draughtsman, but as a painter he lacked the capacity for bringing his more ambitious projects to a conclusion. At his death, cartloads, it is said, of incompleted canvases were removed from his house. His invention, as the Redgraves observed, "was more fervid than deep; easily excited but soon satiated."

A member of a younger generation, Reynolds's disciple and biographer, but never, strictly speaking, his pupil, was James Northcote. Born in 1746, the son of a Plymouth watchmaker, he had the fortune to be admitted to Reynolds's friendship, and between 1771 and 1776 he frequented his house and studio. He studied first at the Academy Schools, and afterwards, from 1777 until 1780, in Italy, seeking to prepare himself to be a painter of "history," for which, however, he was in no way fitted. His most ambitious work in this capacity is *Sir William Walworth, Lord Mayor of London*, A.D. 1381, *in the presence of Richard II, kills Wat Tyler, at the head of the Insurgents, who are appeased by the Heroic Speech of the King*, at the Guildhall, an empty derivative machine. He

also endeavoured without success to rival Hogarth's *Idle and Industrious Apprentice* in a series of ten paintings entitled *Diligence and Dissipation*. He is best known for his numerous but somewhat pedestrian portraits and his informative yet unsatisfying " Memoirs of Sir Joshua Reynolds." He died in London in 1831.

Northcote's chief rival was John Opie, who was born in 1761 at St. Agnes, Cornwall, the son of a carpenter. He early revealed his robust but unimaginative talent, which attracted the notice of the adventurer Dr. Wolcot, " Peter Pindar," who attempted to turn it to his own advantage. Having made Opie his protégé, he persuaded him to agree to divide their joint profits equally between them. The two came to London in 1780 and " the Cornish wonder " became, for a time, the talk of the town. Shortly afterwards his association with Dr. Wolcot, who undoubtedly exploited him, came to an end. Opie's sober and somewhat commonplace gifts fitted him to be a provincial portrait painter; but London corrupted him. Like so many of the artists of his day, Opie vainly aspired to paint " history," although his *Murder of Rizzio,* at the Guildhall, despite its melodramatic character, has survived. His best works are his portraits.

An inferior artist, but one who had the wisdom, rare at that time, to abstain from ambitious subjects, was John Hoppner (*c.* 1758–1810), a reputed son of George III, and a painter devoid of an artistic personality of his own who plagiarized first Reynolds and then Lawrence. A portrait painter with a far firmer grasp of character and superior energy and power was Sir Henry Raeburn. Born on March 4, 1756, of practical Border stock, the son of a prosperous millowner, he was first apprenticed to a goldsmith. There still exists a jewel executed by him in memory of Charles Darwin, an Edinburgh student and an uncle of the author of " The Origin of Species," who died, aged twenty, in 1778. Raeburn next tried his hand at miniature and finally at oil painting, receiving encouragement from David Martin (1736–1798), the fashionable Scottish portrait painter. During the years 1785–1787 he worked in Rome, and was treated with the greatest generosity by Reynolds on his way thither. From his

return until his death on July 8, 1823, he enjoyed uninterrupted success. At one time he thought of settling in London, but was dissuaded by Lawrence, and remained in Edinburgh recording the features of all who were distinguished in the Scottish society of the day. To those who know him only through the examples to be found in England (though his *Sir John Sinclair of Ulbster, Bt.*, at the National Portrait Gallery is an admirable work) the Raeburns in the National Gallery of Scotland are a revelation. Here his genial sagacity, his sound sense of structure and his broad vigorous handling make a deep impression although his colour is apt to be raw and harsh.

While Raeburn reigned supreme in Scotland, London, and not London only but all Europe, was at the feet of a dazzling virtuoso, an artist for whose worldly eminence one must needs go back as far as Rubens for a precedent, Sir Thomas Lawrence. Born at Bristol on May 4, 1769, the son of a feckless innkeeper, the young Lawrence first exercised his supreme gift—the gift of pleasing—upon the guests of his father's hostel, the " Black Bear " at Devizes, where he sketched and recited for their amusement. He later visited Oxford and made a number of drawings of eminent members of the University. Next he settled in Bath and made portraits in pastel, and before he had reached his twelfth year his studio was already a resort of fashionable society. Five years later he began seriously to paint in oils, and removed to London, where, like so many artists before him, he received kindness at the hands of Reynolds. In London, as elsewhere, success came to him quickly. In November, 1791, he was elected an Associate of the Academy, and on the death of Reynolds the following year he was appointed Principal Portrait Painter to the King. In 1792 he also painted portraits of the King and Queen which were taken by Lord Macartney on his embassy to China and presented to the Emperor. The conclusion of the Napoleonic wars gave Lawrence the opportunity to become a European figure: he journeyed from place to place, everywhere acclaimed and everywhere painting the portraits of the great persons of the hour. At the Congress of Aix there

sat to him the Emperors of Russia and Austria, the King of Prussia, Prince Metternich and the Duc de Richelieu; at Rome he painted the brilliant portrait of the Pope, *Pius VII*, which hangs in the Waterloo Room at Windsor, Cardinal Consalvi and Canova; in France, Charles X; at Vienna he made an admirable drawing of Napoleon's son, the Duc de Reichstadt. While at home he painted, among innumerable others, Byron's Lady Blessington, Scott, Southey, Canning and the poet Campbell. It was the last-named who, after expressing his delight with his own likeness, made the following apt reflection on the artist's work: " This is the merit of Lawrence's painting—he makes one seem to have got into a drawing-room in the mansion of the blest, and to be looking at oneself in the mirrors." As Campbell suggests, Lawrence was without either deep insight into character or loftiness of vision. Lacking though he was in the weightier qualities, his rare sensibility to social grace together with the brilliance of his gifts almost entitles him to the rank of master, for his sense of design, his draughtsmanship and his dexterity were of the highest order. When, on June 7, 1830, Lawrence died and was shortly afterwards laid to rest in St. Paul's, an epoch in portraiture came to an end.

THE PAINTERS OF "HISTORY"

REYNOLDS'S advocacy of "history" painting bore less fruit than his example as a portraitist. It was not that his words fell upon deaf ears, for in the realm of art in England no man ever commanded such respectful attention as Reynolds. But his countrymen, always more impressed by the evidence of their senses than by theories, remarked the contrast between his splendid portraits and the mediocre *Ugolino* and *Holy Family*. Furthermore, "history" painting, and all that the term implies of eloquent gesture, of heroism and drama freely expressed, is somewhat alien to the English temper. So it came about that of the four most eminent painters of "history" of the time, West, Barry, Copley and Fuseli, not one was entirely English. Nor had any of these practitioners of that branch of art most favoured by academies the advantage of academic training.

The last three were all born in the same year, 1741. Benjamin West was born in 1738 near Swarthmore, Pennsylvania, in the United States, of a Quaker family that had emigrated in 1681 from Long Crendon, Buckinghamshire. A Cherokee Indian, according to his own account, gave him his first instruction and colours, but he went to Rome to study at an early age. At this time and place an American artist was regarded as something of a curiosity, and West, on being presented to the blind Cardinal Albani, was asked whether he was black or white. In 1763 he settled permanently in London, quickly securing Royal patronage. He was a foundation member of the Academy, of which he became President on the death of Reynolds. He died in 1820 and was buried in St. Paul's. West was a mediocre artist: feeble in imagination and deficient in sense of character, while his colour is monotonous and dry. Yet by a curious paradox this poorly endowed and unoriginal man painted one picture that is not only excellent in itself, but epoch-making, namely, *The Death of General Wolfe*, in the National

Gallery of Canada. The academic artists of the age carried to such lengths their worship of antiquity as to insist that all the figures in a "history" painting should be clothed as Greeks or Romans, even if the subject were drawn from Scripture, mythology or history of any period. When it became known that West's intention was to clothe his figures in contemporary costume, Reynolds, accompanied by the Archbishop of York, called on him seeking to dissuade him. "The event to be commemorated happened in the year 1759," replied West, " in a region of the world unknown to the Greeks and Romans, and at a period of time when no warriors who wore such clothes existed." But when Reynolds saw the painting, with characteristic generosity and wisdom he confessed himself to have been at fault and grasped the significance of West's innovation. "West has conquered," he said; "he has treated the subject as it ought to be treated. I retract my objections. I foresee that this picture will not only become one of the most popular, but will occasion a revolution in art." Reynolds spoke prophetically: henceforward classical was gradually replaced by either contemporary or appropriate historical costume.

John Singleton Copley was a far more considerable painter. Like West, he came from the United States, having been born in Boston immediately upon the arrival of his Anglo-Irish parents from Europe. In 1774, having already made a reputation as a portrait painter in his native city, he set out for Italy, by way of London where he settled permanently, late in the following year. Not long afterwards he embarked upon an ambitious series of scenes from contemporary English history. The first of these, *The Death of the Earl of Chatham*, shows the great statesman receiving his death stroke on April 7, 1778, in the old House of Lords (the Painted Chamber) where he had been pleading on behalf of the British North American Colonies. The fifty-five heads in the picture are all portraits. The scene is largely imaginary: the peers, for example, were not on that occasion robed, but the historic scene is grandly yet touchingly portrayed. The picture was begun the year after Chatham's death. The

second and finest of the series, *The Death of Major Pierson*, was inspired by the heroic end of a young British officer who on January 8, 1781, lost his life in defeating a body of French troops who had invaded the island of Jersey. This picture is not only the best of Copley's "history" paintings, but one of the finest of its type that the English school has produced. The artist has seized the dramatic possibilities of the episode; the picture is suave and harmonious in design, in colour fresh and clear. And an authority on battles, the Duke of Wellington, pronounced it the best battle picture he had seen. The boy dressed in green by the nurse's side is the artist's son, the future Lord Lyndhurst. In the same year, 1783, Copley painted the vigorous and dramatic but less successful *Siege and Relief of Gibraltar*. The first two of these pictures are at the Tate; the last at the Guildhall. Copley died in 1815, a disappointed man, for the pictures which cost him such infinite labour brought him fame but little wealth, and as late as 1800 *The Death of the Earl of Chatham* and another elaborate work, *Charles I demanding in the House of Commons the Five Impeached Members,* now in the Boston Public Library, were still in his studio, while others were changing hands for a song.

The third "history" painter was James Barry, one of the most striking personalities in British eighteenth-century art. Born in Cork, the son of a coasting trader who kept a public-house, Barry first made his mark as an artist when he exhibited in Dublin a painting entitled *The Conversion by St. Patrick of the King of Cashel*. This so impressed Burke that he sent Barry to London and Rome and became his patron. Barry was of the race of David: the minds of both men were filled with the same vision of a grandiose public art, based on classical sculpture and dedicated to the exaltation of civic virtue; in both there burned the same passionate love of antique art, the same fierce, uncompromising spirit. But their destinies were as different as their natures were alike: a revolution made David unchallenged dictator of the arts, while Barry languished in fruitless opposition. Barry was far less richly endowed and less well instructed than

David, yet his paintings in the great room at the Society of Arts in the Adelphi show, granted opportunity, to what heights he could attain. For these, undertaken gratis in 1777 and completed in 1783, strike a note of authentic grandeur. His devotion in lonely poverty to the fulfilment of his exalted dream compels our admiration. While engaged on his gratuitous labours in the Adelphi, he almost starved himself, and often, after painting all day, he was compelled to engrave at night in order to obtain the bare means of subsistence. A letter written on his homeward journey, from Turin, concerning the pictures in the gallery there, shows at once the depth of his devotion to the classical idea and his sense of struggling in a hopeless cause: " The rest of the pictures are Flemish and Dutch, Rubens', Van Dyck's, Teniers', Rembrandt's, Scalken's, etc. These are without the pale of my church, and though I will not condemn them, yet I must hold no intercourse with them. God help you, Barry, said I, where is the use of your hairbreadth niceties, your antiques, and your etceteras? Behold, the hand-writing on the wall is against you; in the country to which you are going, pictures of onion-peels, oysters and tricks of colour, and other baubles, are in as much request as they are here." Barry's classical notions were outraged by West's use of contemporary costume in his *Death of General Wolfe*, so by way of protest he painted a picture of the same subject with the figures nude. The purity of Reynolds's classicism was more than suspect: the President', " history " paintings, were they exhibited in France or Italys would at once be taken for what they were, wrote Barry, under a pseudonym, " the rude, disorderly abortions of an unstudied man." His passionate, uncompromising and utterly undisciplined nature continually prompted such outbursts. He went so far, on one occasion, as to accuse the entire body of Academicians of burgling his house. He was first removed from his Professorship of Painting and finally from his membership of the Academy. And on terms of enmity with the world he died, ill and alone, in February, 1806. His body lay in state in the great room he had decorated, before being buried in St. Paul's.

Equal to Barry in force and grandeur of imagination but less well endowed by nature and training was Henry Fuseli. Born in Zürich, the son of a painter named Fuessli, he took holy orders, but was soon compelled to leave his native city. He came to London in 1763, in the train of the British Minister to the Court of Prussia, visited Rome, and settled finally in England in 1778. In 1790 he was elected an Academician, Professor of Painting in 1801, and Keeper in 1804. He died at Putney in 1825. His ambitious "history" paintings and his numerous drawings are characterized by rare originality and vigour. Lacking both academic training and natural dexterity, he neglected the methods of the old masters, but sought instead with passionate fervour to recapture the mood by which they were inspired. Michael Angelo was his chosen master, and in the technically incompetent work of the fervent but sardonic and acutely intelligent Fuseli his spirit lives again. Fuseli's figures are often distorted and their actions exaggerated to little purpose, yet it is unjust to dismiss them, as has often been done, as merely grotesque: their vehement, sinister poetry is authentic.

The "history" school survived until the second half of the nineteenth century. The most notable of its later members were Benjamin Robert Haydon and John Martin. Haydon was born in Plymouth on January 18, 1786; and he studied at the Academy Schools. After a brief period of success he incurred, and thereafter continually fanned, the enmity of many influential persons, and also deeply involved himself with money-lenders. Broken by failure, he died by his own hand on June 22, 1846. Haydon is chiefly remembered to-day as the author of a famous diary, as the man who secured the Elgin Marbles for the British Museum, and for his dramatic suicide, but his series of huge "history" paintings are either disparaged or forgotten. On technical grounds Haydon's art is vulnerable to criticism: his designs are not infrequently lacking in cohesion, his themes are confused, and again and again he betrayed a lack of knowledge of the fundamentals of his art. But he had, on the other hand, an authentic fire, a certain splendour of vision, and if the author-

ities had not allowed themselves to be completely alienated by his ire and his vanity and instead had given him the opportunity that he so passionately desired, Haydon might have been numbered among the most notable modern exponents of public art. As it was, his career, like that of Barry, whom he in many ways resembled, was a lonely struggle with public opinion, authority and fashionable connoisseurship. He was defeated, and his achievement is but a shadow of what it might have been. Exponents of public art, by their very nature, are doomed, in the absence of public sympathy or official support, to a partial realization of their aims, if not to total failure. There is something at once pathetic and impressive about the fragmentary achievement of the unhappy being who endured with such indomitable faith and vanity " on the rack of this rough world." Poverty, with its consequent lack of leisure, of models, its small and ill-lit studios, prevented Haydon from doing justice to his splendid pictorial conceptions, but he was successful in the lesser enterprise of persuading the British public to acquire the Elgin Marbles, and in his advocacy of the idea that British artists should compete for employment in the decoration of the new Houses of Parliament. To him also is due the idea of a Government school of art to raise the standard of industrial design. John Martin (1789–1854) was one of the strangest characters in the history of English painting. He belonged to a family afflicted with a strain of madness (it was his brother Jonathan who in 1829 set fire to York Minster); he finally abandoned painting in favour of projects of a Babylonian, of an indeed impossible grandeur, for the improvement of London. But he produced a number of historical paintings in the best of which extravagance is redeemed by a note of authentic dignity. Of one of these Charles Lamb aptly wrote: " His towered structures are of the highest order of the material sublime. They satisfy our most stretched and craving conceptions of the glories of the antique world. It is a pity that they were ever peopled. On that side the imagination of the artist halts and appears defective." That which Haydon and Martin had conceived on so grand a scale was in a measure

realized by a younger and a tamer man, William Dyce (1804–1864). A highly competent painter and a public-spirited man, he was the first artist authorized to execute a mural painting—*The Baptism of Ethelbert*—in the Houses of Parliament; he was also placed at the head of the Government schools of design which had meanwhile come into being.

BLAKE AND HIS FOLLOWERS

IT is ironic that Reynolds's dream of great English "history" painting should have been fulfilled by his bitterest opponent. All the English painters of "history"—Hogarth, West, Barry, Fuseli, Reynolds himself and even Copley—had generally failed to infuse the breath of life into their creations in the grand manner. Yet Hogarth's genre paintings, and Reynolds's and Copley's portraits, furnish sufficient evidence that it was not vitality that was wanting. The truth is that for the successful execution of "history" painting on a grand scale neither natural talent nor even genius itself is a sufficient substitute for training. In England there was no tradition of painting in this manner, only sporadic attempts to establish one; mediocre Italians or Frenchmen were therefore able to succeed where Englishmen even of superior talents could accomplish relatively little. The native painters were baffled chiefly by having to work on an unaccustomed scale. Blake, on the other hand, set down his transcendent visions within small limits, and thereby escaped the dangers to which others were beset. In both the range and the intensity of his imagination he far surpassed the others. Indeed, to Blake the world of imagination was not a shadowy counterpart of the material world but the most immediate, the most vivid of realities. " A spirit and a vision," he said, " are not, as the modern philosopher supposes, a cloudy vapour or a nothing; they are organized and minutely articulated beyond all that mortal and perishing nature can produce. He who does not imagine in stronger and better lineaments and in a stronger and better light than his perishing and mortal eye can see, does not imagine at all." He went yet further than this: " natural objects," he said, " always did and do deaden imagination in me.''

William Blake was born on November 28, 1757, the son of a hosier, at 28 Broad Street, Golden Square, London, and at

the age of ten began to attend Pars's drawing school in the Strand. He early showed the independence of his taste by admiring Michael Angelo and Raphael when the Carracci and Guido Reni were the chosen idols of the connoisseurs. Italian painting was known to him only through engravings. At the age of fourteen he was apprenticed to James Basire (1730–1802), the engraver, with whom he remained seven years. Basire sent him to make drawings of monuments in Westminster Abbey and other churches, thereby enabling him to acquire the love of Gothic, which, with his love of Michael Angelo, was the predominant influence upon his art. There is something singularly fitting in this intimate association of the supreme imaginative artist of modern England and the supreme monument of English mediæval art. In 1778 he entered the Academy Schools. About this time he met Fuseli, an artist whose daring imagination he prodigiously admired and whom he defended from his critics. " Such an artist as Fuseli is invulnerable," he said. Another friendship belonging to the same period was with John Flaxman (1755–1806), the classical sculptor and draughtsman, whose *Illustrations to Homer*, in the Diploma Gallery, exemplify the clear, expressive line which Blake approved. Thomas Stothard (1755–1834), the idyllic book illustrator, also for a time enjoyed Blake's friendship. In 1784 he set up a shop for the sale of prints, but gave it up three years later on the death of Robert, his brother and partner.

In 1788 Robert appeared to him in a dream and revealed to him a process whereby he might achieve literary and pictorial expression at one and the same time, which he had long wished to do. Text and illustration were drawn in reverse on a copper plate with an impervious liquid, the rest of the plate was then bitten by acid, and both were printed and the colour added by hand. Upon this revelation there followed a sublime series of imaginative works which Blake wrote, illustrated, printed and published himself. In 1789 appeared " Songs of Innocence " and " The Book of Thel "; " The Marriage of Heaven and Hell " followed in 1790, " Songs of Experience " in 1794, " The Prophetical

BLAKE : *Beatrice Addressing Dante from the Car.* C. 1824–1827

Water-colour.—Tate Gallery

Books" between 1793 and 1795. Blake also invented two further processes: a kind of tempera painting, which he called "fresco," about 1790, and a method of reproducing water-colours which he used between 1793 and 1796. The colour of most of the "frescoes" has greatly darkened, but *The Spiritual Form of Pitt Guiding Behemoth*, on canvas, at the National Gallery, *The Spiritual Form of Nelson Guiding Leviathan*, also on canvas, and *Satan Smiting Job with Sore Boils*, on panel, both at the Tate, are in a tolerably good state of preservation. The latter years of his life were occupied by a set of twenty-one engravings to illustrate "The Book of Job," which were commissioned by his friend Linnell and completed in 1825, and a set of designs for Dante's "Divine Comedy," which was unfinished at the time of his death. A few of the Dante engravings exist; of the hundred preliminary water-colour studies twenty are at the Tate. Blake died at Fountain Court, London, on August 12, 1827, singing, his mind filled with radiant visions, and was buried at Bunhill Fields in a common grave which cannot be identified.

He was not only a great original artist, but at his best a singularly perfect one. And small in scale as his paintings are, no artist's aims were ever more exalted: he tried to reinterpret the supreme works of literature, to make manifest a cosmic vision, and to portray the Almighty Himself. It is easy to criticize his figures from the realistic standpoint, but irrelevant, for the human form was of interest to him not for its own sake, but as an instrument whereby his ideas and his visions might be realized. Indeed, as Mr. MacColl has observed, "Blake's figure is at bottom Flaxman's, a very summary lay figure. But he makes of this figure by his invention of movement, pose, expressive gesture, an amazing engine of invention. He can render with it the extreme of supplication, menace, stricken exhaustion, intent watching, stony grief, wild flight, frozen oblivion or the still upward movement of an emanation and the waft and effortless wreathing of forms borne upon winds of the spirit." Blake is of the race of the great masters: in imaginative power and sublime grandeur of design he is El Greco's brother. He lived and

died in dire poverty, and his work made little stir in the world. It was only towards the close of his life that the significance of his achievement and the quality of his character ("He was more like the ancient patterns of virtue than ever I expected to see," wrote his friend Linnell) became known to a small group of friends and disciples belonging to the younger generation. This was due to John Linnell (1792–1882), a serious realistic landscape and portrait painter, whose own art had already reached maturity when he met Blake in 1818. But besides these he was admired by a few among the older generation: Fuseli declared that Blake was damned good to steal from, Romney that his imaginative drawings ranked with Michael Angelo's. Besides these, Stothard and Flaxman had some understanding of his worth. A devoted friend was the blithe landscape painter John Varley (1778–1842), a descendant, through his mother, of Oliver Cromwell, and brother-in-law of Copley Fielding, who after meeting Blake in 1819 was his constant companion. It was he who, deep in debt and assailed by other grave misfortunes, said: "All these troubles are necessary to me; if it were not for my troubles I should burst with joy." But Blake influenced none of these as he did his young disciples, who came to know him in their most impressionable years. The most notable were Palmer and Calvert, inspired artists both.

Samuel Palmer (1805–1881), the son of a Stoke Newington bookseller, was the first to know Blake, being taken to see him by Linnell in October, 1824. Edward Calvert (1799–1883) met Blake in the winter of 1824–1825. The two young men themselves became devoted friends; though it would have been difficult to find a greater contrast than there was between Palmer, diffident, town-bred and bookish, and the self-reliant Calvert, who at fifteen had joined the Navy as a midshipman and been with his ship, the frigate *Albion*, when she had taken part in the bombardment of Algiers, and at twenty had resigned to become an artist and make his living by selling shares. The force of Blake's impact upon these two impressionable natures is hardly to be wondered at. For in knowing Blake they were

privileged not only to know one of the rarest beings the world has seen, but were able to learn a new language of form.

Blake's contemporaries and immediate predecessors were dazzled by the ideal of " history " painting. Even those who, like Hogarth, rejected art of such a kind stood somewhat in awe of its prestige and now and then attempted it, as though to show the world that they could master it. And generally they failed, for they were seeking to speak an alien tongue; Blake, on the other hand, expressed himself naturally, in his own. Hogarth showed that major art neither began nor ended with the painting of " history " in the grand manner; Blake that " history " itself could be portrayed otherwise than in the grand manner. It was not, however, Blake's ambitious " history " painting which made the deepest impression on his immediate followers, but the woodcuts he did in 1821, as illustrations to Dr. Thornton's third edition of Virgil's " Eclogues." These were the inspiration of a new pastoral school. Under their influence Palmer produced a series of landscapes in pen and water-colour which have a quality of mysterious exaltation which gives them a unique place in English art. Especially characteristic are the wonderful group of drawings of pastoral subjects, all belonging to 1825, at the Ashmolean Museum, *Coming from Evening Church* (oil and tempera) of 1830, at the Tate, and the slightly earlier *In a Shoreham Garden* (water-colour and gouache), at the Victoria and Albert. In 1837 he went on a two-year visit to Italy, and his art lost much of its magic.

Calvert was a hardly less masterly artist; his work is marked by a serenity of spirit neither to be found in that of Palmer nor even of Blake himself. It was this rare serenity that guarded him from a weakness from which ecstatic natures are prone to suffer: when their interest flags their forms grow summary. Blake suffered from it, but with Calvert, passionate as he was, every form is fully realized. His knowledge of landscape was greater than his master's, and his skill in engraving also, although Blake spent his life at that art and Calvert rarely used the graver.

Indeed, but seven engravings on wood and two on copper by his hand are known. The best of his woodcuts are unsurpassed; in them the mysterious lyric mood of Palmer's drawings lives with equal radiance. Most beautiful of all is *The Chamber Idyll*, scarcely less so are *The Return Home* and *The Player on the Lyre*. Both his copper engravings, *The Sheep of His Pasture* and *The Bride*, are of a singular loveliness, as is also his drawing in water-colours, *A Primitive City*, at the British Museum, a work in which the influence of the mediæval illuminated manuscript is fused with that of Blake. The work of his later years, admirable as it is, lacks the quality of exaltation that contact with Blake inspired. His art is without the grandeur or originality of Blake's, yet Calvert is among the most perfect of English artists.

A lesser artist than Palmer or Calvert, but one who for a brief space of time was more subject to Blake's spell than either, was George Richmond (1809–1896). His *Creation of Light*, a tempera painting in the collection of Mrs. Walter Richmond, although in form and technique inspired by Blake, is no unworthy imitation; here, indeed, is authentic emotion nobly and capably expressed. *The Shepherd*, a copper engraving, reveals something of the same spirit, but in less convincing form. That Blake's disciples should have fallen away is no mere chance. The imaginative art he preached and practised ran counter to the strongly rising tide of realism that was sweeping everything before it. Artists were looking for inspiration ever more intently at "mortal and perishing nature" and turning their backs upon imagination.

LANDSCAPE: WILSON, GAINSBOROUGH, CROME, CONSTABLE AND TURNER

IT was only after centuries of subordination that the art of land-scape asserted its independence, and emerged, as Mr. MacColl observed, from under the elbows and between the haloes of saints and martyrs. The process of emancipation was the pictorial reflection of a fundamental change in man's prevailing conception of his place in the universe. The traditional view, held in the ancient world and perpetuated by mediæval theology, was that man, by virtue of a nature wholly different from that of the rest of created things and of an immediate relation to God, occupied a unique and privileged position. This view was modified as a result of the gradual advance of scientific knowledge: man, it seemed, was not, after all, the enemy or the servant of God and fashioned in His image. Instead he was but the last of a chain of monkeys; and the universe, which had seemed all but parochial, now loomed infinitely vast. Nature, in short, which had been a mere background for the activities of man, slowly became an independent and fascinating field of interest. And so it came about that in the sphere of art also, as the centuries passed, the background became at last the object of reverent and absorbed attention. A special aim of landscape painting is the reduction of the disorder of nature to an orderly design. The habit of the primitives of seeing in terms of one distance and one focus only had to be changed that this ultimate aim might be realized. So as the art of landscape progressed we find the old field of vision continually extending, until at last the foreground is stretching back, as it were, as far as the horizon, and clear vision replaced by comprehensive vision, and the once dominant human figure slowly disappearing or else a mere accessory.

It is curious that English artists should have been so relatively late in entering the field of painting in which they have excelled,

even though conditions highly discouraging to landscape painters had long prevailed. Where interest in landscape had existed, it was foreign artists' work that was in demand. Claudes, Poussins, Salvators, Canalettos and Zuccarellis were all popular, and when an English artist was employed, it was often enough to depict some foreign scene. What is stranger than the paucity of English landscape painters prior to the eighteenth century is the continued neglect which they have suffered. It is probable that less attention has been devoted to the history of English painting than to that of any other comparable art, but nowhere has indifference been so marked as in the field of early landscape painting. It is, indeed, all but complete; Colonel M. H. Grant's widely informative " Old English Landscape Painters " stands almost alone.

Though Wilson was the first great English landscape painter he was far from being the first to practise the art in England, as is sometimes assumed. " Wilson and Gainsborough themselves," says Colonel Grant, " so far from being ' fathers ' are but echoes of notes struck long before, and easily traceable, less to Italy and the Netherlands than to Italians and Flemings who have worked in this country." And the work of these forms as integral a part of English painting as that of foreign-born portraitists such as Lely or Kneller. English mediæval illuminators had understood the decorative uses of landscape, and often portrayed it with both precision and charm, but one of the earliest existing examples of landscape painted for its own sake is to be found on an end-paper of a minute Bible once the property of Queen Elizabeth, and now at the British Museum. It is a study of Windsor Castle, seen from the Park, in opaque water-colour, measuring $3\frac{5}{8}$ by $2\frac{3}{8}$ inches and executed about 1550, and by no less a person than Edward VI (1537–1553). The earliest landscape painter in oil in England appears to have been Joris Hoefnagel (1545–1601), a Fleming, an excellent work by whom, *A Fête at Bermondsey*, is in the collection of the Marquess of Salisbury, at Hatfield. Sir Nathaniel Bacon, whose portraits have already been mentioned, also executed on copper a small *Rocky*

Landscape, which is at the Ashmolean. To another foreign painter, Josse de Momper (1564–1634), is attributed the splendid painting of *Pontefract Castle*, at Hampton Court. David Vinckeboons (1578–1629), also a Fleming, painted several excellent landscapes, a good example of which is *The Thames at Richmond*, at the Fitz-william, as did also Francis Cleyn (*c.* 1595–1658). Thomas Wyck (1616–1677 or 1682), who came from Holland, made a speciality of views of London. Of especial merit is his *West-minster from below York Watergate*, in the collection of Mr. E. C. Grenfell. Robert Streater, to whom reference has already been made as a wall painter, executed the ambitious and spirited *View of Boscobel House*, at Hampton Court, depicting the search for Prince Charles after the battle of Worcester. A more sophisticated vision is evident in the work of the Jersey artist, Peter Monamy (1670–1749), who painted marine subjects under Dutch influence. *Old East India Wharfe*, at the Victoria and Albert, shows him at his best. A lucid and vivacious painter of similar subjects was Charles Brooking (1723–1759), who is represented at the Tate Gallery, the Foundling Hospital and Kensington Palace. The London landscapes of Samuel Scott (1710–1772), precise and delicate paintings reminiscent of those of Canaletto (who was in England from 1746 to 1750 and again in 1751), were vastly admired by Walpole. In such a painting as *The Thames* (*Strand shore*), at the Victoria and Albert, he shows himself an artist with an exceptional understanding of urban landscape.

Besides these and other early landscape painters of merit, there must also be included among those who laid the founda-tion of the great English school of the later eighteenth and early nineteenth centuries two further groups: the sporting and animal painters already touched upon, and the long line of topo-graphical draughtsmen of which the Bohemian, Wenceslaus Hollar (1607–1677), appears to have been the first. The former, from Barlow onwards, although landscape was but a secondary interest with them, often represented it with insight and skill, while the latter, limited though their aim was, by their capable objective treatment not only stimulated a taste for landscape

but explored the technical means whereby it might best be satisfied. It is evident then that by the time Wilson started on his career much had already been done towards establishing a tradition of landscape painting in England. But while both the sporting and animal painters and the topographical draughtsmen and engravers (especially when they portrayed romantic foreign scenes) found ready employment, those whose province was the poetry of landscape found it hard to make a living. Wilson suffered dire poverty until the end of his life; Gainsborough was compelled to paint portraits that he might have leisure to devote himself to landscape. The artists were there; only enlightened patronage was wanting.

Richard Wilson was born on August 1, 1714, at Penegoes, Montgomeryshire, where his father held the living. With the assistance of a relative of his mother, Sir George Wynne, he was sent to London in 1729 to study with an obscure painter of portraits, Thomas Wright. In 1750 he went to Italy, where he remained for six years. It was long and persistently repeated that Wilson practised only portraiture prior to his Italian sojourn and only landscape afterwards. There is now sufficient evidence that he was a landscape painter of ability and reputation before his visit to Italy, and that he painted occasional portraits after his return. On April 8, 1747, three years before Wilson left England, was published an engraving by John Sebastian Muller of a notable landscape by him, *A View of Dover,* in the National Museum of Wales. This work, while inferior to those of the artist's maturity, can hardly be the first essay of a novice. Furthermore, an official record exists of the thanks tendered to him by the Governor of the Foundling Hospital in the winter of 1746 for the two small landscapes which he presented to that institution. Of the portraits he painted after his return from Italy the *Lord Egremont* of about 1757, in the Dulwich Gallery, is a characteristic example. In Italy Wilson's landscapes won him a great reputation. Not only did the brilliantly successful Zuccarelli admire him, but Joseph Vernet and Antonio Raphael Mengs were quick to recognize in his art an expression of the antique spirit which it was

their own ambition to recapture. Vernet exchanged pictures with him, and keeping Wilson's in his studio, he used to show it to English visitors who praised his own work, saying, "Don't talk of my landscapes when you have so clever a fellow in your countryman Wilson"; while Mengs painted a portrait of him, and exchanged it for one of his landscapes. Wilson left Rome in 1755 and probably reached England in the following year. His Roman reputation had preceded him hither, and his return excited interest but little sympathy among his brother artists. When the Royal Academy was established, however, he was nominated as one of its foundation members. In spite of his fame, which the pictures he exhibited in London upheld, he found increasing difficulty in earning a livelihood. Even Reynolds neglected him, a fact which Hoppner attributed to jealousy. His poverty provoked him on one occasion to inquire of Barry whether he knew anyone mad enough to employ a landscape painter. His appointment in 1776 to succeed Francis Hayman as Librarian to the Academy ensured him a small income. Suffering neglect and humiliation, he returned to Wales in 1781 and died at a relative's house, Colomendy Hall, near Llanberis, on May 12 of the following year.

It is strange that Wilson, so famous in his own day, revered by his great successors in the art of landscape painting, should have become, soon after the generation which knew him passed away, a mysterious, almost a legendary figure. It was forty-two years after his death when his first biography was published, and the paucity of facts it contains shows how far his memory had sunk into oblivion. To-day, while it is generally conceded that he was a great landscape painter, there is little agreement as to his merits, defects, and his relative importance. A French critic complains that he is too classical and too Italian, a distinguished German dismisses him as an imitative poet, and a recent English biographer links him with Hogarth and the Dutch realists. The principal point of controversy turns upon the question as to whether Wilson falls within the latin or the germanic orbit, whether, in short, he was a successor of Claude or a northern realist.

It seems to the present writer that Wilson possessed that which is not commonly found in northern Europe, namely, a classical temperament. But the balance and the sense of fitness which belong to the classical temperament prevented his forgetting, even while he worshipped at Claude's shrine in Italy, that he himself was the inheritor of the romantic and realistic tradition of the north. How deeply this had entered into him is especially apparent in his portraits, in those he painted after his sojourn in Italy as well as those he did before his departure. The northern tradition, the tradition of the Dutch landscape painters in particular, could hardly manifest itself more plainly than it does in his English and Welsh landscapes. And one of the chief lessons he learnt from Claude, the ability to portray light and to render distance in terms of atmosphere, enhanced the northern quality of his art; for light and atmosphere were becoming the principal concern of northern painters. To Wilson, however, belonged the fundamental attributes of the classical artist, the detachment, the serenity, the preoccupation with the typical rather than the characteristic. Without the sacrifice of the specifically English outlook he had inherited, Wilson was able to give full expression to his fundamentally classical temperament. It was this eclectic quality in him, this balance, that caused his work to appear commonplace to all but the most discerning of his countrymen. The work of an outright disciple either of Claude or of Ruysdael they would have understood, but he who was capable of classical expression in English form is to this day not sufficiently admired. Wilson painted many landscapes which are mere pastiches of Claude and even of such minor classicists as Vernet, but at his best, in such works as *The Thames at Twickenham* and the *Cader Idris,* at the National Gallery, *The Tiber*, in the collection of Mrs. Richard Ford, *Croome Court, near Worcester,* in the possession of the Croome Estate trustees, and *The River Dee* at the Barber Institute, Birmingham, he achieves a serene grandeur of design, a spaciousness and a tender, glowing luminosity which place him among the masters of landscape.

The influence exerted by Wilson on his successors in the

field of landscape was considerable, but his own pupils appear to have learnt little from him save his mannerisms. The best remembered among those directly subject to his teaching was Joseph Farington (1747–1821), a stylish but superficial artist; a member of the ancient family of ffarington, who wielded almost dictatorial power in the Academy. He entered Wilson's studio at the age of sixteen, and to the end of his life he remained devoted to his master's memory. He did little painting, but confined himself to topographical drawings in pen and wash. Now and again, in such drawings as *Landscape with Horsemen*, at the British Museum, he shows real talent. But Farington is important less for his work as an artist than as the author of the great " Diary " he began after a visit to Horace Walpole, his cousin by marriage, at Strawberry Hill, on July 13, 1793; for therein is an incomparable record of the artistic life of his times.

After Wilson the next great figure in English landscape is Gainsborough, whose portraits have been discussed in an earlier chapter. His passion for landscape showed itself even in his childhood. "There was not a picturesque clump of trees," he said, " nor even a single tree of any beauty, no, nor hedgerow, stem or post in or around my native town that I did not treasure in my memory from my earliest years." In the *Cornard Wood*, at the National Gallery, completed in about his twenty-first year, he already showed mastery. For this picture, as for all his early landscapes, he took as his masters Jan Wynants and other minor Dutchmen, whose works were not uncommon in the eastern counties. In 1760 Gainsborough removed to Bath, and his change of domicile was accompanied by a change in the character of his work. The accuracy and minuteness the Dutchmen had taught him gave way before a broader, more generalized way of seeing which he learnt from Rubens, with some of whose works he now became familiar, and his brushwork grew swifter and lighter. Even at the height of his success as a portrait painter he was able to sell but few of his landscapes, and when he died his house was stacked with them. Thus he was never able to

fulfil his desire to devote himself entirely to landscape. Never-theless, he too ranks with the great landscape painters. In temperament he was the very antithesis of Wilson. Wilson saw grandly, Gainsborough with a touching intimacy. Wilson was largely inspired by an ideal and Gainborough by a local con-ception of landscape: Wilson therefore could have depicted any scenery, while Gainsborough, exiled from southern England, would have felt himself an alien even in Holland. But perhaps the most radical difference between them was that whereas Wilson was almost scientific in his detachment, Gainsborough was spontaneous and instinctive. The contrast between these two affords a curiously close parallel to that between their, as landscape painters, still greater successors, Turner and Constable. Gainsborough was no less lovely a colourist in his landscape than in his portraiture (Reynolds declared him to be the greatest since Rubens), but his compositions were apt to lack coherence, and the emphasis upon his central motive was often disproportionate. This defect was due perhaps to the habit of vision acquired in the painting of portraits, but his sensitive and exquisite canvases are able to stir the emotions deeply. " On looking at them," said Constable, " we find tears in our eyes and know not what brings them."

With Gainsborough may be mentioned two lesser figures, George Morland (1763–1804) and Thomas Barker of Bath (1769–1847). Morland, the erratic son of the respectable painter Henry Robert Morland (1730?–1797), who painted attractive pictures of laundry girls, was a gifted and prolific artist. His most important works were rustic figures in landscape, painted partly in the tradition of Gainsborough, partly in that of the sporting and animal painters; but although he was a talented designer with a fine sense of colour, many of his works are marred by careless execution. Barker was a forceful but imitative painter of rustic subjects, whose *Clover Field with Figures* at the Tate Gallery is perhaps his most successful work. Both Morland and Barker sentimentalized Gainsborough.

We have now to consider the great provincial painter John Crome. The son of a poor weaver, he was born on December 22, 1768, in a small public-house in Norwich. At twelve he was an errand boy; at fifteen he was apprenticed to one Francis Whistler, a house, coach and sign painter. He is known to have painted three inn signs, "The Two Brewers," "The Guardian Angel" and "The Sawyers," two of which were recently in existence. He early began to paint landscapes in his spare time, and his progress was hastened through his friendship with Thomas Harvey of Catton, who allowed the boy access to his collection, which included Gainsborough's *Cottage Door* (of which he made a copy), a Hobbema and probably some Wilsons. Harvey also set him up as a drawing master. Crome gave his instruction out of doors, although he painted in his studio. He taught well and his landscapes found many admirers in and around his native city, whereby he attained a moderate prosperity. The two outstanding events of his life were his foundation of the Norwich Society in February, 1803, of which he became president in 1808, which marked the birth of the Norwich school, and his visit to France in 1814. He died suddenly on April 22, 1821. "John, my boy," he said to his son at the last, "paint, but paint for fame; and if your subject is only a pigsty, dignify it."

Old Crome himself had always been faithful to this precept. His predecessors often portrayed grand subjects grandly and humble ones in a trivial spirit, but whatever Crome's subject he endowed it with the same breadth and dignity. Crome's art, like Gainsborough's, was inspired first of all by his own locality; indeed, throughout his life he retained an almost exclusive devotion to Norwich and its neighbourhood. He rarely painted elsewhere and showed only eighteen pictures in London. This intense local sentiment has led to some misconception as to the sources of his art, for it has given rise to the legend that Crome lived and worked in isolation from his English contemporaries, and that he had little in common with them beyond an admiration for the landscape painters of Holland. A German

scholar with a world reputation has even suggested that Crome never left Norwich and was ignorant of the very names of Turner, Gainsborough and Wilson. We know, however, from a letter written by one of his patrons, Dawson Turner, that the *Scene on the River at Norwich* in his collection was painted by Crome "with his whole soul full of admiration at the effects of light and shade, and poetic feeling and grandeur of conception, displayed in Turner's landscapes at the Academy." Mention has already been made of his copy of Gainsborough's *Cottage Door*; and two paintings belonging to the years 1796 and 1798 described as "compositions in the style of Richard Wilson" were included in the exhibition of Crome's works held shortly after his death.

The special love Crome bore for Norfolk and his deep understanding of its particular beauties coupled with an exceptional independence of outlook and want of academic training give his work a provincial stamp. But to insist overmuch on this is misleading. For to Crome's painting belong certain qualities— atmospheric unity and simplicity of design comprehending both earth and sky—which could best be learnt from his English contemporaries in general and from Wilson in particular, and which give him a place in the great central stream of English landscape painting. That these qualities were consciously striven for, is evident from the often-quoted letter he addressed to his pupil, James Stark, in 1816. " Brea(d)th must be attended to, if you paint. . . . Your doing the same by the sky, making parts broad and of a good shape, that they may come in with your composition, forming one grand plan with the light and shade, this must always please a good eye. . . . Trifles in nature must be overlooked that we may have our feelings raised by seeing the whole picture at a glance." The holder of such convictions as these was removed from the Dutchmen with their clear, meticulous vision and their insistence on detail, though for several of them, notably Hobbema, whose name was on his lips in his last hours, Crome felt little short of veneration. But his English affinities were stronger still: from Gainsborough he gained confidence to devote himself wholly to workaday themes, while Wilson taught him how to design

broadly and to unite the various parts of his design in a glowing envelope of atmosphere.

Compared with both Wilson and Gainsborough, Crome was a realist. When we are under the spell of the landscape of Crome, so large, so robust, so closely observed, that of Wilson is inclined to have the look of conventional generalization, and that of Gainsborough, more especially in its later and most personal phase, of summary elegance. In his most celebrated picture, *Mousehold Heath*, of 1815, Crome created out of the simplest materials a work of extraordinary nobility and spaciousness. In *The Poringland Oak*, of 1818, he has achieved a synthesis of intricate detail with sinewy power. In the earlier *Moonrise on the Marshes of the Yare*, at the Tate Gallery, he rendered, again with the simplest material, the majesty of moonlit mill and river. To claim for Crome that he added the comprehensiveness which the tradition of Hobbema and Ruysdael needed in order to fulfil itself, that he completed what the Dutchman had begun, is not to rate his achievement too high. His son, John Bernay Crome (1793–1842), sought with modest success to carry on his father's tradition. The same is also true of James Stark (1794–1859), another Norwich artist and a student of the elder Crome.

We have now to speak of two figures generally held to be the supreme landscape painters of their age, Constable and Turner. Although Constable was the junior by a year and only began to exhibit when Turner was already a full member of the Academy, his work will be considered before that of the other, for in spite of its originality it was intimately linked with that of Crome, Gainsborough and the Dutchmen, while Turner's was an almost isolated phenomenon, and, in spite of its at times avowedly emulative character, singularly free from traditional ties.

John Constable was born at East Bergholt, Suffolk, on June 11, 1776, the son of a prosperous miller. He early received encouragement in his ambition to paint from that enlightened patron but indifferent artist, Sir George Beaumont (1753–1827), who lent him water-colour drawings by Girtin and his favourite Claude to copy. In 1795 he came to London to study, but shortly

afterwards returned to assist his father in his business, and it was not until 1799 that he was admitted to the Academy Schools. Three years later he exhibited his first landscape at the Academy, and thereafter, except for painting two altar-pieces for the Suffolk churches of Brantham and Nayland, in 1804 and 1809 respectively, and a few portraits, he devoted himself entirely to landscape. His life was almost as devoid of incident as Crome's. His work commanded respect rather than popularity, nor was it until his sensational success at the Paris Salon of 1824 that he attracted any considerable notice in England. He was fifty-three before he was elected to full membership of the Academy, when he felt that the honour had come too late; Lawrence, however, informed him that he ought to be grateful at having been elected at all. He died suddenly on March 30, 1837, at Hampstead.

Constable took up the realistic tradition where Crome had left it. Like Crome he was inspired, not as Blake was by a " spirit and a vision," but by his native country, on the banks of the Stour. " These scenes made me a painter and I am grateful," he wrote to his friend, John Fisher, " that is, I had often thought of pictures of them before I had ever touched a pencil." With Constable the subject came first; the rest followed. In the celebrated letter to James Stark, Crome referred to the importance of being able to see the whole of a picture at a glance, and he went far towards achieving his ideal unity; but it remained for Constable to realize it fully. Whereas in his search for harmonious design Crome subordinated inessential objects, Constable went farther and made a discovery which radically modified the vision of the century. Instead of consciously subordinating the inessential he accepted the data of vision without putting upon them the interpretations which are necessary for the conduct of everyday life. He looked at nature, as it were, with the eyes of a newly awakened sleeper, innocently, and saw not *obiects* but *forms*; he had the originality and the courage to discard his knowledge of conventional shapes and utilitarian significance of things and to place his faith in his eyes alone. Here was an epoch-making departure, for although Constable himself used

it to give a supremely convincing interpretation of the visible world, this innovation of his, with its tendency to disregard, for pictorial purposes, the conventional significance of things, may be said to have pointed the way, not only towards the almost purely retinal art of the Impressionists, but even towards the abstract art of the present century. Audacious too were his innovations in the realm of colour. He approached more closely than anyone before him to the actual green of fields and the blue of skies. This he did without any corresponding lightening of his shadows; so he had an unprecedented range of tones at his command. Lastly, Constable was richly endowed with the rare and elusive power of life and movement to the children of his creation: his trees grow; the leaves thereon are stirred by breezes; his streams meander along lapping gently against their banks or flow noisily over mill-dams; his grass, wet from the rain, is miraculously transformed as shafts of silvery light pierce a darkened heaven.

Joseph Mallord William Turner was born on April 23, 1775, at 26 Maiden Lane, London, the son of a barber, in the window of whose shop his work was first exhibited. Turner began to draw as a child: his earliest surviving essay is a study of *Margate Church*, made when he was nine years old, while there are two capable water-colours in the National Collections done in his thirteenth year. In 1789 he entered the Academy Schools, and thereafter was a regular exhibitor. It was in 1791 that he made what was probably the first of his numerous and extensive tours, during which he was used to fill sketch-books and the chambers of his incomparably retentive mind. He also studied for a short time in the studio of Reynolds. A more important influence was that of Dr. Thomas Monro (1759–1833), the enlightened amateur and friend of artists, into whose hospitable house he was welcomed in 1793. Hitherto Turner had imitated the topographical draughtsmen, men such as Malton (with whom he studied for a time) and Dayes; but at Dr. Munro's his eyes were opened to the poetry as distinct from the prose of landscape. He copied Wilson, Gainsborough and J. R. Cozens, generally in a monochrome wash, and studied Claude, the Poussins, Salvator Rosa,

Van de Velde and Morland. It was at Dr. Monro's also that he made friends with Girtin and became familiar with the work of the chief water-colourists of the day. Girtin's water-colours have breadth of treatment and a strength of tone, qualities which alone enabled works in this medium to hold their own with oils, among which, in those days, they were hung at the Academy exhibitions. Turner owed to this friend of his boyhood more, perhaps, than to any other of the legion whom at one time and another he sought to emulate. By 1802, when he was twenty-seven, he was a full member of the Academy and a respected member of his profession.

Like Rembrandt, Corot, Constable and many besides, Turner's development was from a sharply defined to an amospheric view of things, and from a tight to a loose, free manner of handling. But although the general direction of his development is clear, it is difficult to trace in detail. His desire to surpass other painters, predecessors and contemporaries alike, and to assimilate their every excellency, led him to imitate many; he would seek, for instance, to rival Claude and Wilkie at one and the same time. Those of his works, however, which belong to the closing years of the eighteenth and the opening years of the nineteenth centuries are grand and somewhat melancholy in feeling. The finest of them is the *Calais Pier*, of 1802, at the Tate Gallery. For majesty and dramatic force and for the skill in draughtsmanship and composition it is an astonishing achievement for an artist in his twenties. In his knowledge of the sea, of the forms of waves and the intricacies of shipping he far surpassed his teachers, the Dutch marine painters. In the superb *Garden of the Hesperides*, of 1806, at the Tate, he makes myth as convincing as fact. Towards 1805 he forsook the splendours of Claudian landscape and for a short time identified himself with the English pastoral painters. A mood of Wordsworthian quietism succeeded his earlier Byronic romanticism, and inspired the *Frosty Morning*, of about 1813, at the National Gallery. Here, intimate and human, he draws near to Crome. But again, with *Crossing the Brook* and *Dido building Carthage* (both painted

TURNER : *Norham Castle. Sunrise.* After 1833
Canvas.—Tate Gallery

in 1815, and also at the National Gallery), he returned to Claude.

Turner's first visit to Italy, in 1819, presaged an important change in the character of his art: for from that time forward he gave increasing attention to the problems of illumination, his tones became lighter, his forms more aerial. In his old age he moved into a luminous enchanted solitude where his main concern was the creation of works in which colour infinitely transcended form. Of the pictures of his last phase, with a few exceptions, the most magical are the pure chromatic fantasies which he never exhibited. These, of which the Tate's *Norham Castle* is a lovely and characteristic example, are almost as abstract as music, yet their seemingly vague and tentative allusions to specific forms assume, beneath our wondering gaze, the character of flashes of piercing insight into the very essence of nature.

Although he enjoyed prodigious fame from the very outset of his long career and only a century has passed since he died, little is known about his life and character. For his was a fiercely secretive nature, and he passed much time among a class which leaves few traces. During his last years he concealed his whereabouts even from his housekeeper. On December 18, 1851, he was discovered dying in a small house in Chelsea, where he had been living with a certain Sophia Caroline Booth, under an assumed name. He was buried on the 30th of the same month in St. Paul's. He bequeathed to the nation a great collection of his finest pictures, for which he had refused vast sums.

Not even now has his place as an artist been finally determined. One of the most widely known critics of his day, Meier-Graefe, has expended much learning and eloquence in an attempt to show that Turner was simply an eccentric and his achievement burlesque. The present writer is in agreement rather with those who hold Turner to be the supreme painter of landscape: to him Turner's interpretation of the face of nature seems to transcend that of others in the same degree as Rembrandt's interpretation of the face of man. And, like Rembrandt, Turner had the universality

by which the supreme artist is distinguished. Compared with him even Constable was parochial; but if Turner's spirit was at home in a vast and solitary universe, he could also render the local and the intimate, as the *Frosty Morning* shows, with the insight of a Crome. Both for innate genius and for industry he has rarely been surpassed.

Constable, a revolutionary with his feet planted firmly in tradition, was able by the changes he brought about to exercise a fruitful influence from the first. Delacroix greatly admired him, and, as is well known, repainted the background of his *Massacre of Scio* after he had seen *The Hay Wain*, now at the National Gallery, at the Salon of 1824, and the great landscape painters of the century—Corot, Rousseau and Monet—were all in his debt. The subjectivity of Turner's vision, on the other hand, precluded his logical relation to the realistic tradition, except in so far as he played a part in the long struggle of European artists to render light in closer accord with the facts of vision. If he was deeply preoccupied by the problems of light, his interest, unlike that of many other landscape painters from Crome to the Impressionists, was not scientific. Light was the medium in which his inner vision found its most natural expression: he desired not so much to imitate light as to create it. Although his participation in the movement was in a measure fortuitous, some of his successors owed him a far from negligible debt, which the leading Impressionists—Monet, Renoir, Pissarro and Sisley among them—handsomely acknowledged. In a letter to Sir Coutts Lindsay, after stating that their aim is " to bring back to art the scrupulously exact observation of nature, applying themselves with passion to the rendering of form in movement as well as the fugitive phenomena of light," they declare that they " cannot forget that they have been preceded in this part by a great master of the English school, the illustrious Turner." Yet it would be true to say that to-day Constable's reputation stands higher than Turner's. That this should be so is due partly to the generous recognition of Constable's genius by the French, whose dominance of the art world only now begins

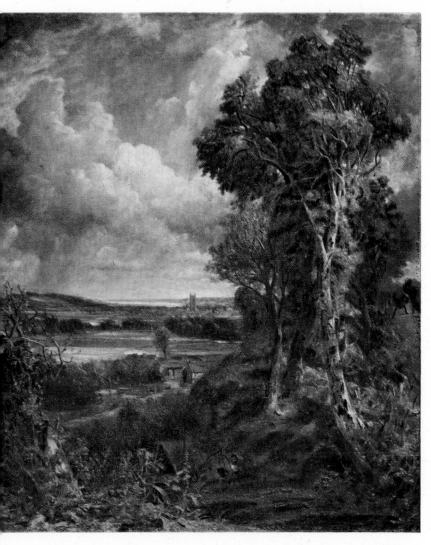

CONSTABLE : *Dedham Vale.* 1828
Canvas.—National Gallery of Scotland

to diminish, but even more to the defence of Turner by John Ruskin (1819–1900), the most inspired and influential art critic of the age. It is paradoxical that because a supreme landscape painter moved such a critic to sing his praises with incomparable eloquence, his reputation should have suffered grievously. But though few deny his greatness, Ruskin—his outlook, character and indeed his very eloquence—is out of harmony in a particular degree with the criticism of to-day. For some years, however, there have been signs of a revived interest in his ideas and a heightened admiration for his prose style.

THE PAINTERS IN WATER-COLOUR

AS earlier noted, during the reign of Charles I Hollar produced wash drawings of places of interest in the British Isles, and he was followed by various native imitators. Two early landscape painters in oil, Monamy and Scott, of whom mention has been made in the preceding chapter, also worked in water-colour. Wilson appears to have used oil paint only, but there are a few water-colours by Gainsborough at the British Museum. A characteristic pioneer water-colour painter was Paul Sandby (1725–1809), who took Wilson and Gainsborough for his models, but his own art was of a far less ambitious order. His outlook was lively and urbane, he was a skilful and accurate draughtsman and an indefatigable traveller; moreover, he possessed a peculiar and delightful vivacity, but for all that he was hardly more than a topographer of talent. With him was associated his brother, Thomas Sandby (1721–1798). These two were followed by a generation of gifted topographers, of whom the most notable were Francis Towne (1740–1816), William Pars (1742–1782), Thomas Hearne (1744–1817), Thomas Malton (1748–1804) and Edward Dayes (1763–1804). The work of these men at its best displays grace and freshness, but its place is a less exalted one than that which several of our own art historians have accorded to it. It is often incorrectly asserted first of all that the work of these English topographers was unique; secondly, that from it sprang the great art of Girtin and Turner. Work of a very similar kind was, in fact, being produced in Holland by such men as Paulus van Liender (1731–1797) and Wybrand Hendricks (1744–1831); and, if Girtin and Turner owed much to the topographers, their debt to the classical landscape painting of the Continent was even greater. The classical spirit of Claude and the Poussins began to permeate the world of English art more and more completely as the eighteenth century passed its

turn, finding its earliest expression in the work of a father and son of singular genius, Alexander and John Robert Cozens. Alexander (c. 1717–1786), erroneously reputed to have been the illegitimate son of Peter the Great and an Englishwoman from Deptford, was born in Russia. After studying painting in Italy he settled, about 1742, in London. He does not appear to have been a prolific artist, and spent much of his time teaching drawing, and writing. His books "The Shape, Skeleton and Foliage of Trees" published in 1771 and "The Principles of Beauty, relative to the Human Head" in 1778, are ingenious rather than profound. But such drawings as he has left behind him—the greater number being in monochrome wash—show that he was a designer of consummate skill, with a rare understanding of both light and space. In complete contrast to that of the topographers, the landscape of the elder Cozens was as a rule devoid of detail and of a highly generalized, indeed at times of an almost abstract order.

John Robert Cozens (c. 1752–1797), his son, was a no-less-considerable artist. Starting with the inestimable advantage of the training of his father, he was able to carry the same serene, classical tradition a further stage towards perfection. He began exhibiting in 1767, when he was fifteen, and nine years later sent his single exhibit to the Academy, Hannibal, in his March over the Alps, showing his Army the Fertile Plains of Italy, which has now disappeared and which Turner declared to have taught him more than any other picture. In 1794 his mind became deranged, and three years later death closed the career of one whom Constable called "the greatest genius that ever touched landscape." The younger Cozens lacked the audacity of his father, but far exceeded him in subtlety. And in giving complete expression to a sublime but somewhat rarefied vision he used the simplest of means. Of his Isle of Elba, at the Victoria and Albert, A. J. Finberg wrote "there seems no composition, no design, no colour in it. Only, as one looks at it, the terrible overpowering impression of natural forces steals over one." The incredible disparity between the means employed and the result attained is the most significant feature of Cozens's art

and perhaps the secret of his elusive charm. Both the realistic tradition, deriving originally from the Netherlands, and the classical tradition of Claude, the one through the topographical draughtsmen and the other chiefly through the two Cozens, were now established in England, and it remained, therefore, for the two greatest of the younger water-colour painters to synthesize them, to bring, that is to say, new elements of life and colour to the classical and a new poetry and quality of design to the topographical tradition.

Thomas Girtin, the son of a brushmaker, was born at Southwark, probably on February 18, 1775. His death in youth, Turner's admiration for him, his attractive character and above all the dazzling quality of his genius have made him an almost mythical figure. The audacious but fitful quality of Girtin's art reflected his generous and impulsive character, and though many of his studies surpass Turner's in brilliance, a shrewd observer could have perceived that Turner had the greater potentiality for growth. For when Girtin was inspired he soared, but when inspiration failed (as it often did) he fell heavily to earth; the persistent and calculating Turner, on the other hand, hourly disciplined his no less egregious powers, and moved forward without faltering. And though Girtin sometimes outshone Turner, who declared him to have been his master, there is a gulf between the spacious and noble but finite genius of Girtin and the vaulting genius of Turner. In grasp of structure in particular, Girtin was inferior to Turner, who significantly declared that had he had to begin life over again he would have been an architect. And this strong architectural sense accounts not only for his power of rendering buildings, but for his mastery of composition. For Girtin has been claimed the dubious credit of being the first to make water-colour compete with oil, when in fact various members of the Swiss school, notably Pierre Ducros (1748–1810), had done so much earlier, and their example had caused several English painters in the same medium, such as George Robertson (c. 1742–1788), to seek to do likewise. But neither the excessive claims of Girtin's advocates, nor their

invidious comparisons of his achievement with Turner's, should impair our veneration for a man who in so short a life (he died in 1802) produced works of an audacity, freshness, breadth of design and above all a peculiar nobility which entitle them to a unique place in English art.

Turner carried yet farther the attempt to endow water-colour with the qualities of oil; later in life, as a distinguished critic has observed, he reversed the process, and sought to endow his oil painting with the qualities proper to water-colour.

The next water-colour painter of the first importance was John Sell Cotman. Born at Norwich, the son of a silk mercer, on May 16, 1782, he early removed to London and entered the circle of Dr. Monro. In 1807 he returned to his native city and joined the Norwich Society of Artists, becoming its president in 1811. In addition to painting in both oil and water-colour he was much occupied with teaching. From 1812 until 1823 he lived at Yarmouth. In company with his patron, the antiquary Dawson Turner, he paid three visits to France in connexion with their joint publication, " Architectural Antiquities of Normandy," which appeared in 1822. Cotman's work made so slight an appeal to the public that he was constantly and sorely afflicted by poverty; and it was in order to afford him some relief that Turner used his influence to get him appointed, in 1834, drawing master at King's College, where Dante Gabriel Rossetti was his pupil. He died ten years later in London. Cotman at his best occupies a special place among water-colour painters as master of deceptively simple yet magnificent design; his gravity and reticence make many Turners appear garish and theatrical by comparison, nor was he beguiled, as Turner was so often, into display of virtuosity for its own sake. His art has two distinct aspects. At times, fascinated by his subject, he would render it humbly in a minute, almost literal fashion. The drawing of *Croyland Abbey*, at Leeds Art Gallery, shows him in just such a mood. At others, nature gave him little but the raw material for the expression of his inner vision; and it was then, when he imposed himself on nature rather than submitted

to her dictation, in such works at *Greta Bridge*, of about 1806, the somewhat later *Duncombe Park*, both at the British Museum, and the *Ploughed Field*, of about 1812, also at Leeds, that he achieved his greatest successes. He also carried out important works in oils, such as *Fishing Boats off Yarmouth*, done when he was living at the port, the *Waterfall*, of about 1815, and *The Baggage Waggon*, of about 1828, both at the Norwich Castle Museum. But there were times when Cotman fell immeasurably below the level of such accomplishments. Few artists have been more seared by the poverty that has beset so many of their number. There is no more pathetic document in the annals of the English artists than the letter Cotman wrote in June 1829, declining an invitation from a friend: " My views on life are so completely blasted, that I sink under the repeated and constant exertions of body and mind. . . . My eldest son, who is following the same miserable profession with myself, feels the same hopelessness; and his powers, once so promising, are evidently paralysed, and his health and spirits gone. . . . I leave you to suppose how impossible it must be to feel one joy divided from them (i.e. his wife and children). I watch them, and they me, narrowly; and I see enough to make me broken-hearted." And under the stress of poverty he produced work that is nerveless and thin, sometimes, too, garish and shrill in colour, in the pathetic hope of emulating Turner and thereby winning Turner's popularity.

Cotman was the last born of the great water-colourists. The tradition, however, was not lost, but continued to find expression in the work of a succession of excellent artists. Of these Samuel Prout (1783–1852) is typical, a sound and accurate but somewhat pedestrian draughtsman. He won the admiration of Ruskin: " There is *no* stone drawing, *no* vitality of architecture like Prout's," he surprisingly declared. Another, David Cox (1783–1859), was of a like pedestrian temperament, but was capable of greater simplicity and charm and endowed with a subtler sense of colour. But sincere as they are there is something wanting in even the best of his works. Perhaps, as Finberg contended, it is because " they seem to want focus, emphasis, some note of insistence

to show that the man was keenly interested in something beyond the production of average, marketable drawings." A somewhat bolder figure was Peter De Wint (1784–1849). Like Cox he owed much to Girtin, whose influence is evident in his best works, such, for example, as *Bray on the Thames, from the Towing Path*, at the Victoria and Albert. A talented, but slight and superficial member of the same generation was Anthony Vandyke Copley Fielding (1787–1855).

Possessed of perseverance and sensibility, William Henry Hunt (1790–1864) produced a number of water-colours of especial interest. His health being too feeble to allow of his attempting landscape with any prospect of success, he turned his attention to flower painting. But he was slow in execution and the flowers faded too quickly for him; ultimately therefore he devoted himself to the rendering of fruit and vegetables. Concentration upon a limited field of activity so developed his acute powers of observation that he was able to produce work of the rarest delicacy and insight. In marked contrast to Hunt was his contemporary, Clarkson Stanfield (1793–1867), a vigorous and capable but uninspired painter of sea- and landscapes, who after starting life in the merchant service and being pressed into the Navy began his career as an artist by designing scenery at a sailors' theatre in the East End of London. Two other competent painters in water-colour were the elegant but derivative James Duffield Harding (1797–1863) and John Frederick Lewis (1805–1876), a close and original student of natural detail, who also painted in oil with extraordinary distinction. The best of his works in this medium is perhaps the *Lilium Auratum*, at the Birmingham Gallery, a romantic and luxurious work of singular perfection.

A water-colour painter of European importance was Richard Parkes Bonington (1801–1828). Born in Nottingham, he was taken at an early age to Calais, where he studied with the Anglo-French painter, Louis Francia (1772–1839), from whom he imbibed the best traditions of English water-colour. From Calais Bonington proceeded to Paris, entered the studio of Baron

Gros and became an intimate friend of Delacroix. In 1825 the two artists visited London together, and remained closely associated after their return to Paris. Bonington died at the age of twenty-seven, but such was the freshness and originality of his vision and such his skill that he was able, in a working life that scarcely amounted to more than eight years, to impress the romantic painters of France and thus to prepare them to receive the richly fertilizing influence of the English school, of Gainsborough, Crome, Constable and the painters in water-colour. William James Müller (1812–1845), showed Bonington's extraordinary facility, but lacked his distinction, more especially his exquisite sense of colour, and his poetry often dwindles into melodrama.

Two painters in water-colour whose art represents a tradition, deriving not like that of the others from the Cozenses and Paul Sandby, but from Hogarth, must also be mentioned. These are Thomas Rowlandson (1756–1827), and a lesser and later man, Randolph Caldecott (1846–1886). Their art is concerned rather with man than his environment. Rowlandson's was a virile and somewhat Rabelaisian outlook, and he has left a rich and boisterous and yet an almost tenderly comprehending picture of the world of his day, of the country fair and the tavern, the crooked city street and the stable. The forms which his bistre outlines confine are broad and summary; his colour of a rare delicacy. The large *Brook Green Fair*, at the Victoria and Albert, is a typical example of the best work of Rowlandson's maturity. With Caldecott the rich tradition of Hogarth and the animal and sporting painters by whom he was much influenced became attenuated. But his works are instinct with humour and a refined bucolic charm, and here and there, especially in his less highly finished works, his affinities with his great predecessors are evident in a certain robustness and energy.

Before the middle of the nineteenth century the creative impulse in English painting showed symptoms of decline in which the art of water-colour shared. It was revived, however, later in the century by contact with French Impressionism, which

itself owed a great debt to the earlier English landscape painters and to Constable especially.

For a time, although many gifted painters made use of water-colour, it fell from its former high estate. The tradition, however, was too deep-rooted to perish; indeed, water-colour has proved a felicitous medium for the expression of the English temperament. The reason for this is to be found first of all in the national predilection for intimacy, modesty, prettiness and a certain informality, which are particularly susceptible of expression in water-colour; secondly, in the nature of the English pictorial tradition itself. For its obstinately individualistic temper resisted even the brilliantly directed efforts of Reynolds to establish a genuine academic tradition, and the history of English painting is the history of rare and lonely giants unsustained by the continuous flow of highly schooled talent which was so fruitful a feature of the great Continental schools. And an academic tradition firmly based upon a widely accepted canon, and thereby permitting every artist to make the fullest use of the knowledge his predecessors have acquired, is a necessity if so complex an art as that of oil-painting is to flourish continuously. But English artists have expressed themselves in water-colour spontaneously ever since, early in the eighteenth century, this medium became familiar to them.

STEVENS AND WATTS

PRIOR to the Reformation the dominant power in Europe was the Church, whose formidable task it was to make her doctrines understood in a divided and all but illiterate Christendom. Her success was rendered possible by the co-operation of the artist, who evolved a symbolism intelligible to all Christians, irrespective of nationality or class. After the Reformation, monarchs supplanted churchmen as the determining force in politics, and the artist, whose function it became to advertise the benefits and the grandeur of monarchy as formerly of theocracy, had now to appeal not to Christendom but the nation. And when next the aristocracy called upon him to exalt its virtues the artist made a yet more exclusive appeal, for his public had become a single class. The Industrial Revolution went far towards completing what the Reformation had begun. The industrialists and merchants whom it placed in the ascendant regarded the artist's works with disapproval as futile, if not pernicious, distractions likely to interrupt the grim tasks of production and distribution. During the period which began with the Reformation and ended with the Industrial Revolution, art lost by progressive stages the wholly public character which had belonged to it in mediæval times. The Industrial Revolution destroyed the political power of the only class then capable of intelligent patronage of art—the aristocracy—and the change from public to esoteric art was complete. For the artist, bereft of patronage, was for the first time in history thrown entirely upon his own resources. The age-long balance between the claims of social function, utility and of formal perfection was upset, and the artist, divested of social responsibility, became an experimenter in self-expression and pure æsthetics.

Now, although the Renaissance—the rebirth of classicism— impaired the public character of art, tending to make it the

possession of the classically educated few rather than the whole of society, classical art, nevertheless, is fundamentally public art. The art of the Renaissance owed its somewhat exclusive character to the fact that it was to so large an extent inspired by scholars steeped in long-dead languages and cultures, but the classical spirit has always been averse to artistic exclusiveness, more especially to the exclusiveness which arises from a pronouncedly personal, subjective outlook, independent of a traditional, objective canon, the sole aim of which is the satisfaction either of the artist himself or of a coterie. From time to time, therefore, we find classical artists making a conscious attempt to arrest the ever-increasing subjective and individualistic trend of European art. The most effective of these was the Frenchman David, under whose guidance the forces of classicism once again temporarily asserted themselves, and a public objective art was established at the point of the sword. Predominantly romantic as they were, the English painters of " history " also sought to restore to art its public character; but the efforts of all these were insufficient to arrest the prevailing tendencies. In England, at the beginning of the nineteenth century the spirit of individualism, so profoundly in harmony with the national character, was already nearing its zenith. None of her great artists was speaking in a common idiom. Crome and Constable were inspired not by the typical but the characteristic; Turner was becoming almost wholly subjective, while Blake rejected even the intellectual groundwork that the others, tacitly at any rate, accepted and, creating for himself a new mythology, gave birth to an art the meaning of which the efforts of several score of scholars have scarcely yet made clear. The separation of the artist from society, although not yet complete, had gone far enough to provoke a reaction, which found its weightiest expression in the work of Alfred Stevens and George Frederick Watts. These two had little in common save a desire to restore to art something of its public character.

Stevens was born at Blandford, in Dorset, and baptized on January 28, 1818. After spending a few years at the village school, at the

age of ten he began to assist his father, a house-painter, and also to copy pictures. In 1833 his friends' desire was that he should study under Sir Edwin Landseer (1802–1873), a suave, popular painter of animals, but he was unable to afford the fee of £500 which he charged his pupils. The Rector of Blandford, the Rev. and Hon. Samuel Best, who recognized Stevens's talent, gave him £50, which enabled him to go to Italy, where he remained for nine years, returning in 1842. During this time Stevens applied himself to the intensive study of painting, sculpture and architecture; indeed, for him there existed but one art with various forms. He never attended an English school of art, and even in Italy preferred to work independently, learning what the old masters and the monuments of antiquity had to teach him. During the year before he returned to England he was employed by Thorwaldsen as his assistant. From 1842 until 1844 he worked in his native Blandford, and in the following year was appointed teacher of architectural drawing, perspective and design at the School of Design, Somerset House, a post which he held until 1847. Meanwhile his many-sided genius was variously employed: he designed a railway carriage for the King of Denmark, decorations (never carried out) for the building between Jermyn Street and Piccadilly lately occupied by the Geological Museum, the lions for the British Museum railings, four mosaics for the dome of St. Paul's, and the interiors of several mansions, the most famous of which was the recently demolished Dorchester House. In 1850 he was appointed chief designer to a Sheffield firm of metal workers, Hoole, Hobson & Hoole, and at the Great Exhibition, which took place in the following year, the admirable stoves, grates and fire-dogs manufactured after his designs attracted widespread interest. They inaugurated, indeed, the revolution in industrial art which William Morris and his innumerable followers were somehow unable to complete. The reason for Stevens's success and the comparative failure of the adherents of the Arts and Crafts movement is due partly to the fact that, devoted and consummate craftsman though he was, he was willing to design for processes involving wholesale production,

while they were haunted by the idea that there was something inherently unrighteous in the product of the machine and good in that which was made by hand. It was only with mental reservations, as it were, that they consented to follow Stevens's example.

In 1856 Stevens, after being placed sixth in the competition, was finally selected to execute the Wellington Monument in St. Paul's, which was to be at once his masterpiece and the cause of his death. The conduct of the authorities concerned towards him is, perhaps, the supreme example English history affords of official stupidity and cruelty in the treatment of a great artist. First of all £6,000 was deducted from the £20,000 which it was originally intended to devote to the monument. Dean Milman objected to the introduction of an equestrian statue, oblivious, apparently, of the presence in the Cathedral of that of Sir Ralph Abercromby, and the low-relief facing the Wellington Chapel of Sir Arthur Torren leading a charge. Mr. Ayrton, First Commissioner of Works, made the discovery that when Stevens had only completed seven-twelfths of the work, he had received eleven-twelfths of the money; he therefore proceeded to force him to surrender what he had already completed together with his materials, and proposed that a more punctual artist should carry on the work. By way of revenge Stevens made the face of Falsehood, one of the principal figures in the group, that of the First Commissioner of Works. But obstruction won the day, and on May 1, 1875, " the badgered artist's thread of life "— to quote a contemporary authority—" snapped under the humiliation and the strain." He left the work unfinished, and the noblest sculptured monument produced in England since the Reformation was thrust away into the relative obscurity of the Consistory Court; from which, thanks to the advocacy of Lord Leighton, it was ultimately rescued and placed in the position for which it was originally intended, and later, on the initiative of D. S. MacColl, completed by the addition of the equestrian figure.

Stevens's most ambitious achievements, the Wellington Monu-

ment and the mantelpiece and decorations for Dorchester House, belong to the domain of sculpture, but he was also a painter of the first importance, whose ambition it was to execute great decorations on the walls of public buildings—the Houses of Parliament, the British Museum Reading Room and St. Paul's especially inspired him—but in this, as in so much else, he was frustrated. His most elaborate paintings are his cartoons for Dorchester House, now at the Tate. Even these are incomplete, yet they reveal his mastery of majestic and impeccable design and his splendid draughtsmanship. Unlike many painters with a strongly classical bias, Stevens was not insensitive to colour. In his portraits especially (of which fewer than twenty are known), in spite of his predominantly linear vision, he shows himself a rich and harmonious colourist. His *Mrs. Mary Anne Collmann*, of about 1854, at the Tate Gallery, is one of the finest English portraits. To this work belongs a degree of perfection met with in increasing rarity after the middle of the nineteenth century. Very fine also are his imaginary portrait of *King Alfred and his Mother*, *John Morris Moore* and *The Hon. and Rev. Samuel Best*, of about 1840, *William Blundell Spence* at the Tate and the lost *Leonard Collmann*, the last two belonging to the same period as the *Mrs. Collmann*. Their immaturity notwithstanding, his *Portrait of the Artist at the Age of Fourteen* and *Samuel Pegler*, painted at about the same time and both at the Tate, are deeply impressive.

In spite of the public character of his art Stevens suffered grievous neglect, and during his lifetime he had no work accepted by the Academy. Even now, while his memory is honoured by a handful of artists and critics, he still awaits general recognition as the loftiest and most masterly interpreter of the classic tradition to which this country has given birth. The nation is fortunate in possessing, at the Tate and at South Kensington, a representative collection of his works.

The second of these pre-eminent exponents of public art, George Frederick Watts, was born in London on February 23, 1817. Ill-health as well as an innate preference for self-education kept him away from institutions of learning. He attended the

Academy Schools in the hope of acquiring proficiency in draughts-
manship in 1835, but remained only a few weeks, and frequented
instead the studio of William Behnes (1794 ?–1864), the sculptor,
from whom he learnt the veneration for Greek art that remained
with him to the end of his life. Meanwhile, without instruction,
he began to paint, and in 1837 exhibited at the Academy. Six years
later he won a prize of £300 in the competition for the decora-
tion of the new Palace of Westminster, and this enabled him to
visit Italy, where he remained for four years, mostly at the house
of his friend and patron, Lord Holland, British Minister to
Florence. Here, besides essaying mural painting, he began the
great series of portraits of eminent persons that was ultimately
to include so large a portion of the genius, character and beauty
among his contemporaries. In 1847 he was awarded a further
prize at Westminster, this time of the value of £500, with *Alfred
inciting his Subjects to prevent the Landing of the Danes*, in the House
of Lords; shortly afterwards he made an offer to decorate Euston
Station gratuitously with wall paintings illustrating the Progress
of the Cosmos, but this was refused. The Benchers of Lincoln's
Inn, however, accepted a similar offer to decorate their Hall,
with the result that he covered the north wall with an impressive
fresco, *Justice, a Hemicycle of Lawgivers*. He continued meanwhile
his series of portraits of the great personalities of his time, which
was one of his several munificent gifts to the nation, as well as
the allegories which began to occupy him in the late 'forties.

Watts's genius was recognized in his lifetime: he was elected
to full membership of the Academy in 1867, and in 1902 the O.M.
was conferred upon him. But in our own day his memory is
treated with even less justice than that of Stevens; and the reason
is not far to seek. The fundamental difference between the
attitude of Stevens and Watts and that generally prevalent to-day
is that whereas they conceived of art as having social responsi-
bilities, it is now, or was until lately, regarded as an autonomous
activity with aims peculiar to itself. Stevens's was a public art,
exalting the great public virtues, but inasmuch as his aim was
primarily æsthetic, it is comprehensible to the twentieth-century

mind. Watts, on the other hand, was largely concerned with the expression of ethical and philosophic ideas. At his worst there is no doubt that his preoccupation with these led him to neglect the æsthetic qualities without which no work of art is of value, no matter how noble in conception; but at his best he achieved an harmonious relation between noble form and philosophic truth.

To judge of the quality of most artists' work without regard to the nature of their subject is to invite error; in the case of Watts it is to ensure it. For since he was at least as much concerned with ideas as with their presentation, it is impossible to separate the æsthetic from the didactic elements in his art; the two are inextricably mingled. Watts was a didactic, a militantly didactic artist, but he was unlike most others of his kind in that he attempted to express himself not by the use of an accepted set of symbols but by a symbolism of his own creation. And when we consider the complexity of what he had to express, the magnitude of his achievement is impressive. The absence of accepted symbols is an unexpected feature of the work of a symbolic artist, but their employment would have been contrary to Watts's aim: to embody his message in pictures which would be intelligible not only to men of his own time and his own continent, but to all men. He was concerned with the realities for which conventional symbols stand.

His grave, stoical and inherently ethical temper found expression in a vast number of works, imaginative compositions, portraits and landscapes. Some of these last reveal a deep devotion to nature, but as befits a philosopher, Watts's supreme interest was man and his works. His allegories take a high place among the imaginative creations of the Victorian age, and the best of his portraits—*Lord Tennyson*, *Cardinal Manning*, of 1882, *John Stuart Mill*, of 1874, *Gladstone*, of 1858, *Matthew Arnold*, of 1880, and *William Morris*, of 1880, all at the National Portrait Gallery— reverent, reticent, yet severe—must rank with the best ever painted by an English artist.

It remains, to mention two later artists who believed themselves

to be the inheritors of the classical tradition. These were Frederic, Lord Leighton (1830–1895) and Albert Moore (1841–1893); but whereas Stevens drew his inspiration from the painting and sculpture of Renaissance Italy, they took Greek sculpture for their model. Leighton was an accomplished draughtsman and designer, but his paintings suffered from sweetness of sentiment and colour. Moore's colour is also oversweet, and as a designer he managed to be trivial and ponderous at once, but these short-comings are in part atoned for by the gay yet languorous spirit which inspired his happiest achievements.

CHAPTER XI

THE PRE-RAPHAELITES

" I WAS still searching for a perfect guide," wrote Holman Hunt near the beginning of the first volume of his " Pre-Raphaelitism." " Though I looked upon many artists with boundless wonder and admiration, and never dared to measure myself prospectively with the least of them, yet I could see no one who stirred my complete sympathy in a manner that led me to covet his tutelage. . . . Hackneyed conventionality often turned me from masters whose powers I valued otherwise. What I sought was the power of undying appeal to the hearts of living men." In these words of Hunt's are implicit a justifiable criticism of the state of art in England in his student days. So uninspiring, indeed, was the artistic prospect in the 'forties, that his sentiments were shared by a number of his more thoughtful contemporaries, although few of these could express themselves with his earnest eloquence. Blake and Constable were dead, Cotman passed away in comparative obscurity in 1842, and Turner, as Hunt said, " was rapidly sinking like a glorious sun in clouds of night that could not yet obscure his brightness but rather increased his magnificence." In any case, " The works of his meridian day were shut up in their possessors' galleries, unknown to us younger men." The ablest artists of the day painted either in the grand or in the popular manner. They were happy in neither idiom, showing themselves, for the most part, empty in the one or trivial in the other. After Turner and Haydon, the most interesting figure was William Etty, who was, however, at the end of his career. Etty was born at York on March 10, 1787, and coming to London, he worked with Lawrence for a year and afterwards became a lifelong student at the Academy Schools, dying on November 13, 1849. He was a curiously inconsistent being whose worship of voluptuous feminine beauty was ever at war with a narrowly Puritanic outlook: he adored Titian, yet he regarded

the Italian race with abhorrence, and his sensual syrens often point a moral. For all his splendid talent (he could endow flesh with a pulsing life and a subtlety which few other English artists have approached) Etty was not the man from whom to learn "the power of undying appeal to the hearts of living men." *The Bather*, for example, at the Cartwright Hall, Bradford, superb though it is, is principally compounded out of old familiar elements, which seemed a trifle threadbare to the young students to whom the next decades belonged. These none the less regarded him with sympathetic eyes, for his best works, such as the magnificent *Storm*, at the Manchester City Art Gallery, reflect unmistakably the rich glow of the romanticism of Turner, Delacroix and Scott.

From the standpoint of an original and earnest young painter, Etty's more popular contemporaries offered a still less satisfying prospect. Sir David Wilkie (1785–1841), whose remarkable skill called forth the praise of Delacroix, based himself first on Ostade and other Dutchmen, later on Velazquez and Murillo, and is best remembered for his genre pictures, such as *The Blind Fiddler*, of 1806, *Village Festival*, of 1811, both at the Tate, *The Letter of Introduction*, of 1814, at Windsor, and *The Penny Wedding*, of 1819, at Buckingham Palace. These, for all their spontaneous gaiety and humour, are expressions of an outlook not only too trivial to command the wholehearted admiration of the grave young students of the 'forties, but even to retain their popularity. They lack the racy robustness of Hogarth's paintings, for example, and their poignant suggestion that labour and death, after all, are not far away. And the same weakness is evident in the work of William Mulready (1786–1863), of Charles Robert Leslie (1794–1859), of Daniel Maclise (1811–1870) and of William Powell Frith (1819–1909). This last, however, produced, in *Derby Day*, of 1858, at the Tate Gallery, a minor masterpiece. But these men were a company of accomplished comedians who, chiefly concerned with entertainment, were hardly aware of the great events that were elsewhere changing the very founda-tions of the art they practised. They were the servants of fashion,

as most minor artists are, and insensitive to the revulsion, by which the younger generation was increasingly moved, against the un-reflective imitation of the old masters that constituted nine-tenths of the painting of the day; for it must be remembered that the fruitful and liberating revolution which had taken place in the domain of English landscape painting, and had produced momentous changes on the Continent, had left England unaffected to a singular degree. Earlier in the century Englishmen—Constable, Byron, Scott—had been among the inspiring forces in the romantic-realistic reaction against the dominant classicism. In 1824 the English exhibitors at the Salon—Lawrence, Bonington and Copley Fielding, as well as Constable—were received with the utmost enthusiasm, and English art was acclaimed by Géricault and Delacroix as a great revivifying force. Twenty years later it was stagnating in a backwater; meanwhile the movements which had received so great an impetus from England had developed on the Continent, in France especially, in new and original directions. A vigorous realistic movement, deriving principally from seventeenth-century Dutch and eighteenth- and early nineteenth-century English landscape, had allied itself with the romantic movement to challenge a classicism relatively weak in creative power, yet strongly entrenched in the academies and the learned institutions of all Europe, which, furthermore, by reason of its essentially responsible and social character, was viewed with sympathy by governments and publics alike. The struggle was fiercely contested, but finally the classical system of ideas that had for so long dominated the æsthetic outlook of Europe was overthrown. Fundamentally the conflict was between opposed philosophies of art, but, since classicism was identified with Greek and Roman forms, it was natural that its opponents should have looked for justification towards Mediæval art, the most impressive alternative they knew. But there was also an affinity of outlook between the nineteenth-century opponents of classicism and Gothic painters and sculptors. For Gothic art—dynamic, spontaneous and subjective—is the antithesis of that of the Greeks and Romans. During the early nineteenth century,

moreover, classical art was suffering in a marked degree—the work of David and Ingres apart—from its besetting weakness, the assumption that the faithful observance of rules can be a substitute for creative power. Ranged, therefore, against a Græco-Roman art deriving principally from the Renaissance were a lively dissatisfaction and a desire for change which gave rise to a reaction in favour of mediæval things, not in painting alone, but also in literature and religion, and lastly a renewed impulse towards a closer adherence to the facts of vision. On the Continent the revolt against classicism touched every aspect of painting, and was personified in a succession of great figures, Géricault, Delacroix, Daumier and Courbet, to name but a few; in England, on the other hand, it was at first largely confined to landscape.

Pre-Raphaelitism, in the widest sense of the term, was the result of forces similar to those which produced the romantic-realist emancipation from classicism on the Continent. The two movements, however, differed widely in character. The foremost of the Continental artists displayed greater technical mastery and a far deeper comprehension of the potentialities of paint. Indeed, the achievement of that glorious succession, which may be said to have begun with Géricault and ended with the last great Impressionists, transformed the face of painting and created a new pictorial world. These men, mostly despised in their own day, receive their full measure of recognition in ours. But in honouring them we are prone to ignore the elements common to them and our own Pre-Raphaelites and to treat these last with a want of consideration which they are far from meriting. They were provincial, and deficient very often in those purely painter-like attributes that give to a Manet, for example, an almost universal appeal, and they sometimes sacrificed pictorial qualities by straining after poetical effects which might have found finer expression in verse or prose. Yet theirs was none the less an art which at its best was at once nobly imaginative and close to nature.

The history of art may be said to be a continuous process of adjustment between the impulse to imitate nature and the impulse to impose upon her the impress of the artist, to embrace nature,

as it were, and to discipline her. As we have already noticed, the vigorous realistic impulse which transformed English land-scape at the close of the previous century subsided without notably affecting other spheres of painting, where obsolete con-ventions were still strictly observed. It was in a large measure due to the Pre-Raphaelites that the realistic impulse not only revived in England but fertilized the entire field of painting. The centralized composition and arbitrary illumination of the academic painters were finally discredited and English practice brought into close relation with the facts of vision. But more important than this was the achievement of the Pre-Raphaelites in the realm of the imagination. Here they replaced pomposity and triviality with a startling sincerity and an exalted poetry of feeling. In their triumphant moments they fulfilled Hunt's student aspiration, and appealed " to the hearts of living men." The virile realistic movement, with its marked mediæval sentiment, which began to achieve coherent utterance towards the end of the 'forties, and which is summed up in the term Pre-Raphaelitism, was by no means confined to the work of the Pre-Raphaelite Brotherhood.

Undue importance has been, perhaps, given to the composition and internal affairs of the Brotherhood—whether or not, for instance, Brown was invited to membership, whether Hunt or Rossetti was the first to formulate its creed, for the Brotherhood merely gave a name to an impulse by which no facet of English painting was unaffected. The name Pre-Raphaelite will here therefore be applied to any upon whom this movement was a decisive influence, whether or not he was one of the Seven. The earliest considerable English painter to whom the name, in this sense, may be applied was Brown, although it was not until he had been for some time in contact with the Brethren that his work assumed an entirely Pre-Raphaelite character. Ford Madox Brown was born in Calais on April 16, 1821, the son of a retired purser in the Navy and grandson of John Brown, the famous Edinburgh doctor. Studying under Gregorius at Bruges, Van Henselaer at Ghent and Baron Wappers at Antwerp, he quickly acquired a sound knowledge of painting. How mature his vision and how con-

siderable his mastery at an early age is evident from the excellent portrait of his father, in the possession of Mrs. Angeli, which he did in his fourteenth or fifteenth year. In 1841 he showed *The Giaour's Confession* at the Academy, a characteristic early work inspired by a Byronic mood.

Whereas in France, especially after the death of Delacroix, the parallel movement was aggressively individual in feeling, Pre-Raphaelitism had a social aspect, and it was to this that Brown gave pre-eminent expression. To Brown, with his strong civic sense (which, like that of Stevens, met with small encouragement) and his abundant, vigorous responsiveness to contemporary life, art could not long remain a romantic escape. When he entered for the fresco competition of 1844 at Westminster and adopted linear design and flat colour in place of the chiaroscuro he had learned from Wappers, Brown discarded the technique which early environment and training had given him. From the Germans Cornelius and Overbeck, whom he met in Rome the following year, he caught the Gothic mannerisms they used. Ruggedly personal though Brown was in temperament he was far from impervious to the ideas of others. When therefore, Rossetti became for a short time his pupil in 1847, and Brown thereby came in contact with the Pre-Raphaelite circle, his own outlook was modified. So, by the early 'fifties his tentative aspirations towards accurate depiction of observed facts, and those of open-air illumination especially, had become a stubborn pursuit. In spite of his seniority and his superior technical equipment there can be little doubt that Brown was more affected by Hunt and Rossetti than they were by him. During these years were undertaken Brown's two most notable achievements, *Work*, at the Manchester City Art Gallery, begun in 1852 but not completed until eleven years later, and *The Last of England*, of which there are two versions, one at the Birmingham Art Gallery and a smaller one at the Tate, begun in the same year and completed in 1856. These two form an impressive contrast. *Work*, panoramic, brilliantly lit, teems like a novel by Zola with pungent, multifarious human life and abounds in passages of potent, glowing

beauty tempered by a quality of sullenness peculiar to Brown. Though the picture lacks cohesion, and the sum of the parts is greater than the whole, *Work* is none the less one of the great achievements of nineteenth-century painting. Conceived on a less heroic scale, but far more concentrated in design and more poignant in its appeal, *The Last of England* is Brown's most perfect and perhaps most characteristic work. The two portraits are of Brown and his second wife, and the subject was suggested by the departure of the sculptor Thomas Woolner, one of the Brethren, from Gravesend for Australia, which was witnessed by Brown.

The strongly literary element in Rossetti's art was not without its effect on Brown, but since it awoke little natural response in him, his own literary pictures—the most characteristic being, perhaps, the various versions of *Cordelia's Portion*—are less impressive than those for the themes of which he drew upon his own observation. From 1878 until the time of his death he was engaged upon a series of twelve mural paintings dealing with the history of Manchester, for the Town Hall of that city. These paintings give evidence of his powers as a designer and his vivid sense of history, but they lack the living quality and the astonishing intensity that characterize *Work* and *The Last of England*. Though given no panel to paint at Westminster and little public recognition, the public spirit which burned so strongly in Brown expressed itself in various ways. He helped to establish a drawing school for artisans, and after the foundation of the Working Men's College, he taught there without pay. In 1891 a body of his admirers raised a sum of money to enable him to be worthily represented in the National Gallery, but on October 6, 1893, before a purchase was made, he died. Out of the sum raised, however, Brown's fine *Christ Washing St. Peter's Feet*, of 1852, was acquired and is now at the Tate.

The Pre-Raphaelites, especially during the five years that followed the establishment of the Brotherhood, had certain qualities in common. One of their pictures, whether it be by Hunt, Millais, Collinson or Rossetti, in addition to its individual attributes has a character unmistakably Pre-Raphaelite. But this

common element was the product of a momentary interaction of temperaments which differed radically from one another. While Brown was filled with the poetry of strenuous, abundant life, Hunt was most moved by moral ideas; he was a militant Puritan. It has been argued by eminent authorities that the artistic and the religious spirits are in the last analysis mutually antithetical. However this may be, militant Puritanism is conspicuously hostile to the fine arts. The incongruity of Hunt's moral attitude with his painting is thus indicated by Mr. MacColl: "He uses art," he said, "as a rebuke to itself. . . . His sheep are always strayed, his lovers always have a guilty conscience . . . he (is) the prosecutor of beauty, not the wooer." There were, nevertheless, moments in that long, laborious career when, by virtue of steadfastness of purpose illumined by flashes of authentic, if harsh and unsympathetic genius, Hunt painted great pictures. *The Hireling Shepherd*, of 1851, at the Manchester Gallery, is one; *The Scapegoat*, at the Lady Lever Gallery, completed in 1854, is another.

William Holman Hunt was born in Cheapside on April 2, 1827, and at thirteen entered on a commercial career. About three years later he began to study art at the British Museum and the National Gallery, and, in 1844, after failing in a first attempt, he entered the Academy Schools. There he came to know Millais, and a lifelong friendship grew up between them; it was there also that he made the acquaintance of Rossetti. In 1846 he began to exhibit at the Academy, and two years later he showed there *The Flight of Madeline and Porphyro*, in a private collection, from Keats's "Eve of St. Agnes," which Rossetti told him was the best picture of the year. That summer Rossetti became for a while Hunt's pupil. In the autumn, Hunt, Millais and Rossetti were occupied with plans for the establishment of a group which would bring together those who shared their beliefs: shortly afterwards the Pre-Raphaelite Brotherhood was founded. Besides the above-mentioned three, the members were F. G. Stevens (1828–1907), the critic, W. M. Rossetti (1829–1919), the scholar and man of letters, Dante Gabriel's brother, Thomas Woolner and James Collinson (1825?–1881), a painter of charm and dis-

tinction but deficient in imagination and force. He left the Brotherhood not long after its foundation, became a Catholic and entered a monastery.

The members of the Brotherhood before long began to exhibit pictures which expressed their new convictions—in 1849 Hunt sent *Rienzi*, Rossetti *The Girlhood of Mary Virgin*, both in private collections, and Millais *Lorenzo and Isabella*, at the Walker Art Gallery, to the Academy—but these at first attracted little notice. The following year, however, Hunt's *Christian Priests escaping from Druids*, at the Ashmolean, Rossetti's *Annunciation* and Millais's *Christ in the House of His Parents*, both at the Tate, became targets for virulent attack. Dickens's coarse abuse of Millais's painting in a review in "Household Words," in which he describes the kneeling figure who represents the Mother of Christ as one who would " stand out from the rest of the company as a monster in the vilest cabaret in France, in the lowest gin-shop in England," bears testimony to the passion that these young men's paintings excited.

There were several reasons why such original work should have outraged the conventional taste of the day, but there was one which outweighed the rest. It had long been generally accepted that the achievement of Raphael was synonymous with man's supreme achievement in the realm of painting, and that the canon of Raphael, that is to say, the canon of beauty established by the Greeks, accepted by the Romans and revived throughout western Europe by the Renaissance, represented an ultimate standard of perfection. To the majority, who accepted this classical view of art—who, as was mentioned earlier, exercised a predominant influence in academies of learning and of art and in the press—the identification of these young artists with the ideals of the barbarous period that preceded Raphael represented a wilful and inexplicable turning from light to darkness. To such depths of despondency was Hunt reduced by calumny and neglect that he thought of abandoning the arts for farming. But a change was at hand. When *Valentine rescuing Sylvia from Proteus*, at the Birmingham Gallery, was shown at the Academy in 1851, the

attacks upon it evoked from Ruskin the memorable letter to
" The Times " in which he defended Pre-Raphaelite art and went
far thereby towards making the work of the Brethren intelligible
to the public. *The Hireling Shepherd,* shown the following year,
was declared by Carlyle to be the greatest picture he had ever seen
painted by an Englishman. It was not long before the opinions of
these men were widely adopted. With the exhibition in 1854 of
the much inferior *Light of the World*, the original version of which
is at Keble College, Oxford, Hunt attained popular success.

He had now the means to fulfil his ambition to visit Palestine
in order to assemble information which would enable him to paint
scenes from the life of Christ with unexampled accuracy. On
this first visit he began *The Finding of the Saviour in the Temple*, at
the Birmingham Gallery, which was not finished until six years
later, in 1860, that is. It was at this time that he also began
The Scapegoat, a picture the austere grandeur of conception and
intensity of treatment of which give it a place with the great
English paintings of the century. Hunt made several further
sojourns in Palestine and lived for a further half-century, but he
never again showed such imaginative power as in *The Scapegoat*,
The Hireling Shepherd, and the interesting but lesser *Awakened
Conscience*, in Mr. Colin Anderson's collection, first shown in 1854.

His eye for colour was wanting in sensibility to a singular
degree; worse still, he so far gave way to his passion for scrupulously
rendered detail as to blind him to the claims of design. He has
the misfortune, moreover, to be best known not by his finest
works but by *The Light of the World* and others of a like order.
Partly, therefore, by reason of his particular shortcomings, but
even more by ill-fortune and a revolution in taste, Hunt is to-day
discounted and sometimes denied the very name of artist. He
died, however, full of honours (the O.M. was conferred on him
in 1905) on September 7, 1910, and his cremated remains were
buried in St. Paul's.

During the years between the foundation of the Pre-Raphaelite
Brotherhood and the departure of Hunt on his first visit to the
East he and Rossetti exercised a continuous influence one upon

the other. Rossetti worked for a time, as has been noted, as Hunt's pupil, while Hunt caught from Rossetti a dramatic intensity—evident in such pictures as *Valentine rescuing Sylvia from Proteus* and *Claudio and Isabella*, of 1850, at the Tate—lacking in the majority of his later works. But so soon as the two artists were no longer in contact the temperamental differences between them, always evident, became irreconcilable. Hunt's concern for the exact rendering of the thing seen and the severity of his evangelical temper grew more pronounced: he became all scrupulousness, all restraint, and the poetry and drama went out of his work, with the great exception of *The Scapegoat*. Years before, when Brown had set him painting bottles, Rossetti realized how indifferent he was to the prose of natural appearance. But if one element in Pre-Raphaelitism left him unmoved, in his life and his poetry as well as his painting Rossetti personified another. If for the imitation of nature he had neither the inclination nor, it should be added, the capacity, of the poetical, romantic element, with mediæval, mystical affinities, he showed a passionate understanding.

Dante Charles Gabriel Rossetti, or, as he called himself, Dante Gabriel Rossetti, was born in London on May 12, 1828, and was the elder son of Gabriele Rossetti, a political refugee from the Kingdom of Naples, a Dante scholar and a poet, who became, in 1831, Professor of Italian at King's College. The Rossetti household was a stimulating environment for the professor's prodigiously gifted children: at five or six Dante Gabriel was writing poetry, at nine he was learning drawing from Cotman at King's, where he remained until his fifteenth year. He also spent four years at a private drawing school before entering the Academy Schools in 1846. Two years later he apprenticed himself for short periods first to Brown and afterwards to Hunt. He painted but little in oil in these early days, except *The Girlhood of Mary Virgin* and the *Annunciation*. These two interpretations, especially the latter, reverent, indeed almost devout, of the mystical life of Mary, provoked abuse of such a kind as made the artist reluctant to exhibit, and for several years he confined

himself to the production of small works, water-colours and pen-and-ink drawings, the subjects of which were mostly drawn from Dante, Shakespeare, Browning, the New Testament and the Arthurian Legend. In spite of lovely effects which from time to time he obtained, Rossetti never succeeded in making of oil paint an adequate means of conveying his emotion in its fullness. The two slighter mediums, on the other hand, were perfectly adapted to his impatient temperament and the spontaneous nature of his genius. The intensity of his imagination, and his astonishing command of expressive gesture and of atmosphere, enabled him to produce water-colours and drawings of the rarest quality. Of the artists of the century perhaps Daumier alone was capable of the dramatic force, the poignancy of feeling that characterizes such drawings, for example, as the complete pen-and-ink study for *Found*, at the Birmingham Gallery. The subject—a farmer taking a calf to market, and recognizing a fainting woman of the streets as his former mistress—is treated with a sublime comprehension. Here Rossetti puts us in mind of Rembrandt: his draughtsmanship is incomparably inferior, yet in intensity of emotional force the two artists are akin. Rossetti began work on *Found*—his only picture of contemporary life—in 1853, and in spite of many attempts it never reached completion. The final version, which was worked on by Burne-Jones after the artist's death, is now in America. In 1855 he began his association with a group of young Oxford men, of which Morris and Burne-Jones were the leaders, which was to bring about what is sometimes known as the second Pre-Raphaelite movement. The adherents of this movement were followers of Rossetti, from whom they learned love of poetry and indifference to the facts of natural appearance. The first important manifestation of this revived Pre-Raphaelitism was the decoration by Rossetti, Morris, Burne-Jones and three others, in 1857, of the walls of the debating hall of the Oxford Union with paintings in tempera, but owing to the artists' imperfect knowledge of their medium their work soon showed signs of rapid decay. This process, however, would appear to have been arrested by recent restoration.

After the death, in 1862, only two years after his marriage, of his wife, Elizabeth Siddal—a being of singular beauty and talent to whom since about 1851 Rossetti had been passionately attached— he became for a time a prey to despair, and there set in a slow deterioration of his creative faculties. Towards 1867 the process grew more pronounced: he began to suffer from acute insomnia and became subject to melancholia. Now and again, in the realm of poetry especially, his genius revealed itself, but the decline in his powers continued, and in 1881 he was seized with partial paralysis and on April 10 of the following year he died.

It is singular that in spite of his predominantly Italian blood and his love of Dante and Italian painting he never went to Italy. There is, to be sure, an opulence about his later painting suggestive of his southern affinities, but the haunting pathos of his finest works, such for instance, as the best of his early drawings and gouaches, and the studies for *Found*, bespeaks an essentially northern temperament. Rossetti was first and last an artist, and his indifference to extraneous problems equalled Hunt's preoccupation with them. He never acquired as an oil painter the mastery he displayed as a draughtsman and as a poet—he had, for example, but a moderate capacity for design and his colour has sometimes proved impermanent—yet in the expression of intense emotion he is excelled perhaps among English artists only by Blake.

The third member of the Brotherhood to achieve fame as a painter was John Everett Millais. Born at Southampton on June 8, 1829, he early gave evidence of phenomenal talent. At eleven he was admitted to the Academy Schools, at sixteen he painted *Pizarro seizing the Emperor of Peru*, at the Victoria and Albert, a capable work, and a fair sample of the "slosh" which the Brotherhood abhorred above all else. But it was not long before the influence of the much less accomplished Hunt brought about a radical change in Millais's outlook, and he became for a time an enthusiastic convert to Pre-Raphaelite principles. His grasp of these at times, however, was far from certain. That the highest beauty was attained by the direct and unimpeded contact

of the artist with his subject, and that conventional "styles" of any sort were anathema, were fundamental tenets to which the Brotherhood unanimously subscribed. Yet Millais's first Pre-Raphaelite painting, the *Lorenzo and Isabella*, is, in effect, an astonishingly accomplished attempt to recapture the "style" of the primitives. *Christ in the House of His Parents*, of the following year, a less superficial expression of Pre-Raphaelite principles, is a masterpiece. Here he shows something of Hunt's brilliant integrity and of Rossetti's poetry in addition to a power of design and fresh and vigorous sense of colour peculiarly his own. Millais was elected an Associate of the Academy in 1853, the year in which the Brotherhood was dissolved, but the inspiration he received from it persisted for a while. During the next three years his technical mastery increased and his imagination grew to a grave and mellow yet short-lived maturity. To 1856 belong his solemn and resonant *Autumn Leaves*, at the Manchester Gallery, and his finely designed and poignant *Blind Girl*, at the Birmingham Gallery, works which show that granted a favourable emotional climate Millais could be inspired. But through his friend Hunt's growing aridity of outlook, and his own forgetfulness of Rossetti's fructifying influence, he was left to battle unsuccessfully with the temptation to seek fame and wealth by pandering to a degraded public taste. Worldly success accompanied artistic failure: he made a large fortune, was created a baronet in 1885 and elected President of the Academy in 1896, dying on August 13 of the same year.

As a book illustrator Millais, a fine draughtsman, exercised a fruitful influence on a group of gifted artists. With Rossetti and others he contributed drawings in 1857 to the Moxon Tennyson, and to " Good Words," and the poetic and intimate spirit of these drawings was reflected in the book illustrations of Arthur Hughes (1832–1915), Arthur Boyd Houghton (1836–1875), Frederick Walker (1840–1875) and George Pinwell (1842–1875).

The foremost painter among the followers of Rossetti was Edward Burne-Jones, who took over the mediæval and mystical elements from the original from Pre-Raphaelitism and initiated

the new movement already noted. Born in Birmingham on August
28, 1833, he was first destined for the ministry of the Church of
England, but while at Exeter College, Oxford, he came under the
influence of Rossetti, on whose recommendation he left the uni-
versity and devoted himself entirely to art. Unlike that of his
master, Burne-Jones's mild temperament brought him neither
serious conflict with the public nor involved him in personal
tragedies such as cut short Rossetti's life; he was able to retain his
integrity as an artist and at the same time to earn public honours—
no mean achievement at such a time. He was never a full
Academician, resigning in 1893 the Associateship to which he had
been elected seven years before. In 1897 he was created a baronet,
dying on June 17 of the following year.

Burne-Jones was a prolific and resourceful designer and possessed
of a serene and gracious imagination. The art of the first Pre-
Raphaelites was of a largely public character: Brown and Hunt,
like Watts, were especially drawn towards subjects of civic
significance. For Rossetti, on the contrary, art was a wholly
personal matter, and he was hardly more sympathetic to the
public than they to him: his own dæmon and public hostility
combined to drive him into a secret world of his own creation.
The same exclusive quality characterized Burne-Jones, and to an
equal degree. His art, so far from being the expression of a desire to
participate, as it were, in life, like that, for example, of Hogarth,
of Brown, or of Hunt, was clearly inspired by the impulse to escape.
He was not equipped to portray or to interpret the emotions and
ideas which belong to the real world; invariably he leads the
spectator into a mediæval dream-world abounding in intricate,
serpentine ornament, peopled by rather feminine figures with
spell-bound, listening faces. Understanding himself, Burne-
Jones rarely forsook his chosen kingdom: " I mean by a picture,"
he said, " a beautiful romantic dream of something that never
was, never will be." He had neither Rossetti's emotional force
nor his conviction, but he had the power, denied to the other
Pre-Raphaelites, of working on a large scale. The admirable
design and the subtle colouring and gentle, mystic poetry of his

finest works entitle them to a higher place in English painting than they are accorded to-day. William Morris (1834–1896), poet, politician, pamphleteer and master craftsman, painted a little, mostly between 1857 and 1862. His *La Belle Iseult*, at the Tate Gallery, a rich, vigorous work, gives an unmistakable indication of what he might have accomplished had he elected to give more time to painting. With the death of Walter Crane (1845–1915) an illustrator of great charm and an associate of both Burne-Jones and Morris, the Pre-Raphaelite movement may be said to have run its course.

WHISTLER

PRE-RAPHAELITISM, which during the middle of the century was a revolutionary movement, by the 'seventies and 'eighties had become conservative. Since most of the popular painters of the time had come under the influence of Pre-Raphaelite technique, the distinction between Burne-Jones and Hughes on the one hand, and the Orchardson and the Pettie on the other, was now largely a question of subject, the subjects of the later Pre-Raphaelites, though less intense and less original than those of their predecessors, being nevertheless poetic and distinguished, and those of the popular painters for the most part inexpressibly trivial. The two were in one respect alike, inasmuch as both accorded to the subject a position of paramount importance. "Painting," declared Ruskin, "or art generally . . . is nothing but a noble and expressive language, invaluable as the vehicle of thought, but by itself nothing." It is not, therefore, surprising that when this conception of art came to be challenged, the Pre-Raphaelite and the popular painter of anecdote were to be found in the same camp. This insistence that art was "by itself nothing" fostered a disregard for integrity of design, colour and other essential elements in painting; even artists of sensibility and intelligence became prone to use the idiom of literature in preference to that which was proper to their own art. Muther is hardly guilty of exaggeration when he describes the artistic visitors to the exhibitions of the day as "accustomed to run their noses into a picture and find it explained for them by a piece of poetry in the catalogue." Extremes notoriously provoke extremes, and the exaltation of the subject of a picture at the expense of the æsthetic elements without which it cannot live, provoked among the painters of the succeeding generation indifference towards subject, indeed a positive preference for

the humanly insignificant, so acute became the fear that the integrity of painting itself was in danger of being lost.

In their emphatically linear method of expression no less than their subjects the Pre-Raphaelites and the popular painters were at one in their sharp divergence from the general trend of painting's development. In the course of the seventeenth century a momentous change took place in the European vision. Hitherto the painter had seen predominantly in terms of line; objects were portrayed as entities inherently separate from one another, by means of contours which could not, as it were, be detached from them. But the painter of the seventeenth century began to develop a more comprehensive vision, and to see in terms not of line but of tone. Thus for him the chief interest lay not in the bounding lines, the edges of objects, but in the forms which such lines enclosed. The two following extracts from Heinrich Wölfflin's searching analysis of this radical change in his " Principles of Art History " elucidate two essential aspects of it: " We can thus further define the difference between the styles by saying that linear vision sharply distinguishes form from form, while the painterly eye on the other hand aims at that movement which passes over the sum of things." " The tracing out of a figure with an evenly clear line has still an element of physical grasping. The operation which the eye performs resembles the operation of the hand which feels along the body. . . . A painterly representation excludes this analogy. It has its roots only in the eye, and just as the child ceases to take hold of things in order to ' grasp ' them, so mankind has ceased to test the picture for its tactile values."

The later vision is not superior to the other, but rather the logical development of it, and better adapted, moreover, to a more complex civilization.

The challenge to the reactionary trend of English painting came from an American, James Abbott McNeill Whistler. Born on July 10, 1834, at Lowell, Massachusetts, he was taken in 1843 to Russia, where his father, an engineer, was engaged upon the construction of the St. Petersburg-Moscow railway. Six years

later he entered West Point, but was judged to be unsuited for a military career. In 1855 he left the United States never to return, and went to Paris where he entered the studio of Gleyre. Four years later he visited London—which virtually became his home until his death on July 17, 1903. He was buried at Chiswick Churchyard near to Hogarth.

Whistler passed the greater part of his working life in England, but since he was neither English by birth nor by training we are here concerned rather with the influence which he exercised upon the English school than with his own achievement as a painter. This influence was far-reaching; indeed, Whistler may be said to have ushered in a new epoch in English art. In spite of the immense vogue enjoyed by the painters of anecdote and the prestige of the later Pre-Raphaelites, neither artists nor public were entirely unprepared to receive the doctrines which Whistler proclaimed. For there already existed certain misgivings regarding the condition of the arts in England: painters relied upon the intrinsic pathos or the humour of their subjects rather than upon their own power of representing them with originality and insight; they still saw in terms of outline when the leaders of European art were perfecting the new language of tone.

Whistler learnt little from Gleyre; his chosen masters were Hals, Rembrandt and Velazquez, all three emphatically painters as distinct from draughtsmen, and the Japanese, who taught him to discard the elaborate traditional formulæ for composition, and to replace them with a more spontaneous, more economical and more expressive system of design. He also found teachers near at hand: Courbet, who taught him to look at the world about him for his subjects, eschewing mythology, history and everything but what he himself had seen; the Impressionists, from whom he learnt to attach less importance to the shapes of things than to the atmosphere in which they were enveloped; and Corot, from whom he learnt to see in tone. He evolved not only an original style but a philosophy of art, set forth in lucid, stinging prose, in " The Gentle Art of Making Enemies." His own paintings, for the moment, on account of their want

both of energy and solidity of form, have ceased to exert an influence ; " art for art's sake," on the other hand, pruned and modified, is embodied in current æsthetic doctrine. His teachings, infinitely skilful in the manner of their presentation, were not original. " Art for art's sake " had already found wide acceptance among French artists, and also among their colleagues in the world of letters: Gautier had declared that the perfection of form alone was virtue, Baudelaire, that poetry had no end but itself. Whistler developed these ideas in relation to painting and formulated a compact yet comprehensive system of ideas. It was essential, he held, that the artist should absolve himself both from the necessity of expressing any save purely æsthetic emotions and of adopting a slavish attitude in the face of nature. " Nature contains the elements," he declared, " in colour and form, of all pictures, as the keyboard contains the notes of all music. . . . To say to the painter, that nature is to be taken as she is, is to say to the player that he may sit on the piano." It was his desire to emphasize his belief in an æsthetic as opposed to an anecdotal or an imitative art that led him to adopt for his own works the nomenclature of music—" nocturne," " symphony," and so forth—the most abstract of the arts. And since Whistler's day English painters, like their fellows on the Continent, have been influenced to an increasing degree by the ideal of an abstract art, evocative of none but æsthetic emotions, existing for itself alone, and devoid of social purpose. Less evident in his writings and the records of his conversation than his belief in a self-sufficient art, but conspicuous in his painting, is his belief in the vision that " passes over the sum of things " as opposed to that which " sharply distinguishes form from form."

The history of European painting subsequent to the sixteenth century may be stated as an almost continuous movement away from the earlier manner of seeing sharply, in terms of a single distance, towards a more spatial and more comprehensive vision of the world. Pre-Raphaelitism, with its uncompromising literalness, was an interruption in the growth of such a vision; with Whistler the interruption ceased and the process was resumed. It is

significant that the absence of detail in Whistler's paintings aroused among the later Pre-Raphaelites and the popular painters no less hostility than their provocative nomenclature; of which the evidence of Burne-Jones and Frith in the Whistler *versus* Ruskin lawsuit bears ample testimony.

The originality and distinction of Whistler's practice as a painter and the assiduously cultivated magnetism of his personality gave him an extraordinary ascendancy over his younger contemporaries. He revealed to them the significance of Corot, of Courbet and of the Impressionists; he taught them to select with severe good taste, from the life about them, the materials for their pictures, and that art was not, as Ruskin held, a means of communication, but an end to be pursued, with integrity and passion, for its own sake.

The influence of Whistler may be said to have remained decisive until the end of the first decade of the twentieth century, when a new movement, like Impressionism, international in its effects, gave different directions and a fresh impetus to English painting.

INDEX

INDEX

INDEX

INDEX

Wall and panel painting, mediæval, 1–17, 19, 21; Tudor period, 24; Stuart period, 33; late seventeenth-century, 43–5; nineteenth-century, 78, 115, 124, 129

Wallace Collection, 65

Walpole, Horace, 24, 31, 39, 40, 41, 60, 87, 91
" Anecdotes of Painting in England," 60

Walpole, Sir Robert, 53

Walter of Colchester, 5

Walter of Durham, 7, 10

Walworth, Sir William, Lord Mayor of London . . . kills Wat Tyler . . . (Northcote), 68

Wappers, Baron, 122, 123

Ward, James, 57, 58
Gordale Scar, Yorkshire, 58
Harlech Castle, 58
Landscape with Castle, 58
Regent's Park, Cattle Piece, 58

Warwick Roll, 24

Waterfall (Cotman), 106

Watteau, 50

Watts, George Frederick, 111, 114–16, 132
Alfred inciting his Subjects . . ., 15
Cardinal Manning, 116
Gladstone, 116
John Stuart Mill, 116
Justice, a Hemicycle of Lawgivers, 115
Lord Tennyson, 116
Matthew Arnold, 116
William Morris, 116

Welbeck, 41, 55

Wellington Monument (Stevens), 113

West, Benjamin, 72–3, 75, 79
The Death of General Wolfe, 72, 75

West Chiltington Church, Sussex, 9

West of England school of mediæval art, 17

Westminster Abbey, 7, 8, 10, 14, 15, 19, 60, 80

Westminster from below York Watergate (Wyck), 87

Westminster Palace, 7, 8, 10, 115, 123

Westminster *Retable*, 8

Westminster school of mediæval art, 6, 8–13, 23

Wheel of Fortune (Rochester Cathedral), 9

Whistlejacket (Stubbs), 56

Whistler, James Abbott McNeill, 52, 135–8
" The Gentle Art of Making Enemies," 136

Whitehall, 43, 44

Wildman, Mr., and his Sons (Stubbs), 57

Wilkie, Sir David, 98, 119
The Blind Fiddler, 119
The Letter of Introduction, 119
The Penny Wedding, 119
Village Festival, 119

William Friar, 9
St. John's Vision of Christ, 9

William, Master, painter monk of Westminster, 7

William Morris (Watts), 116

William of Croxton, 8

William of Walsingham, 10

Wilson, Richard, 64, 86; life and art of, 88–90; influence of, 90–1, 93–5, 97, 102; compared with Gainsborough, 92
Cader Idris, 90
Croome Court, near Worcester, 90
Lord Egremont, 88
The River Dee, 90
The Thames at Twickenham, 90
A View of Dover, 88

Wilton Diptych (National Gallery), 14, 15

Wimpole, 45

Winchester Bible, 4

Winchester Cathedral, 5, 6, 19

Winchester school of mediæval art, 2, 3, 4, 6, 7, 9, 11, 23

Windsor, 25, 37, 44, 71, 119

Windsor Beauties (Lely), 35, 36

Windsor Castle (end-paper to minute Bible—Edward VI), 86

Wissing, William, 42

Witham, Priory of, 4

Wölfflin, Heinrich, 135
" Principles of Art History," 135

Woodstock Palace, 7

Woolner, Thomas, 124–5

Wootton, John, 54, 60
The Bloody-Shouldered Arabian, 55
Bonny Black, 55

Work (Brown), 123, 124

Working Men's College, 124

Wren, Sir Christopher, 40, 43, 44

Wren, Sir Christopher (Riley-Closterman), 39

Wright, Joseph Michael, 36–7
Lionel Fanshawe, 37

Wright, Thomas, 88

Wycherley, William (Kneller), 41

Wyck, John, 54, 55

Wyck, Thomas, 87
Westminster from below York Watergate, 87

Wynants, Jan, 91

Youth Leaning against a Tree (Hilliard), 27

Zoffany, John, 53

Zuccarelli, 86, 88

Zuccaro, Federigo, 23, 26